# THE AESTHETIC QUESTION

ALSO AVAILABLE FROM BLOOMSBURY

*Aesthetics and Nature* by Glenn Parsons
*Aesthetics of Care* by Yuriko Saito
*Aesthetics and Glamour* by Carol S. Gould
*Architectural Aesthetics* by Edward Winters
*Aesthetics and Morality* by Elisabeth Schellekens
*Aesthetics and Design* by Jeffrey Petts
*Aesthetics and Video Games* by Christopher Bartel

# THE AESTHETIC QUESTION

*Experience, Judgement, Value*

## JANE FORSEY

BLOOMSBURY ACADEMIC
LONDON • NEW YORK • OXFORD • NEW DELHI • SYDNEY

BLOOMSBURY ACADEMIC

Bloomsbury Publishing Plc, 50 Bedford Square, London, WC1B 3DP, UK
Bloomsbury Publishing Inc, 1359 Broadway, New York, NY 10018, USA
Bloomsbury Publishing Ireland, 29 Earlsfort Terrace, Dublin 2, D02 AY28, Ireland

BLOOMSBURY, BLOOMSBURY ACADEMIC and the Diana logo are trademarks of Bloomsbury Publishing Plc

First published in Great Britain 2026

Copyright © Jane Forsey, 2026

Jane Forsey have asserted her right under the Copyright, Designs and Patents Act, 1988, to be identified as Author of this work.

For legal purposes the Acknowledgements on p. ix constitute an extension of this copyright page.

Cover design: Louise Dugdale
Cover image © Georgeclerk/Getty Images

All rights reserved. No part of this publication may be: i) reproduced or transmitted in any form, electronic or mechanical, including photocopying, recording or by means of any information storage or retrieval system without prior permission in writing from the publishers; or ii) used or reproduced in any way for the training, development or operation of artificial intelligence (AI) technologies, including generative AI technologies. The rights holders expressly reserve this publication from the text and data mining exception as per Article 4(3) of the Digital Single Market Directive (EU) 2019/790.

Bloomsbury Publishing Plc does not have any control over, or responsibility for, any third-party websites referred to or in this book. All internet addresses given in this book were correct at the time of going to press. The author and publisher regret any inconvenience caused if addresses have changed or sites have ceased to exist, but can accept no responsibility for any such changes.

A catalogue record for this book is available from the British Library.

A catalog record for this book is available from the Library of Congress.

ISBN: HB: 978-1-3505-5230-2
PB: 978-1-3505-5231-9
ePDF: 978-1-3505-5233-3
eBook: 978-1-3505-5232-6

Typeset by Integra Software Services Pvt. Ltd.

For product safety related questions contact productsafety@bloomsbury.com.

To find out more about our authors and books visit www.bloomsbury.com and sign up for our newsletters.

# CONTENTS

*Preface* vi
*Acknowledgements* ix

**1** Framing the Question 1

**2** Aesthetic Attention 23

    Aesthetic Pleasure 26
    Aesthetic Attitude/Aesthetic Attention 37
    Disinterest 43
    Disinterest and Pleasure 64

**3** Aesthetic Judgement 83

    Aesthetic Judgement 85
    Judgement and Pleasure 97
    Judgement and Disinterest 109

**4** Aesthetic Value 125

    Verdictive and Substantive Values 128
    Value Empiricism 141

**5** Aesthetic Experience 161

    Attention 162
    The Subject and Object 169
    Discordant Aesthetics 182

*Postscript* 192
*Bibliography* 195
*Index* 206

# PREFACE

One January afternoon, while strolling up rue St Denis, I was struck by a window display of washing machines for sale. The central one – a white front-loader – was poised door open, with skeins of bright-purple yarn tumbling from its interior onto the floor, right up to the window where I stood. Most, if not all, were stuck with knitting needles, at oblique angles. (The two accompanying washers were similarly poised but less memorably: I think the one on the left was exhibiting a reverse peristalsis of white plush bears.)

Having stopped – or having been stopped – by this violet overabundance, I lingered and wondered a number of things. What have yarn balls to do with laundry, exactly? One does not wash unknitted wool as a rule (and I think the needles would wreak havoc during the spin cycle). Was the display suggesting that my clothes would be returned not just to a condition of newness but even to some pristine prenatal state if I bought the washer? Or, more prosaically, that the machine came equipped with a woollens setting, as well as one for colour? (But then what of the plush bears?) I rejected these suggestions, in favour of something more radical: the skeins and the display could mean any of these things, or nothing at all.

The washers brought to mind other windows, other displays, other sights and sounds and smells that had similarly struck me in my time as a *flâneuse* of the French capitol: the *rondelles de chèvre* marching away from a window in order of ascending age, until the last was

mostly black; the chickens at the Marché aux Oiseaux, plumage coiffed, staring beady-eyed at prospective buyers; the regal woman in fur at the café, pampering the ugliest little dog imaginable; the feel of the cobblestones under my feet; the characteristic smell that can only be the French Métro. Paris, I thought, is one of the most *aesthetically* stimulating cities I have visited. And that thought led me to others: What precisely makes such sights and experiences aesthetic? Were they all beautiful? Did they all provide me with pleasure? If so, what kind? Did they all call forth a judgement or a particular reaction from me? Did they all possess some common property or value that I noticed or determined or purported them to have? At least, I thought, these things made me *look* (and listen and smell). But is that what being aesthetic amounts to?

After some years of being nurtured and then weaned by graduate professors, and even more years of teaching in the discipline, I had become comfortably fluent, I imagined, with its major figures, problems and positions. And yet at the start of every new course, invariably my students would ask me, 'what does "aesthetic" actually mean?', and the question would give me pause. With the philosophy of art, they were at ease: they had something to be getting on with – they (thought they) knew, or had an idea of, what a work of art is and could anticipate the questions a study of art would generate. But with philosophical aesthetics more broadly, they were at sea. Their question was not merely semantic, it was conceptual: just what was the study of aesthetics *about*? And I found no quick answer was satisfying, to them or to me, as an entrée into the field. To reply, 'it is the study of beauty' is inaccurate; 'it is about a certain kind of value –

aesthetic value' is both unhelpful and question-begging; 'it is about appreciation' is similarly too narrow; 'it's about a particular way of engaging with the world', while I think closer to the mark, is at once too vague and too broad as an introductory comment.

As I walked away from the washers to continue my stroll, I considered that while the term 'aesthetic' is often used with facility, underlying it is a primary confusion about – or unwillingness to investigate – its conceptual parameters. Is there something that links skeins, chickens and pampered dogs – the odd, the beautiful and the ugly – or that links my perceptions and experiences of them together such that they can all be delineated as aesthetic? And what is that something? As Mary Mothersill has noted – and Dominc McIver Lopes has echoed – 'primitive' questions are those which both generate a theory and delimit the range of answers it can provide. For Mothersill, a primitive question must be both interesting to and understood by those who are unfamiliar with any of its related theoretical responses. It is a question couched in lay terms that is intended to motivate a search for possible answers. 'What is the aesthetic?', my students taught me, is about as primitive a question for my discipline as there is. And, I reflected, thanks to their curiosity and persistence, the time had come for this *flâneuse* to quit her peripatetic musings and attempt to finally answer it. The following is an account of just that.

# ACKNOWLEDGEMENTS

I am very grateful to a handful of anonymous reviewers whose insightful comments and suggestions have strengthened the text. I can with confidence state that any remaining lacunae are mine alone. The Bloomsbury Academic group, especially Colleen and Aimee, have been enthusiastic, supportive and professional, and I would like to acknowledge and thank them for their work on the manuscript. The University of Winnipeg has aided my work by providing me with the time, through research leaves, to concentrate on writing. Finally, I would like to thank my students of aesthetics for asking the very daunting questions that inspired this book and for not taking 'I don't know' for an answer.

# 1

# Framing the Question

Years of teaching philosophical aesthetics has meant years of students asking what, exactly, does the 'aesthetic' or 'aesthetic experience' amount to, and years of my fumbling attempts to answer them. My neighbour, after asking what I did for a living, said, 'Oh, Aesthetics! The study of how things look!' Well yes, and not quite. While 'what is the aesthetic?' is the primitive question that guides this work, it is important to note that primitive questions not only motivate but also constrain the range of possible replies. As Kant reminds us, 'reason has insight only into that which she herself produces on her own plan':[1] how we articulate a question will already frame its possible returns. The question I seek to address can be formulated as 'what is aesthetic about human lived experience?' or, perhaps, 'what does aesthetic experience amount to?' and in this I have already subtly signalled certain commitments and set certain parameters to the following investigation. My goal now is to provide a conceptual

---

[1] Immanuel Kant, *Critique of Pure Reason*, trans. Norman Kemp Smith (New York, NY: St Martin's Press, 1965), Bxiii.

framing of the aesthetic question to make clear what this work will include as much as what it will leave out.

What follows is the consideration of certain conceptual dilemmas, and an attempt at their resolution. These include, why has beauty long been the main, if not sole, preoccupation of the discipline in its definition of the aesthetic? And why does pleasure – or aesthetic pleasure as a distinct kind – play such a central role in aesthetic theories? What began as a very broad inquiry quickly became distilled into a few of these particular questions and the search for a clear articulation of what aesthetic experience actually is. One way to approach the aesthetic is to consider what it is *not*, or what it omits, or what its discipline finds most troublesome. Is the ugly aesthetic? The horrific? The banal? And this is where I begin framing my investigation, with a particular problem that has popped up frequently, and seems to greatly trouble philosophers in the field.

This problem is called, broadly, the paradox of negative emotion, or the paradox of pleasure, and sometimes more specifically the paradox of tragedy, or even the paradox of horror. In general, the problem runs like this: How can we explain the enjoyment of, or pleasure found in, our experiences of artworks that elicit sadness, horror, disgust or pain? Or, to put it another way, why would we intentionally seek out, submit ourselves to and/or find aesthetic satisfaction in experiences that make us sad, frightened, horrified and so on? In this second sense, we needn't limit ourselves to artworks at all but can also include experiences of nature – such as those often found under the heading of the sublime – as well as our responses to artefacts of various kinds.

There have been any number of attempts to resolve this paradox, from Aristotle's notion of catharsis; to Hume's theory of conversion, whereby pain is converted into pleasure by means of appreciating

the virtuosity of artistic technique; to more recent theories such as Feagin's, which suggests that our immediate responses of sadness, and so on, bring with them a meta-response of pleasure in our awareness of our moral sensitivity and humanity; or Eaton's, which claims that in controlled aesthetic experiences, we are free from the normal demands of action and responsibility and can thus find pleasure in painful things from a point of remove.[2] Jerrold Levinson, in his introduction to a book of essays dedicated to the paradox, provides a partial taxonomy of approaches to its resolution that, beyond the above, include revisionary and deflationary strategies as well, which claim that so-called negative emotions are not intrinsically unpleasant or which deny that negative emotions are really aroused at all in these aesthetic experiences.[3]

What interests me about the paradox of negative emotion is not its resolution so much as its genesis. That is, what makes it a paradox, or an aesthetic problem, in the first instance? And it seems to me that the paradox is generated by a long-held belief that aesthetic experience must be – essentially *is* – pleasurable: the tragic, the horrific and the ugly cause consternation because they appear to violate this assumption. Yet, these other sorts of objects and our reactions to them cannot simply be dismissed because there are too many instances of the negative to be found in experiences and phenomena that we broadly describe as aesthetic. Thus it is thought that the paradox must instead be resolved, somehow, and almost all the proposed solutions

---

[2] See Mark Packer, 'Dissolving the Paradox of Tragedy', *Journal of Aesthetics and Art Criticism* 47, no. 3 (1989): 211–19 for a summary of these approaches.
[3] Jerrold Levinson, 'Introduction', in *Suffering Art Gladly: The Paradox of Negative Emotion in Art*, ed. Jerrold Levinson (New York, NY: Palgrave Macmillan, 2014).

labour to fit the negative to this key premise: they seek to make our responses of sadness or fear consistent with a general view of aesthetic pleasure that has almost taken the form of an axiom within the discipline.

But the paradox *is* a paradox only if this first premise holds true; and, as axiomatic, it has largely escaped scrutiny. This belief, which comprises aesthetic hedonism, Dominic McIver Lopes has called the 'party line' in philosophical aesthetics, and James Shelley has referred to it as one of the 'default settings' for aesthetic theory at large.[4] Questioning and challenging this premise is one of the goals of this work. If the link between the aesthetic and pleasure does not hold, not only is the problem of negative emotion effectively dissolved but the aesthetic can then be opened out to more directly include experiences that are difficult, unpleasant, painful or even banal – without those experiences being defective or transgressive in some way that needs further explanation. I would like to be able to claim that an experience of Picasso's *Guernica*, while eliciting horror and pity, is straightforwardly aesthetic; that viewing a warty toad and judging it to be hideous is aesthetic; that the perusal of an exhibit of insipid landscapes that leave me disappointed is nevertheless aesthetic; and that being struck by a display of caged and very confused chickens that may elicit no emotional or interpretive response whatsoever is still an aesthetic experience, and part of the aesthetic tenor of our lives. That is, what I seek to offer is a conception of aesthetic experience that does not lead to the impasse that the paradox of pleasure saw as

---

[4]Dominic McIver Lopes, *Being for Beauty* (New York, NY: Oxford University Press, 2018), 9; James Shelley, 'The Default Theory of Aesthetic Value', *British Journal of Aesthetics* 59, no. 1 (2019): 1.

inevitable. More, I want to suggest that these other-than-pleasurable experiences and judgements are not rare, problematic or otherwise poor cousins to the beautiful and the pleasing: they, quite possibly, account for the majority of the aesthetic experiences of each of us, unless we have been extremely fortunate, or unless we have stopped our eyes and ears and refused to take in the greater part of our surroundings. Indeed, aesthetic theory in recent years has seen considerable expansion into previously uncharted territory, from considerations of design, to video games, ruins and memorials, food, fashion and the Everyday. But, as with the noted attention to horror and drama, these attempts at expansion have been, if not impeded, then slowed by a certain amount of conceptual confusion as to what aesthetic experience is, at base level, and what role pleasure, or some kind of positive valuation, plays in it. So my primary question, 'what is the aesthetic?', will first be framed by an abjuration of pleasure as one of its constitutive components. Or, to put it another way, one of my guiding presuppositions will be that a theory of the aesthetic can be achieved without direct dependence upon a notion of pleasure, or of indirect reliance upon positive valuation of any kind.

Challenging the link between aesthetics and pleasure in particular is not an easy task, so entrenched is it; nor is it one that I believe can be done with finality, unless one were to take on the greater part of the discipline. This work is not a history of aesthetics, nor is it a genealogy that sets out to trace the development of, or reasons for, this relation. Indeed, to ask why aesthetics has long been tied to pleasure is itself an *extra-aesthetic* question, one more suited to a work of history, or to a philosophical anthropology, rather than to a project that

intends to remain exclusively within the bounds of aesthetic theory itself. Nevertheless, some (very) preliminary remarks will help to articulate my concerns.[5] From the early identification of beauty with truth and goodness, to Kant's conception of aesthetic judgements as providing a free and harmonious pleasure in our fit with the natural order (and the sublime as revealing our moral vocations), to Schiller's view of the aesthetic as reconciling our fragmented being, to Dewey's notion of aesthetic consummation, and to Berleant's and Saito's recent focus on overcoming or expiating what is negatively aesthetic in our lived environments, there has been a strong – if at times implicit – moral dimension at the heart of discussions of beauty and aesthetic pleasure. Beauty has been a call to order, whether metaphysical, social or political, that has the power to console, heal, reconcile and help us achieve harmony, freedom, oneness as moral goals. But this ideal of beauty, as Adorno has written, is in fact 'a spell on a spell, tainted by the legacy of that spell'[6] which is, flatly, naive to continue to endorse. Addison, for instance, introduced the notion of the free play of our mental faculties into aesthetic experience, which became a major theme in modern theories. Paul Guyer notes that this play for Addison (and others) is 'intrinsically pleasurable just because it is free and freedom itself is a source of deep satisfaction for us.'[7] But in a

---

[5] I am indebted here to discussions during the VIIth International Wassard Elea Symposium, on Aesthetic Foundations (19–22 May 2017), and especially to Rachel Silverbloom's paper 'The Critical Power of Ugliness', collected in *On the Ugly: Aesthetic Exchanges*, eds. Jane Forsey and Lars Aagaard-Mogensen (Newcastle upon Tyne: Cambridge Scholars Publishing, 2019).
[6] Theodor Adorno, *Aesthetic Theory*, trans. R. Hullot-Kentor (Minneapolis, MN: Minnesota University Press, 1997), 70.
[7] Paul Guyer, *A History of Modern* Aesthetics, *Volume I: The Eighteenth Century* (Cambridge: Cambridge University Press, 2014), 64. Guyer notes also that this play has 'further cognitive and moral benefits' and traces it as a theme throughout the history of the discipline.

post-Enlightenment, post-Romantic and post-Existentialist age, can we really still believe this myth, and are we really still under its spell? Freedom can be equally disconcerting, even terrifying, so we have learnt, and the realization of a transcendental order must surely now be seen as little more than a fantasy. The liberatory or conciliatory impetus that underlies much of the history of aesthetics brings with it a superficial reassurance, a false tranquillity and an empty hope.

As long as we have remained under this spell, ugliness and the other-than-pleasing have been considered as either non-aesthetic, because only aesthetic properties and experiences produce the pleasures of beauty, or as included in the aesthetic domain merely as its negative image: deformed, degenerate and transgressive. Rosenkranz, who wrote the first treatise on ugliness, argued that, as biology is also concerned with illness, ethics with evil, and theology with sin, so too should aesthetics consider the ugly, which is the *negation* of the beautiful.[8] But to approach the ugly, the horrific, or the monstrous as that which must be expunged is to remain in thrall to a myth of order: the condemnation of the ugly and the disagreeable as perverse still retains a progressive imperative that underlies the aesthetic, even despite Modernity's claims to its autonomy.

But Modernity's focus on the autonomy of aesthetic pleasure in fact serves to diminish and marginalize the discipline within philosophy as a whole. If aesthetic experience 'just' nets us pleasure, even if it is of a unique kind, it becomes akin to entertainment, something we can enjoy, or that provides an escape from the rigours of understanding – and controlling – the world in which we live

---

[8]Karl Rosenkranz, *Aesthetics of Ugliness: A Critical Edition*, trans. Andrei Pop and Mechtild Widrich (London: Bloomsbury Academic, 2015), 25, 33.

(the purviews of epistemology and metaphysics, long considered the core of philosophy). The idea that there is a 'hermetic realm of aesthetic experience that has no practical application or motive', in Crispin Sartwell's terms,[9] fares no better than an explicit link to the moral good: the aesthetic becomes disenfranchised, as Danto has well argued, where our experiences – especially those experiences of fine art – become what he has called 'a kind of ontological vacation place from our defining concerns as human'.[10] The continued link to pleasure in one way or another has made aesthetics vulnerable to charges of being esoteric: no other field in philosophy is so regularly asked to account for its inclusion in and contribution to the whole.

Instances of the ugly and the other-than-pleasing present a challenge, both to what I see as a certain complacency within the discipline (its 'party line') and to some of its detractors from without. These notions are antagonistic to the historically central currents in aesthetics in that they demand that we consider the world fully, with all of its blemishes and horrors, and that we make visible what we might prefer to ignore, alter or eradicate, without expiation or consolation. To give up the hope intrinsic in the myth of beauty, or the confined reassurances of aesthetic pleasure, threatens to lead us into a confrontation with disorder, violence and disunity: it denies the consolations that aesthetics has long held out to us but it simultaneously offers to expand the discipline as the study of one way – a unique but important way – of being engaged with and living

---

[9]Crispin Sartwell, 'Aesthetics of the Everyday', in *The Oxford Handbook of Aesthetics*, ed. Jerrold Levinson (New York, NY: Oxford University Press, 2003), 765.
[10]Arthur Danto, 'The Philosophical Disenfranchisement of Art', in *The Philosophical Disenfranchisement of Art* (New York, NY: Columbia University Press, 1986), 9.

in the world. If aesthetic experience begins with the perception of things in themselves, just as they appear to us – as many have argued, and as I will too – then genuineness in this experience requires an openness to all of that with which we are confronted. Adorno, again, has stated that beauty 'is only a moment in the totality of aesthetic reflection',[11] and a frank confrontation with those aspects of the world which we might prefer to ignore or deny – but which are nevertheless phenomena we can approach aesthetically – is to free the aesthetic from its residual liberatory connotations and naiveté, and to focus on how the world actually reveals itself to us, rather than how we might wish it could be.

But it is not just pleasure itself that the following theory abjures; I had mentioned also positive valuation of any kind. To broaden the compass of the aesthetic (while simultaneously trying to nail it down) is equally to question its implicit relation to the positive, where the aesthetic has long been taken to be a 'good-making' property, or value, or aspect of human life. Dominic McIver Lopes, for instance, for all that he argues against aesthetic hedonism in his work *Being for Beauty*, nevertheless formulates his primitive question of aesthetics like this: 'what is the place of aesthetic value in the good life? Or, what do aesthetic goods bring to my life to make it a life that goes well?'[12] And this formulation presupposes not just the desirability of the aesthetic but that its presence has teleological normative force for the good – a moral impetus, in fact. Similarly, Mary Mothersill's primitive motivating question is 'why do I find this work of art so

---

[11] Adorno, *Aesthetic Theory*, 75.
[12] Lopes, *Being for Beauty*, 3.

moving?'[13] which reduces the aesthetic to the act of appreciation (which Lopes has shown is too exclusive), and this, too, evokes if not pleasure directly, at least favourable recognition or esteem. And this appreciation, again, has a positive connotation. Lopes' and Mothersill's guiding questions lead to theories that differ from what I seek to present here. It is not that they are *wrong*, per se, and I do not want to suggest that the aesthetic can be pernicious (but why not?), rather that this work is an attempt to understand the aesthetic without already having decided – pre-theoretically – that it must enhance or enrich our lives. If the aesthetic is not inevitably bound to pleasure or the good, this unbinding does not pose a threat to our understanding of the aesthetic writ large. Indeed, those troubled by the paradox of negative emotion have already come half-way, in that they admit that aesthetic experience can involve elements of fear, horror and the like, but they flounder in their attempts to explain these elements in terms of a commitment to pleasure (and/or the good) that largely remains unexplained. To ask 'what is aesthetic about human lived experience?' absent these preoccupations is to present an opportunity to expand the discipline from the closed to the open-ended – from the reductive to the multi-faceted, where the ugly, the disagreeable, the monstrous or the disgusting can equally play a part in our aesthetic engagement with the world.

This first framing of the question leads directly to the second: I seek to represent the aesthetic as in some sense unique, distinct from other kinds of experiences like the purely sensual or the cognitive, and other kinds of values such as the moral, the practical or the

---

[13]Mary Mothersill, *Beauty Restored* (New York, NY: Adams, Bannister, Cox, 1991), 72.

political. The aesthetic, I will claim, is not *reducible to* any of these but is of its own kind. It is somehow singular in the way that it engages us, and in this it has theoretical interest. This, to me, is the point of embarking on the path of aesthetic theory: to ask what distinguishes the aesthetic in a way that acknowledges its compelling interest. This second framing does not single out my approach – just about every aesthetic theory in some way lauds it as special, and for good reason: if the aesthetic were not a specific phenomenon, there would be no need for a discipline dedicated to it. But my framing of the question in this way speaks also to the limitations of what I will offer. I am interested in the demarcation of the aesthetic as a particular kind, in what the aesthetic *is*, outside of, or prior to, any role it may play in our understanding of the world or in the enrichment of our lives.

Not all theorists would agree that this work needs to be undertaken. While the 'party line' often unreflectively equates the aesthetic with (or reduces it to) pleasure, many theories also assume that we know what the aesthetic means, or what aesthetic value amounts to, and that we can proceed from this basic understanding. Lopes again – and I single him out simply because his work is one of the most comprehensive recent aesthetic theories we have – states that his work will 'punt' on the aesthetic question in favour of the normative question of why the aesthetic should 'make any difference to the plans, priorities, and commitments by means of which we structure our lives'.[14] It is sufficient to adopt a 'working conception'[15] of the aesthetic – or of aesthetic value in particular – in order to get on with his major concerns: 'the normative question is mandatory while the aesthetic

---

[14]Lopes, *Being for Beauty*, 47.
[15]Ibid., 46.

question is optional, maybe a distraction'.[16] Lopes is sensitive that his approach only provides a 'stopgap' to the aesthetic question and suggests that an answer to the normative question might eventually yield insight into the aesthetic. That is, he approaches the aesthetic question sideways, as it were, while I intend to meet it head on. When Lopes goes on to suggest his normative account of reasons and motivations is 'plain vanilla' – equally found outside of the aesthetic domain, and not distinctively aesthetic at all,[17] I begin to question how this provides any kind of *aesthetic* theory itself, beyond an application of the (presumed) aesthetic to ethics or to a theory of the good life, whereas what makes the aesthetic unique is my guiding concern.

James Shelley has (gently) taken Lopes to task about his 'working conception' of the aesthetic, based upon Frank Sibley's list of aesthetic terms as being paradigmatic aesthetic values. Lopes' working conception claims that 'a value is aesthetic when it is a paradigm aesthetic value' – for example, one on Sibley's list, or one 'that nobody would object to including on their lists'.[18] But as Shelley points out, there are no *values* on Sibley's list: unified, balanced, severe, sombre, dynamic and the like are aesthetic *terms*, or *adjectives*, or *uses* or *employments* of these words: any one of them can have aesthetic uses as easily as non-aesthetic applications. 'It follows that you can't tell whether a mental representation is an aesthetic evaluation – whether, that is, a property you represent an item as having is an aesthetic value – simply by consulting a list.'[19] The aesthetic question seems to precede

---

[16] Ibid., 48.
[17] Ibid.
[18] Ibid., 46.
[19] James Shelley, 'Punting on the Aesthetic Question', *Philosophy and Phenomenological Research* 102, no. 1 (2021): 215.

the normative one – and to underwrite it – in a way that gives impetus to my project. That is, my second framing of the project opts to 'punt' on the normative question in favour of the aesthetic one, in the view that the aesthetic question takes precedence for a truly *aesthetic* theory. This is not to oppose the aesthetic to the practical – which, for Lopes, makes appreciation the only possible aesthetic act.[20] Shelley believes that the two questions – normative and aesthetic – are in fact intertwined, and to 'punt on one is to risk punting on the other': to ask what reason we have to act aesthetically is to ask what aesthetic reason we have to act 'over and above whatever general reasons we have' (over and above plain vanilla normativity). It is to provide an account 'of how aesthetic reasons give us reasons to act that are neither generally practical, nor hedonic, nor moral, nor anything else but aesthetic'.[21] Shelley's suggested project is more ambitious than mine (and Lopes') in that it has this dual focus. Nevertheless, I maintain that to answer the question of our *aesthetic* reasons for action requires that we first understand what the aesthetic *is* such that it can be singled out as a reason of its own. For Lopes, an aesthetic act depends upon a prior evaluation that something has an aesthetic value; the value motivates and determines the act. But if the aesthetic value is merely what is 'paradigm' or what no one would object to (or what an expert insists upon), and the reasons for acting are 'plain vanilla', then we are in the end begging both the normative and aesthetic questions at once. In attempting to demarcate the aesthetic in its first instance, I may be able to provide tools to aid in responding to these further questions of reasons and motivations, but I maintain that we cannot do so until

---

[20]Lopes, *Being for Beauty*, 33–6.
[21]Shelley, 'Punting', 216–17.

and unless we have first understood what makes the aesthetic its own unique kind.

If we consider Lopes' many examples of the diversity of aesthetic acts – gardening, restoring, collecting, coding, working and so on,[22] they suggest both a certain level of competence or expertise and an insistence on specialization in various particular domains, both of which conditions Samantha Matherne has criticized because they exclude actions engaged in prior to specialization or the development of competence, such as when we 'perceptually, cognitively, affectively, interactively, and communally engage with items of aesthetic value'. For Matherne, we need a more inclusive theory than Lopes provides, one that 'accommodates evaluative and pre-evaluative acts alike'.[23] What are missing from his variety of examples are the simple acts of looking (hearing, touching, smelling, etc.), the more complex acts of evaluating or judging or assessing and the many non-specialized actions that comprise much of our everyday lives, such as cleaning, arranging, dressing, chopping and so on. Matherne's suggestion is that we first consider how the aesthetic applies to these before we move on to notions of competence, expertise and specialization. This leads to the third framing of my original question and speaks to the target of this work in more precise terms.

To get at the aesthetic, one could analyse a range of objects that seem to fit its domain, or the sorts of properties, like beauty, that these objects possess. Here one presupposes the world to have (at least) some

---

[22]Lopes, *Being for Beauty*, 16–24, 32–6, and *passim*.
[23]Samantha Matherne, 'Aesthetic Learners and Underachievers: Symposium on Dom Lopes' *Being for Beauty*', *Philosophy and Phenomenological Research* 102, no. 1 (2021): 230.

independent aesthetic character, and this directs one's theoretical approach. One could equally investigate the nature of the emotive responses we have to the world, as comprising the aesthetic aspect of our lives; here instead the presupposition is that the aesthetic can be found in some inner state of the individual and the approach from the outset is more psychological. Both sorts of projects have generated numerous aesthetic theories but I find both too limiting. Put bluntly and quite roughly, the former is too object-directed and often excludes the living subject from its purview, while the latter too often excludes the world itself. Both approaches also presume, broadly, a representational model of consciousness that passively receives sense data from an independent external world (and then does or does not affectively respond to it). In each case, there is a sharp distinction between subject and object, and the aesthetic is ascribed to one or other of the relata. In asking what is the aesthetic, I, like Lopes, will instead focus on actions, but with the kind of breadth Matherne requires. To capture both breadth and activity, I will use the portmanteau 'experience' to anticipate that the aesthetic arises in and through our interactions with the world, that it is somehow emergent from this relation itself. The presupposition here is that experience underwrites and is necessary for the generation of either an objective or subjective theory (one has to have experienced the world to discover the beauty inherent in it; one has to have an experience of the world in order to feel pleasure in its appreciation) and thus experience, as more fundamental, is also a more suitable locus for an investigation into the primitive question. But the notion of experience on its own is quite vague and needs to be sharpened for use.

We can be said to 'have' experiences, or to 'undergo' them, but in this sense the subject remains passive, the one to whom things happen. Borrowing loosely from the phenomenological tradition, I understand 'experience' in the active voice instead, as an interaction with, and an engagement in, the world in a way that suggests we are affected by, but also affect, our environments: we *live* our experiences rather than merely having them. Experience is intentional in the phenomenological sense of being object-directed, or about the world. It can also be intentional in the common sense of purposive, but it need not be: being surprised by a sudden rain shower is intentional if one's awareness takes that shower as its object. Lopes' examples of aesthetic acts are all intentional in the standard sense – hence his concern with reasons and motivation – while Matherne's expanded list also includes those that may not have been willed or planned, and the notion of experience as I use it is meant to allow for the aesthetic to encompass this greater scope.

The primary question can thus be sharpened to ask what makes some experiences particularly aesthetic, or what singles them out in this specific regard. Dewey, of course, had one answer, couched in terms of the felt character that some experiences have. I will propose another. His work is instructive in that he championed the idea that anything at all can be aesthetic, whether pleasurable or not, beautiful or not, uplifting or otherwise.[24] But the aesthetic, as I will describe it, emerges from the relation itself that is the activity of experiencing, rather than the effects of an experience undergone by the subject, often after the fact. The phenomenological tradition is interested not

---

[24]John Dewey, *Art as Experience* (New York, NY: Capricorn Books, 1958). He refers, for instance, to '*that* meal, *that* storm, *that* rupture of friendship', 37.

only in the felt character of intentional experience but further in the conditions that make that intentionality possible, including language, tradition and social and cultural practices. The subject, experiencing something, even if alone, is not isolated, 'pure' or to be abstracted fully from the context in which experiencing occurs. I have gone on record in the past as being critical of so-called 'spectator aesthetics' which begins with a disengaged, uninvolved perceiver of, for example, beautiful objects as *other*, remote and unrelated to her; the critic is a paradigm example and appreciation is the common focus.[25] This stance presupposes the representational model of consciousness that a more nuanced conception of experience seeks to move beyond.

Some aesthetic experiences will only be had in the doing and the involvement that is part of our everyday lives, including our entanglement in tradition and social communities (think of the culturally specific ways of preparing coffee, for instance). Even if we experience a sunset alone, and judge it to ourselves to be beautiful, this aloneness should not be understood without the background of a supporting structure that makes intentionality, and, through it, experience, possible from the start. This will become important when I write of disinterest, for it will be in contradistinction to a common understanding of the notion as requiring some kind of remote, aloof, disengagement on the part of the subject from her surroundings. Seeking the aesthetic in experience itself is in part seeking to understand what structures or conditions one experience will have that characterizes that relational act and distinguishes it from others

---

[25]See, for example, Jane Forsey, 'The Disenfranchisement of Philosophical Aesthetics', *The Journal of the History of Ideas* 4, no. 64 (2003): 581–97 and *The Aesthetics of Design* (New York, NY: Oxford University Press, 2013), Chapter IV.

such that it can be described as uniquely aesthetic. When do cleaning, strolling, chopping, looking and so on become aesthetic? What, if not pleasure or a striving for the good, sets an action apart and makes it this unique kind? These are, more precisely, the parameters of the aesthetic question; the answer will focus on the manner, or the way that the relational act is undertaken, rather than upon the properties of the object on the one hand or the feelings of the subject on the other.

If the subject is not 'pure' or abstract, neither can the object be so easily isolated. Phenomenology, as the study of 'phenomena', tends to use this term to highlight the primacy of 'appearances' or 'things as they appear to us' to contrast them with an ontology of how things really are. I am sceptical, for instance, of the idea that beauty is a property that objects independently possess, whether primary, secondary or supervenient. Even if metaphysicians were able to construct a reliable ontology of aesthetic objects or aesthetic properties, they would still need a theory of perception or experience to explain how we can (and can fail to) pick them out. And so, again, it is this latter theory that I will offer here; relying on the idea of phenomena as appearances allows me to evade certain problems of aesthetic realism, although I do not think my claims would be incompatible with realism of some kind. 'Object' also tends to imply a discrete, bounded *thing* that is other than, and independent of, the subject – a substance with some ontological status in the world. When I refer to objects (as appearances), I will use the term more loosely, to suggest whatever is the object of our attention – the intentional object – and this can include motion, sound, a touch or a visual array, for instance. Perhaps 'instance' or 'occasion' would be more accurate, whether it is of a

bounded, complete and stable thing, or instead a momentary locus of our perceptual attention.

Matherne refers to both evaluative and pre-evaluative acts in her call for breadth, and herein lies the fourth and final enframing of the aesthetic question. A conceptual distinction can be made between these two actions and this will lead me to in fact offer a double theory of aesthetic experience: a 'minimalist' one, to use Levinson's phrase (but not his formulation),[26] and a more robust account that begins with and depends upon the former but that extends beyond it as it engages more of our faculties or engages them in more complex ways. At minimum, I will suggest, the aesthetic can be located in the manner of our experiencing when we are 'merely' looking (seeing, hearing, etc.): when we engage in a perceptual activity that is pre-evaluative (or non-evaluative in that it might never lead to evaluation), and that is, moreover, pre- (or non-) cognitive and perhaps also pre- (or non-) reflective, in that it might not lead to or contribute to knowledge or be accompanied by a self-consciousness of acting at the time. These 'thin' or 'bare' perceptual activities can, in certain conditions, have an aesthetic character, and indeed I will argue that the whole complex of our aesthetic engagement begins here and is carried forward intact in the manner of our more complicated entanglements in the world. We can and do perceive aesthetically, when our attention has a certain form and structure. We sometimes do no more than this. But we often engage in greater depth, as when we evaluate what we perceive, judge it to be beautiful or ugly, and ascribe to the object an aesthetic

---

[26] Jerrold Levinson, 'Towards an Adequate Conception of Aesthetic Experience', in *Philosophical Pursuits: Essays in Philosophy of Art* (New York, NY: Oxford University Press, 2017), 31.

value. More complex still are the kinds of actions that interest Lopes, actions that are purposively aesthetic, which have normative reasons motivating us towards, for instance, the creation of art or beauty (or to the fulfilment of a good life). A conceptual hierarchy among these different acts is a chimera of Empiricism but that they have conceptual peculiarities is unarguable, and I will keep them distinct for heuristic and analytic purposes.[27] To build up a robust picture of the aesthetic, I will begin by locating it in the heart of our attentive actions, in its first instance, in a 'thin' perceptual act. This is the work of Chapter 2. I will then expand upon the minimalist account by considering both aesthetic judgement and aesthetic value as added layers of complexity that clothe the 'thin' experience more robustly (Chapters 3 and 4). I will in the end draw together these elements as I consider the promise and breadth that my account of the aesthetic can offer (Chapter 5). I will leave theorists such as Lopes to ably take us further into purposive actions, and to consider the normative question. My hope is to provide the aesthetic foundation for these later perorations.

This enframing of the primitive question provides the desiderata for an aesthetic theory: that the aesthetic will be couched in terms of experience, and be emergent from it; that the aesthetic can be understood absent the notions of pleasure or the moral good; that the aesthetic is a unique kind of engagement with the world that differs from others but that nevertheless has philosophical import; and that an aesthetic theory – minimal or more robust – can be formulated,

---

[27]Glenn Parsons and Allen Carlson, for instance, note that for eighteenth-century Empiricist thinkers, 'reason and perception were fundamentally different mental processes', where perception was seen to operate independently of thought, a view that today 'seems, at best an over-simplification and at worst a distortion'. *Functional Beauty* (New York, NY: Oxford University Press, 2008), 18–20.

indeed must be formulated, prior to a consideration of normative questions of reasons and motivations.

Before beginning, two further methodological points are in order. First, while a great deal of aesthetic theory has long concerned itself with fine art, it may seem odd that this book for the most part does not. My interest is in aesthetic experience wherever and however it occurs, and the fundamental constituents that make up this experience. A focus on art adds layers of assumptions to those that I already seek to challenge and obscures some of the more basic questions that I seek to ask. The aesthetic is already presupposed in most discussions of art and plays out in ways that are often over-complicated by ontological commitments about how the fine arts are defined, and epistemological commitments as to what an aesthetic experience of fine art uniquely involves (such as interpretation, understanding, the search for meaning and so on). What I am after is an analysis of the components of aesthetic experience itself, prior to, and outside of, its particular applications. Second, a word needs to be said about Kant, whose work has in many regards defined and directed the course of modern aesthetic theory, my own no less than others', and who is perhaps most responsible for the spectator approach to aesthetics. For Kant, of course, there is a necessary connection between the aesthetic and pleasure that drives his account and that has confounded scholars who have sought to find a place for ugliness, in particular, within his theory. I will not place the source of the connection between the aesthetic and pleasure with Kant, only note that it is most strongly exhibited here, for better or worse, in the context of his system as a whole. Kant's conception of aesthetic experience is notoriously

difficult and complex, and springs from his prior epistemological and moral commitments. One cannot with any ease adopt one part of his theory and leave the rest behind – or discard what one does not like and hope to shore up the rest. It is too tightly woven for such an approach to work. It is thus difficult to be inspired by, or indebted to, Kant's work in any straightforward way, without becoming entangled in problems of transcendental philosophy as a whole. This is a cautionary note for myself as much as for others. The following, then, is by no means a work of Kantian scholarship – or a rehearsal or revision of his system; yet still it does remain influenced by his thought in a number of ways, in particular by his categorization of aesthetic responses as different but related kinds: the beautiful (pure and dependent), the agreeable, the good and the sublime; as well as by his passing comments on the monstrous and the disgusting. What many Kant scholars often neglect, in their detailed analyses, critiques and reconstructions of his theory, is that he allowed for a great *variety* of aesthetic responses to, and judgements of, the world: his theory was not as singular nor as monolithic as has been often supposed. It is this polysemic but often neglected approach to the aesthetic that intrigues me about his work, and to which I remain inspired, even if I do not dwell here on the actual details of his system.

## 2

# Aesthetic Attention

'Aesthetic This and Aesthetic That' is the title of a provocative but little-read appendix to Canadian philosopher Francis Sparshott's comprehensive work *The Theory of the Arts*. There, Sparshott tracked what he called 'the most notorious uses'[1] of the term 'aesthetic' when it occurs in set phrases like '*aesthetic x*': 'aesthetic judgement', 'aesthetic pleasure', 'aesthetic attitude' and so on. He found phrases of the form '*aesthetic x*' to be vague and ambiguous, and his perspicacious yet brief analysis of them provides a fitting guide to the inquiry I will pursue here. Sparshott, in this appendix, showed his concern with the aesthetic question as well; he found the employment of these terms to belie conceptual problems that require clarification and resolution before they can become part of a theory of the aesthetic.

As Sparshott parsed the phrase '*aesthetic x*', it could mean merely *x* as found in the domain of aesthetics (generally understood), implying only that there is, or might be, some pleasure, judgement and so on that has something to do with, or that occurs in, aesthetics.

---

[1] Francis Sparshott, *The Theory of the Arts* (Princeton, NJ: Princeton University Press, 1982), 468.

And this meaning is quite neutral: 'aesthetic judgement', for instance, could mean unrestrictively judgements found within, or in relation to, aesthetics, such as judgements made when viewing works of art, or natural phenomena, that have no different logical structure or phenomenology from other kinds of judgements we make.[2]

There is a second sense, however, when '*aesthetic x*' is taken to mean '*x as characteristic of* the aesthetic. This sense implies that there is some distinctive kind of *x* that has to do with aesthetics. Here, 'aesthetic judgement', for example, would mean restrictively that there is a type of judgement specific to aesthetics, or that occurs only in aesthetics, that differs from other kinds of judgements found in other domains, that is special or that has a unique character of its own. Kant's account of aesthetic judgement (as a 'judgement of taste') is a paradigmatic case of this second sense. Sparshott noted that use of the term '*aesthetic x*' 'virtually testifies to the conviction' that the *x* is distinctive – that in the discipline it is the second sense that is generally implied or assumed.[3]

And it is with this second sense that problems arise because now, of course, the onus is on the theory to explain the restrictive use of *x*, how it differs from other *x*'s, or kinds of *x*'s, and how it is characteristically aesthetic – or, how the aesthetic can be understood in terms of, if not as reduced to, that *x*, be it judgement, pleasure, value or a combination of them. Sparshott left us with a number of questions that can be asked of the *x* of our choice, noting that these questions become objections only when they have not been forestalled (and he thought that they

---

[2]Ibid., 467.
[3]Ibid.

almost never have).[4] For instance, we can ask if the $x$ (aesthetic pleasure, for instance) is recognizable as a single phenomenon – can we point it out, identify it, differentiate it from other kinds of pleasures? Is it the same in all aesthetic instances? We can ask, further, if it is invariably connected to the aesthetic (e.g. occurring in all cases, or only sometimes) and if it is, whether that connection is necessary or contingent. And finally, does the notion at hand make the phenomena aesthetic, or do the phenomena make the $x$ aesthetically distinct? Taken together, I will call these questions the Sparshott Test. A theory can fail it in a number of ways: by simply not making the connection between the terms sound; by failing to accurately describe what is aesthetic about that $x$; by being circular, in trying to explain one $x$ in terms of another or a number of others, layering concepts upon concepts that both complicates the issue and obfuscates the theory's lack of explanatory power; and, of course, a theory can merely presume to understand that '$x$' and proceed from that presumption without attempting to answer the aesthetic question, thus leaving the theory hollow at its heart. To pass the Sparshott Test is to provide a theory that is non-circular, non-question-begging and sound – or to provide a theory that has the usual virtues, as relevant to aesthetics as to any other philosophical pursuit.

In the spirit of Sparshott's concerns, I will analyse a select number of the set phrases that are found in some common accounts of aesthetic experience and demonstrate how these notions can be clarified (and some problems mitigated) if they are to pass the Sparshott Test and provide an aesthetic theory. Those upon which I will concentrate

---

[4]Ibid., 471, *fn* 7.

will form the components of both a minimalist and a more robust answer to the aesthetic question. Of course, 'aesthetic experience' is a set phrase of its own, with similar ambiguities, as Sparshott has noted. My overall goal will be to disambiguate the phrase and shore it up against the kinds of objections Sparshott identified. This chapter – and the next two – will thus do two things at once: argue that pleasure (and other positive connotations) is not necessary to an understanding of aesthetic experience but rather that the link to pleasure is contingent; and offer a theory of aesthetic experience without relying on, or presuming, a reference to pleasure – or pain – of any kind. If, at heart, we begin with an idea of 'experience' as an encounter between a subject and object that forms a relation between the two, however momentary or fleeting, I will begin this chapter with the subject, and show that disinterested attention on our part forms the core of a minimalist account of aesthetic experience.

## Aesthetic Pleasure

A theory that directly claims the aesthetic is determined by, or defined in terms of, a specific kind of pleasure fails the Sparshott Test almost immediately: such theories are unable to identify this pleasure as differing in kind from, say, the erotic, the intellectual or the merely sensory when we experience it. To claim that a certain kind of pleasure just *is* aesthetic requires a psychology or a philosophy of mind that can effectively differentiate our private, subjective sensations and feelings. As Sparshott notes, 'to elaborate such an account would be to write a general treatise on the concept of pleasure and kindred concepts'

that would 'remain purely external' to the articulation of aesthetic experience or phenomena, and that could in the end only be used as an 'extraphilosophical justification' to link the terms of the set phrase 'aesthetic pleasure' together.[5] For no purely philosophical account can make the link hold. A few brief examples will make this failure clear.

First, we can look to early work in the Everyday Aesthetics movement, which has sought to broaden the scope of aesthetics to include more quotidian activities and experiences (a general goal that my work also shares). But I have been critical of attempts by the movement's theorists, such as Yuriko Saito and Sherri Irvin, to do just this: in asserting that scratching an itch, going to a ballgame, eating an apple and patting the cat are all aesthetic, they refer to the pleasures these activities bring without an analysis of how they differ from those times when they are not aesthetic but merely, perhaps, sensory, and the activities simply mundane.[6] These efforts threaten to trivialize the notion of aesthetic experience precisely because they fail to provide a phenomenology of what makes the pleasure in question a distinct kind such that it would invariably fall under their purview, or an account of *when* the pleasure becomes – or what makes it – aesthetic enough to merit their attention in one instance but not in others. One critic, Christopher Dowling, has charged the movement in this regard with 'equivocating between "aesthetic value" and

---

[5]Ibid., 472.
[6]See Forsey, *The Aesthetics of Design*, 200–22 for this discussion. Of course, Everyday Aesthetics is not a homogeneous movement; I refer here particularly to both Yuriko Saito and Sherri Irvin – the examples are theirs. See Yuriko Saito, *Everyday Aesthetics* (New York, NY: Oxford University Press, 2007), and Sherri Irvin, 'The Pervasiveness of the Aesthetic in Ordinary Experience', *British Journal of Aesthetics* 48, no. 1 (2008): 29–44.

"pleasure",[7] while Glenn Parsons and Allen Carlson have suggested that these accounts offer no more than a *reductio ad absurdum* of the notion of aesthetic experience since it would now have to include 'exercising, taking a bath, drinking lemonade, or engaging in sexual activity', none of which have been considered aesthetic pleasures – or aesthetic experiences – historically understood.[8]

While Parsons and Carlson are right that if *all* pleasures are aesthetic then none are, and the set phrase becomes meaningless, they point to what they call a 'long-standing conceptual distinction between aesthetic and bodily pleasure' (favouring the distal over the proximal senses) that has been 'part of our common linguistic practice since ancient times'[9] as speaking in favour of a continued recognition of it in philosophical practice. But a distinction without explanation, however entrenched, does not itself provide the theory needed to justify an account of which pleasure is particularly aesthetic, and why – or of when it becomes so. Even if the pleasures of the proximal senses are 'typically felt as bodily sensations' and 'felt directly in more or less localized regions of the body', this does nothing to explain why they should be therefore discounted as aesthetic, nor does it give reason to label the pleasures of the distal senses as being particularly aesthetic ones: Parsons and Carlson claim there is a 'phenomenological difference'[10] at play here, but do not then provide the necessary phenomenology: Are aesthetic pleasures intellectual because not physical? Not precisely intellectual but also

---

[7]Christopher Dowling, 'The Aesthetics of Daily Life', *British Journal of Aesthetics* 50, no. 3 (2010): 226.
[8]Parsons and Carlson, *Functional Beauty*, 178–80.
[9]Ibid., 185.
[10]Ibid., 177–8.

not bodily? Does it feel different to have them because they are not localized but diffuse? Is there a different way that it *feels like* to have an aesthetic pleasure? That is what is needed to make their account sound. Pointing to a linguistic tradition is no more conceptually illuminating than the Everyday movement's call for breaking that tradition, in pinning down what aesthetic pleasure amounts to.[11]

As Noël Carroll has suggested, what he calls 'affect-oriented approaches' like these take aesthetic experience 'to be marked by a certain experiential quale, or pulsation, or peculiar feeling tone'[12] – usually comprised of pleasure – that is often considered sufficient for an experience to count as aesthetic. But, he cautions, the notion of aesthetic pleasure 'does not locate a specific feeling, categorically distinct from other feelings of pleasure, and, therefore, capable of hiving off aesthetic experience, parsed as a phenomenologically discriminable affect, from other sorts of pleasures and their corresponding experiences (e.g. gustatory or sexual experiences)'.[13] Quite apart from overly internalizing aesthetic experience – how do I know when I am having it? Does it feel aesthetic now? – these approaches give no reason why pleasure of a particular kind is either necessary *or* sufficient for an experience to count as aesthetic. He concludes, 'the experiential qualia of aesthetic experiences

---

[11]One of the merits of the Everyday movement, and of Saito's work in particular, has been to show how the proximal senses do indeed play an important role in our aesthetic experiences of, particularly, quotidian objects. See her example of a knife, where 'its feeling in my hand, determined by its surface texture, weight and balance ... [and] how effortlessly I can cut an object' all contribute to an aesthetic experience of it (in Saito, *Everyday Aesthetics*, 27).
[12]Noël Carroll, 'Aesthetic Experience: A Question of Content', in *Contemporary Debates in Aesthetics and the Philosophy of Art*, ed. Matthew Kieran (Malden, MA: Wiley-Blackwell, 2006), 71.
[13]Ibid., 73.

are ... too diverse in fact to be assimilated to a single formulaic, phenomenological characterization, such as pleasure', in part because aesthetic experiences may engender diverse reactions, including displeasure, or 'no accompanying affect, feeling tone, or quality' at all.[14]

Everyday Aesthetics also suggests, in response to Sparshott's last question, that it is not a particular set of objects and activities that gives us aesthetic pleasure but that certain responsive pleasures instead *aestheticize* our actions and the objects with which we engage. Their reliance on pleasure is not only necessary but is at the forefront of their notion of aesthetic experience. But they do not provide support for these claims: the Everyday movement would need to first explain how to recognize the particular pleasure they have in mind as a distinct kind, and make a case for its invariability across certain experiences and/or actions, before they can assert that this feeling does in fact (and necessarily) make some actions and surroundings aesthetic ones, and its absence leaves others merely mundane. For these reasons, a theory that tries to explain the aesthetic in terms of a certain phenomenologically distinct feeling of pleasure will fail. Yet there are many other theories that make pleasure a necessary ingredient in aesthetic experience which side-step the phenomenology in different, but no less problematic ways. I will canvas a few.

Clive Bell's formalist theory is (in)famously circular. Bell's response to Sparshott's last question is seemingly the converse of the Everyday movement: a phenomenon which he calls 'significant form' is what makes our experience (of, in this case, fine art) an aesthetic one, as

---

[14]Ibid., 93.

it produces a pleasurable 'aesthetic emotion' in the viewer that he likened to 'ecstasy'.[15] Unlike the Everyday movement's focus on the quotidian, for Bell, to appreciate art 'we need bring with us nothing from life ... no familiarity with its emotions'. Instead, art 'transports us from the world of man's activity to a world of aesthetic exaltation' – taking us from the immanent to the transcendent.[16] The problem is that Bell described one notion by means of the other: significant form produces aesthetic exaltation, which is felt only in the presence of, and which identifies, significant form – both of which terms were coined by Bell himself, and neither of which he could clearly define. Thus 'we have no other means of recognizing a work of art than our feeling for it' – and no other means of recognizing this emotion than by experiencing significant form: the 'one quality common to all works of art'.[17] Bell's formulation offers little more than a tautology, and while he shares with the Everyday movement an inability to provide an independent explanation of why this particular emotion – or pleasure – is aesthetic, his theory also rests on the assumption that aesthetic experience (of fine art) just *is* pleasurable, and pleasure is what picks it out.

Much more recently, Rafael de Clerq has attempted to explain aesthetic pleasure as 'the kind of pleasure that seemingly *always* or *necessarily*' accompanies an aesthetic experience,[18] but his account is equally tautological. He uses the term 'beauty' but in a wide sense in

---

[15]Clive Bell, *Art* (New York, NY: Capricorn Books, 1958), 17, 34.
[16]Ibid., 77.
[17]Ibid., 17–18.
[18]Rafael de Clerq, 'Aesthetic Pleasure Explained', *Journal of Aesthetics and Art Criticism* 77, no. 2 (2019): 122.

which it is 'equivalent to aesthetic value'[19] and argues for an 'identity thesis' where 'the same event occurs when (1) a subject experiences aesthetic pleasure and (2) it appears to her that there is something beautiful'. Thus, '[a] subject $s$'s experiencing aesthetic pleasure = it appearing to $s$ that there is something beautiful'.[20] Substitute the terms 'aesthetic emotion' and 'significant form' into this equation and we are no further ahead: de Clerq has provided a necessary link between pleasure and aesthetic experience, but has defined neither the pleasure nor the experience. He cites Malcolm Budd here (but not Bell), who states that 'for pleasurable admiration of something's value to constitute *aesthetic* pleasure, the value must be aesthetic value'.[21] Examples of this kind can be multiplied with varying degrees of complexity.

Monroe Beardsley put it this way: 'a person is having an aesthetic experience during a particular stretch of time if the greater part of his mental faculties during that time is united *and made pleasurable* by being tied to the form and qualities of a sensuously presented or imaginatively intended object on which his primary attention is concentrated'.[22] For Beardsley, aesthetic experience is one of perception and concentration on an object's formal qualities, that brings pleasure in that attention: 'it seems to me plain that aesthetic experience is pleasurable, and indeed essentially so'.[23]

---

[19]Ibid.
[20]Ibid., 124.
[21]Malcolm Budd, 'Aesthetic Essence', in *Aesthetic Essays* (New York, NY: Oxford University Press, 2008), quoted in de Clerq, 'Aesthetic Pleasure', 125.
[22]Monroe Beardsley, 'Aesthetic Experience Regained', in *The Aesthetic Point of View*, eds. Michael J. Wreen and Donald M. Callen (Ithaca, NY: Cornell University Press, 1982), 81, my emphasis.
[23]Ibid., 88.

Antonia Peacocke and others have commented that Beardsley's is the first articulation of aesthetic hedonism, which is a form of value empiricism in aesthetics. Value empiricism generally claims that the aesthetic value of an object is grounded in, or determined by, the value of some experience of it (the converse of Budd's claim above). Hedonism suggests that the aesthetic value of the object is determined by an experience that provides pleasure. In Beardsley's terms, '[t]he amount of aesthetic value possessed by an object is a function of the degree of aesthetic gratification it is capable of providing in a particular experience of it.'[24] Whether value empiricism is viable for an aesthetic theory, I will address in Chapter 4. For the moment I note that for the hedonist, an object's beauty, for instance, would be determined by pleasure, and that pleasure would usually, again, be of a certain kind.[25] One of the most obvious errors that the hedonist makes is to confuse the pleasures of the aesthetic – the pleasures we may take in aesthetic objects and experiences – with aesthetic pleasure itself, and then fail to define the latter. Even barring this error, while I agree that most of us find pleasure in a great many aesthetic experiences, no theorist has convinced me yet that this pleasure is *necessary* or that it determines an object's aesthetic value.

Jerrold Levinson, for instance, claims that 'pleasure in an object is aesthetic when it derives from apprehension of and reflection on

---

[24] Monroe Beardsley, 'The Aesthetic Point of View', in *The Aesthetic Point of View*, eds. Michael J. Wreen and Donald M. Callen (Ithaca, NY: Cornell University Press, 1982), 23.
[25] See Antonia Peacocke, 'Let's Be Liberal: An Alternative to Aesthetic Hedonism', *The British Journal of Aesthetics* 61, no. 2 (2021): 163–83; Servas Van der Berg, 'Aesthetic Hedonism and Its Critics', *Philosophy Compass* 15, no. 1 (2020): 1–15; and James Shelley, 'Beyond Hedonism about Aesthetic Value', in *Disinterested Pleasure and Beauty: Perspectives from Kantian and Contemporary Aesthetics*, ed. Larissa Berger (Berlin: De Gruyter, 2023), 257–73.

the object's individual character and content, both for itself and in relation to the structural base on which it rests'.[26] That is, one must attend to an object's 'forms, qualities and meanings for their own sakes' and also to the way they emerge from the 'low-level perceptual features that define the object', upon which they supervene.[27] New '*aesthetic x*'s' have crept into the picture here: aesthetic value, aesthetic properties, aesthetic attitude (as attention for its own sake) but in the end, these other theories remain as circular as Bell's. In every case pleasure is a necessary constituent of aesthetic experience but it is defined in terms of a new and different '*aesthetic x*', or series of them, which need explanation themselves.

Perhaps these theorists could claim that they have resolved certain problems that concerned Sparshott: rather than a need for a general treatise on pleasure, or a detailed psychology or philosophy of mind, the definition of aesthetic pleasure just *is* pleasure had from the perception/appearance/comprehension of: aesthetic properties or aesthetic values. That is just what makes the pleasure aesthetic, as opposed to any other kind. They are not describing the pleasure itself, but the unique circumstances of its occurrence. However, when a theory makes an analytic equivalence between the explanans and the explanandum, however complex, no new information comes of it: What is aesthetic value, and the experience of it? What are aesthetic qualities or properties, whether supervenient or not? What is aesthetic attention or contemplation? That is, what is aesthetic about *them*? Merely stating that the attention is pleasurable, or the

---

[26]Jerrold Levinson, 'What Is Aesthetic Pleasure?' in *The Pleasures of Aesthetics: Philosophical Essays* (Ithaca, NY: Cornell University Press, 1996), 6.
[27]Ibid.

value is pleasing, provides nothing in the way of understanding how they differ from other forms of perceiving, other kinds of value, or other sorts of properties. Even if these theorists can provide a non-question-begging account of aesthetic value, or aesthetic attention and the like, the aestheticization of these explananda will still need to make a synthetic link to the explanans: they will have to demonstrate how that value, or experience, always and necessarily is pleasurable, or must cause pleasure, whether that pleasure is then called aesthetic or not.

None of these accounts have made a sound link between pleasure and aesthetic experience in the second sense that Sparshott had noted, which somehow makes pleasure characteristic of that experience, or its own '*aesthetic x*'. But nor have they substantiated the claim that pleasure, however described, must be the determining factor or necessary constituent of aesthetic experience, in whatever sense they are using the term. To do so, an independent account of their other, favoured *x* is needed, which will situate the aesthetic *there*, before its tie to pleasure can be made. That is, if the aesthetic is not defined by pleasure, it must be defined by something else. And once it is, it will be harder to make a strong claim that all aesthetic experiences must perforce result in, or involve, pleasure. Or, it will be easier to weaken the assumed link between them. Were pleasure construed in Sparshott's first sense, as contingently occurring in the domain of aesthetics, these difficulties would not arise. For one could allow that some aesthetic experiences are sometimes met with pleasure (like viewing a sunset), others with pain (perhaps an encounter with *Guernica*), and do so while side-stepping the need

to provide an account of what *kind* of pleasure that is, or a circular account of its necessary and invariable occurrence, while relying on some generally understood idea that pleasure is something that we sometimes feel in these instances as in many others. That is, room could be made for displeasure, pain and even ambivalence in the aesthetic dimension of our lives, and this would dissolve – rather than resolve – the supposed paradox of negative emotion I mentioned at the outset.

To do this, however, requires me to consider other *aesthetic x*'s, in order to build up a picture of what aesthetic experience amounts to, if it is not located in a certain kind of pleasure. That is, if I eschew a hedonic approach to my goal of describing aesthetic experience, this kind of experience must still be characterized in some way. If every one of Sparshott's set phrases is understood in the first sense, as unrestrictive, we would end up without an account of the aesthetic as a distinct dimension of our lives at all, which would threaten to undermine the discipline as a whole. The most straightforward way to undertake this task is to look at some of the other contentious notions from Sparshott's appendix, and see if a better picture can be built of the elements that comprise an experience that can be called aesthetic. This and the following two chapters will take up this task.

It is worthwhile to note, as I proceed, that the role of pleasure will change: from definitive of aesthetic experience, as with the Everyday movement on my construal, and as with Bell's and de Clerq's formulations, to invariably concurrent with or emergent from a kind of perception or attention to certain values or properties, as with Beardsley and Levinson. In what follows, pleasure becomes more a

response *to* or an effect *of* an aesthetic experience defined primarily in some other way, and with this, its grip will loosen still further.

## Aesthetic Attitude/Aesthetic Attention

Sparshott was the first to admit that the notion of 'attitude' is 'extraordinarily vague'[28] but I would like to begin here because, in spite of its ambiguity, the phrase contains the kernel of how to best construe a minimalist account of aesthetic experience. 'Attitude' seems to refer to a state of mind; however, even in its second or restrictive sense, as characteristic *of* the aesthetic, 'attitude' can be further subdivided along the following lines. Primarily, Sparshott notes, an aesthetic attitude describes a way of attending to objects 'in which they are subjected to sensory contemplation, that is, looked at or listened to (etc.) attentively and without immediate practical purpose'. More problematically, though, it becomes a 'strategy' adopted to make objects 'suitable' for such contemplation.[29] Indeed, Jerrold Levinson notes that an aesthetic attitude has often been considered as 'prior to aesthetic experience', or preparatory for it, such that one has these experiences 'if, under the right circumstances, one adopts' this 'antecedent mental condition'.[30] Edward Bullough's conception of 'psychical distance'[31] and its heirs is of this sort, suggesting that one needs to first achieve a certain

---

[28] Sparshott, *Theory of the Arts*, 469.
[29] Ibid.
[30] Levinson, 'Towards an Adequate Conception', 28.
[31] Edward Bullough, '"Psychical Distance" as a Factor in Art and an Aesthetic Principle', *British Journal of Psychology*, 1912, reprinted in *Aesthetics: A Critical Anthology*, eds. George Dickie and Richard J. Sclafani (London: St. Martin's Press, 1997), 758–83.

state of mind in order to have an appropriately aesthetic experience – a conception later much criticized by George Dickie and others. In fact, Dickie's famous critique of the aesthetic attitude is premised upon its being defined as a kind of motivation or intention, and he claims that, while motivations may differ, there is 'only one way to *listen to* (attend to) music [etc.]', even though 'there may be a variety of motives, intentions, and reasons for doing so'.[32]

Just as identifying the right sort of pleasure has proven difficult, so too is any claim that one can achieve the right sort of frame of mind, in order to herald it as a necessary precondition for the occurrence of an aesthetic experience. Further, if such experiences depend upon – or are occasioned by – the forming of a certain prior mental state, all aesthetic encounters would have to be intentional in the sense of willed – if not pre-planned – which would exclude those moments when we are struck by, or stopped by, for instance, moments of beauty that are not in our immediate control. It is instead the first construal I am interested in, where 'attitude', however infelicitous a term, is used adverbially to describe a pre-evaluative act of perceiving, or attending to, intentional objects, rather than with some prior interior or mental state. Sparshott treated 'aesthetic attitude' and 'aesthetic perception' as distinct set phrases, but noted that one sense of aesthetic perception is 'perception, notable, not for its properties (all perception is perception equally, it is argued), but for its aim and circumstances: perception in

---

[32]George Dickie, 'The Myth of the Aesthetic Attitude', *American Philosophical Quarterly* 1, no. 1 (1964): 58. David Fenner more recently, in *The Aesthetic Attitude* (New York, NY: Humanities Press, 1996), claimed that the voluntary adoption of a certain attitude 'to make the spectator receptive' to having an aesthetic experience is a 'sufficient condition' for aesthetic experience itself (3, 125). See also Nick McAdoo's review of Fenner's work which is critical of this claim ('The Aesthetic Attitude', *British Journal of Aesthetics* 37, no. 4 (1997): 417–19).

the aesthetic attitude, in fact'.[33] To highlight this more specific sense, I prefer the term 'aesthetic attention'.

As an adverbial phrase, 'aesthetic attention' refers to a manner, or way of attending, one that is often characterized as being 'disinterested'. Dickie claimed that we cannot understand the term without considering what 'interested attention' would amount to, which he linked to various kinds of motivations (economic interest, historical interest etc.). For Dickie, the proper converse of 'interested attention' can only be distraction, or failing to attend, and as such he found the notion of disinterested attention (attending disinterestedly) incoherent.[34] Certainly it cannot mean 'attending with no motivation at all', which, as Kenneth Rogerson noted in his critique of Dickie, would be incomprehensible. Rogerson defended an adverbial conception of disinterest with the corollary motivational term 'for its own sake': the 'motive of mere contemplation of an object'.[35] When objects are attended to without 'immediate practical purpose', in Sparshott's terms, Rogerson claims that they are attended to for their own sakes, or approached with an aesthetic attitude, or for aesthetic reasons. But this formulation does not resolve Dickie's concerns, as Rogerson has not properly given us an adverbial sense of disinterested attention. 'For its own sake' suggests a prior motivation or a reason for approaching the phenomenon rather than a way of attending to it, and this returns us to the normative question on which I would like to 'punt' rather than focusing on the aesthetic question itself. It is to

---

[33] Sparshott, *Theory of the Arts*, 476.
[34] Dickie, 'The Myth', 58.
[35] Kenneth F. Rogerson, 'Dickie's Disinterest', *Philosophia: Philosophical Quarterly of Israel* 17, no. 149 (1987): 156.

ask, as Shelley did, how aesthetic reasons give us reasons to act that are different from our general practical, moral or hedonic reasons for action. To suggest that the aesthetic can be defined by the reasons for which we act is to return to the more problematic sense of a prior 'attitude' that we adopt, or an intention that we form, instead of describing what transpires in the experience itself, or how it so transpires, in a way that can make the notion coherent. For this reason, rather than 'for its own sake', I will adopt the descriptor 'in itself' as a way of attending to a phenomenon as it is in its own particularity, as it appears to us, and it is this kind of focused activity that I suggest forms the core of a minimalist conception of aesthetic experience. However, the notion of disinterested attention has almost uniformly been linked to pleasure[36]; I will try here to extract a workable sense of it from these affective ties, and make the case for it as a foundation for aesthetic experience.

Paul Guyer, in *A History of Modern Aesthetics*, claims that the notion of disinterest can be traced back to Shaftesbury, for whom it meant a detachment from a strictly self-regarding concern for reward, where aesthetic attention had nothing to do with a promise of personal use and consumption.[37] Most recently, Levinson argues that a necessary element of aesthetic experience is 'aesthetic attention', whereby

---

[36]Nick Riggle, to provide a recent example, offers up both negative and positive conditions for disinterest but couches both in the experience of aesthetic pleasure without argument or defense. See 'On the Interest in Beauty and Disinterest', *Philosophers' Imprint* 16, no. 9 (2016): 3. Parsons and Carlson, likewise, find the notion of disinterestedness to be 'necessary for an acceptable analysis of the aesthetic' but presume its definition as 'involving a pleasure taken in perceptual appearance for its own sake' (Parsons and Carlson, *Functional Beauty*, 105, 104).
[37]Guyer, *A History of Modern Aesthetics*, 36–8. And see Jerome Stolnitz, 'Of the Origins of "Aesthetic Disinterestedness"', *Journal of Aesthetics and Art Criticism* 20, no. 2 (1961): 131–43, for a discussion that situates the notion squarely in eighteenth-century Britain but shows its slow maturation, from Shaftesbury through Addison.

one is 'focused on an object's perceivable forms and properties for their own sake and in their full individuality, apart from the utility of so attending'.[38] And Bence Nanay, in his attempt to bring the philosophy of perception to bear on matters aesthetic, as a way to 'move aesthetics out of its unfortunate isolation within philosophy', understands disinterested attention to be focused on a particular object but distributed with regards to its properties: 'I call attention of this kind "aesthetic attention" and argue that it is a crucial feature of some paradigmatic examples of aesthetic experience.'[39] These claims echo Robert Stecker's definition of aesthetic experience as, in part, attending to the forms, qualities and meanings of objects for their own sakes,[40] as well as Mary Wiseman's reference to '*a manner of attending* to an object present to the senses' which is careful and focused: it is the 'careful scrutiny of all and only what the senses present and the mind focuses on'.[41] For Beardsley, earlier, a necessary condition of aesthetic experience was 'object-directedness', our acceptance that 'phenomenally objective properties' will guide our 'mental states' rather than the reverse. It was accompanied by a detached affect and a felt freedom from other concerns.[42] Kant's technical notion of disinterest, central to his account, is perhaps the best known. It, however, is tied to judgement rather than perception or contemplation

---

[38]Levinson, 'Towards an Adequate Conception', 39.
[39]Bence Nanay, *Aesthetics as Philosophy of Perception* (New York, NY: Oxford University Press, 2016), 2, 23.
[40]Robert Stecker, 'Aesthetic Experience and Aesthetic Value', *Philosophy Compass* 1, no. 1 (2006): 4. He takes this formulation in part from Levinson.
[41]Mary Wiseman, 'Damask Napkins and the Train from Sichuan: Aesthetic Experience and Ordinary Things', in *Aesthetics of Everyday Life: East and West*, eds. Liu Yuedi and Curtis L. Carter (Newcastle upon Tyne: Cambridge Scholars Publishing, 2014), 135.
[42]Monroe Beardsley, 'Aesthetic Experience' in *The Aesthetic Point of View*, eds. Michael J. Wreen and Donald M. Callen (Ithaca, NY: Cornell University Press, 1982), 288.

(and I'll return to it in the next chapter). Kant suggests that when we are making a (pure) judgement of taste, 'one does not want to know whether there is anything that is or that could be at stake, for us or for someone else, in the existence of the thing, but rather how we judge it in mere contemplation (intuition or reflection)' – that is, on the basis of the mere appearance of a representation to the mind when we are 'indifferent' with regard to the 'real existence of the object of this representation'.[43] As Eva Schaper noted in her interpretation of Kant, he also intended this to be a 'totally object-centred judgement'.[44]

These – for the moment very partial – constructions are at least suggestive: apart from a loose sense of 'for its own sake' that is often used interchangeably with 'in itself', they do claim that a disinterested attitude can be construed not as the adoption of an intentional stance prior to experiencing objects aesthetically, but instead as a manner of paying attention, and this manner is defined as the *absence* of pragmatic, aquisitory, economic, moral, even cognitive goals or elements in one's attention, whereby in the moment of aesthetic perception, one is free of such personal or quotidian concerns and instead focuses simply on the object or phenomenon as it presents itself. This kind of attention need not be willed or planned; an object can suddenly strike us in such a way that we are taken with its appearance alone, quite apart from any other relation we might

---

[43] Immanuel Kant, *Critique of the Power of Judgment*, trans. Paul Guyer and Eric Matthews (Cambridge: Cambridge University Press, 2000), AK 5: 204–5. But see Jessica Williams, 'Kant on Aesthetic Attention', *British Journal of Aesthetics* 61, no. 4 (2021): 421–35, who argues that we can find in Kant an account of aesthetic attention that is importantly different from the attention we give to objects when we try to cognize them, and this difference lies in part in disinterest.

[44] Eva Schaper, 'The Pleasures of Taste', in *Pleasure, Preference and Value*, ed. Eva Schaper (Cambridge: Cambridge University Press, 1983), 50.

have, or want to have, with it and quite apart from how it makes us *feel*. Much more needs to be said here, however: Can this notion be made conceptually sound – can it pass the Sparshott Test? And can it indeed be construed without any reference to emotion or pleasure? I will discuss these in turn.

## Disinterest

Sparshott's first question was whether the attitude (in this case) is recognizable. Disinterest may seem to present a problem similar to that of aesthetic pleasure: Do we need a 'treatise' on awareness or perception – indeed even an entire philosophy of mind – to clarify this notion? I do not think we do. I take heart in Sparhsott's comment that 'the alleged difficulties in specifying an appropriate sense for "disinterested" … are largely fictitious: what is meant is that attention is paid to the appreciable qualities of the object as object, disregarding any relation the object may have to any purposes of one's own formulated without regard to the object itself'. This meaning, he notes, is 'hardly obscure' and seems to him to be self-evident.[45] Stecker makes the following distinction: when driving a car and looking at a mountain range to see if one is going in the right direction, one would not be paying aesthetic attention to those mountains, whereas looking at their forms and properties as they are in themselves would be – and he presumes we can tell the difference.[46] Similarly, in a

---

[45]Sparshott, *Theory of the Arts*, 674, *fn* 2.
[46]Robert Stecker, 'Aesthetic Autonomy and Artistic Heteronomy', in *Aesthetic and Artistic Autonomy*, ed. Owen Hulatt (London: Bloomsbury Press, 2013), 33.

debate with Nöel Carroll, Stecker argues that 'Charles', although he is attending carefully to the forms, qualities and meanings of an object, is *not* having an aesthetic experience because he is doing this in order to enhance his powers of discrimination and so on, whereas 'Jerome' *is* having an aesthetic experience because his attention has no other interest beyond the object itself – and, whether Carroll or Stecker are right in their conclusions, both find the difference between these kinds of attention to be equally apparent.[47]

The underlying impetus for these formulations, I believe, is to carve out one way of interacting with the world around us where we set aside, even momentarily, our normal purposes, desires and intentions. We are categorizers, doers, makers – purposive beings; we could not function if we were unable to slot new experiences into known conceptual categories or if we were unable to formulate ends and the means to achieve them. And the greater part of our lives is given over to purposive action. We put our hand under the faucet to see if the water is warm enough for bathing; we check the colour of the tomato to see if it is ripe enough to eat; we identify the animal running towards us as a dog rather than a coyote – our normal perceptual experiences of the world take this interested form. But if at times our practical interests are held in abeyance, then we instead pay attention to the feel of the water rushing over our fingers, or the purple/black colour of that heirloom tomato, or note the way the animal's fur catches the sun.[48] What is disinterested about aesthetic attention

---

[47]Robert Stecker, 'Only Jerome: A Reply to Nöel Carroll', *British Journal of Aesthetics* 41, no. 1 (2001): 79.
[48]As with my parenthetical comment in Chapter 1, the aesthetic can indeed be pernicious if being dazzled by the colour of fur prevents us from realizing we are in danger.

is that it, for once, is *just* perception: object-oriented, taking in the phenomenon as it is in itself, or as it immediately appears. Sparshott states, '[t]his might be thought of as perception having to an eminent degree the character of perception ... perception in spades', and in this he reminds us that the Greek root – *aisthesis* – can be translated as sensory perception.[49]

What matters is not our motivation but our attention. We can be interested in our approach to an object, such as going to a lighting store to buy a lamp, or attending a play in order to write a review of it – our normativity can indeed be 'pure vanilla' – but once there, doing the looking, we can be so struck by an object (or performance) that we are indeed 'distracted' as Dickie notes – distracted, that is, not from the object but from our original purposes, and we are instead taken with the appearance in front of us. Dickie in fact sets up a false dichotomy: the converse of 'interested attention' is not 'failing to attend' but being led away from our initial purposes by a phenomenon that lays claim to our awareness such that it draws us out of our more narrow focus and demands our notice: we become disinterested. 'Charles' may have approached the object in order to enhance his powers of discrimination but he may have become so captured by its forms and qualities that these intentions fell away, or he was distracted from them, and then his attention would indeed become aesthetic in the same way as that of 'Jerome'. We further may have a variety of reasons for setting out to have an aesthetic experience in particular, but whether we have one or not is up for grabs, and it is that experience – regardless of our reasons – that I seek to describe. I believe, contra Shelley, that the question of

---

[49]Sparshott, *Theory of the Arts*, 476.

our motivations is extra-aesthetic, for even having an aesthetic reason is not sufficient to guarantee that the experience will be an aesthetic one, as anyone who visited a gallery and then failed to be taken with the art can attest.

Note that these canvassed descriptions of disinterest are couched in negative terms: disinterest is what is *left over* when practical and other considerations are disregarded or set aside. Even were one to characterize the result as a moment of freedom, as in Addison's notion of free play of the faculties I mentioned earlier, it would still be a negative freedom, as freedom *from* the normal conditions and restrictions that govern our practical as well as perceptual lives. This is not an immediate liability for the notion of disinterest: it clears away the extraneous to uncover a necessary (negative) condition for a (pre-evaluative) act to be aesthetic. Such an experience is aesthetic only if it is a disinterested engagement with an intentional object; this disinterested engagement defines some forms of attention *as* aesthetic. Or, more bluntly: the aesthetic begins here.

However, while necessary, is this depiction of disinterest enough for even a minimalist account? Levinson depicts the 'minimalist' conception of aesthetic experience as 'one according to which aesthetic experience is just experience in which there is perception of aesthetic and/or formal properties of some object'. He does not endorse this conception because, for him, it is not enough: aesthetic experience needs to include the idea that it is 'inherently' '*rewarding, valuable* or *worthwhile*'.[50] What Levinson seeks to add is a further, positive aspect that will describe aesthetic experience in fuller

---

[50]Levinson, 'Toward an Adequate Conception', 31.

terms. His suggestion here offers too much, in its notion of reward, and threatens to return to a conception of the aesthetic as defined by its positive value, if not by pleasure directly. But another positive formulation appears with Levinson and Stecker earlier, when they characterize attention not merely as disinterested but as focused on the object in itself. That is, not only is the subject free of other interests but the object now comes into focus as the (positive) locus of that attention. It is Nick Riggle who formalized these aspects of disinterest as two separable negative and positive conditions of, in his case, aesthetic pleasure rather than experience (he labelled them 'DISINTEREST −' and 'DISINTEREST +').[51] Separating them this way opens up the question of whether each are necessary, and whether both are jointly sufficient for aesthetic experience. It certainly, at the least, allows them to be analysed separately.

The positive condition needs some careful treatment. Not only do I make a distinction between the motivationally laden term 'for its own sake' and the more neutral or object-oriented 'in itself' but 'in itself' too easily conjures up the Kantian notion of things-in-themselves, as mind-independent entities, and suggests the aesthetic can grasp things as they somehow 'really are', giving it a cognitive dimension. The phenomenological tradition would alter this formulation to 'object-as-it-appears-to us' and thus dispel the link to cognition. This does not yet shed light on it, however. For Levinson, the positive condition implies attention to the formal properties of the object, 'apart from the utility of so attending'; for Lopes, this suggests that the sole aesthetic act is one of appreciation, in that it bars any other

---

[51] Riggle, 'On the Interest in Beauty and Disinterest', 3.

motivation for attending to objects in this way.[52] With my inclusion of moments that might not be intentionally sought out, the notions of the 'utility' of this attention, or whether or not it leads to appreciation, are beside the point. Again, 'for its own sake' seems to imply a reason to do so, along with an implicit valuation, if not a valorization, of the object: it is no wonder that, for the most part, disinterest is couched in terms of aesthetic values, properties and pleasure.

Another way to consider this positive condition lies in what is attended to. Levinson mentions a focus on formal or aesthetic properties which, as Rogerson has observed, would render the account circular for what makes disinterested attention aesthetic are the aesthetic properties it picks out.[53] Nanay's suggestion is to distinguish between our practical interest in an object, where our attention is focused on a limited number of its features (e.g. those in which we have a specific interest), and aesthetic attention, where we range over the object's properties more broadly. His notion of 'distributed' attention as, in part, constitutive of aesthetic experience is focused on one object, but on a wide range of its features.[54] Yet, as Robert Hopkins has noted in a review of Nanay's work, there are many circumstances where we may attend to a wide range of features which are nonetheless not aesthetic experiences, just as there are many circumstances in which we focus on formal features that do not make that focus particularly aesthetic either, such as when we are trying to discern differences or change in an object over time, or when we are, say, practising our powers of discrimination, as with 'Charles', above.[55]

---

[52]Lopes, *Being for Beauty*, 45.
[53]Rogerson, 'Dickie's Disinterest', 155–6.
[54]Nanay, *Aesthetics as the Philosophy of Perception*, 21–7.
[55]Robert Hopkins, 'Review of *Aesthetics as Philosophy of Perception*', *British Journal of Aesthetics* 57, no. 3 (2017): 341.

It begins to seem as though the positive condition of 'in itself', taken separately, is itself problematic and does not advance a theory of the aesthetic. Indeed, Riggle has written that such language 'suggests that the subject needn't do anything but dispassionately stare at the object, bringing nothing of herself to the table but awareness'[56] which recalls the notion of 'spectator aesthetics' and a passive conception of experience, both of which I seek to disavow.

Perhaps, more simply, instead of seeing these as two separate conditions and complicating an analysis by asking whether one or both are necessary and how, they can be taken in tandem in the following way. If the set phrase 'aesthetic attention' is to have meaning or use for a theory, that attention must be qualified somehow to distinguish it from the normal stream of perceptions we regularly have. Disinterest does this: it becomes a way that the activity of a subject can be characterized, or the conditions required for an intentional (object-directed) act, that renders it different from merely noticing something that one hadn't noticed before, or from attending to some features over others; as well as from epistemological activities such as learning, remembering, categorizing, trying to figure out; from moral activities of judging, deciding and acting; and from instrumental activities of using, buying, wanting or controlling. Further, in contrast to a representational model of the mind as mere passive awareness, experience as active is affected by, and also affects the world as experienced. Disinterested attention subtly alters the object and it becomes an *aesthetic* object for the subject, for at least as

---

[56]Riggle, 'On the Interest in Beauty and Disinterest', 4.

long as that attention lasts. It is not some true 'in-itself' that aesthetic attention grasps, or some independent set of aesthetic properties; the act of attending to a phenomenon with disinterest creates a relation that can be characterized as unique, and this is what we can call aesthetic.

Rogerson's formulation is that '"to attend distinterestedly" is to attend to those features relevant to the motivation of mere contemplation of an object for its own sake'.[57] He argued that the 'substantive claim of disinterestedness theory is that those features relevant to a disinterested motive are the aesthetically relevant ones' but that it is an 'open question' which features those will be[58] – not necessarily *all* of them, as is implied by Nanay, nor only the formal features, as Levinson claims. Taking away the motivation that Rogerson relies on, we can see that disinterest suggests a reciprocity between subject and object, where the subject's mode of attention renders certain of the object's features aesthetic, and the object, in commanding that attention, has the power to override or negate our usual interests and invite mere contemplation of its features.

Riggle, in another context, speaks of an 'unsolicited aesthetic interjection' where one is 'jolted out of whatever hazy cloud of practical thought one was in; one is forced to reconsider one's purely practical and rather indifferent relationship to [one's surroundings] and curiosity … develops'.[59] This curiosity is the disinterested

---

[57]Rogerson, 'Dickie's Disinterest', 156.
[58]Ibid., 157–8.
[59]Nicholas Riggle, 'Street Art: The Transfiguration of the Commonplaces', *Journal of Aesthetics and Art Criticism* 68, no. 3 (2010): 249.

exploration of the properties or features of an object, whether 'distributed' or not, without further agenda. The intentional object becomes the object of our disinterested interest, as it were: suddenly notable, or suddenly in the forefront of our gaze. And in this we take it as it is 'in itself', as it captures our attention, and in so doing, the object becomes aesthetic. Imagine that I normally chop onions merely to get them into the pot to begin cooking. Once, having had my knife sharpened (and having promptly forgotten I had done so), I was again chopping onions when I noticed a difference in the feel of the knife in my hand. The knife in that moment became an aesthetic object for me, and apart from my practical concerns (dinner), I noticed a change in balance, pressure, rhythm and even sound. I took note of the knife 'in itself', or as it appeared to me in that moment; my quotidian experience became an aesthetic experience that emerged from a change in my attention, and a concomitant change in the object to which I attended. These were not two separable conditions but one. It is this core moment that the minimalist account seeks to capture: whether I then went on to appreciate, judge or value the knife depends upon it first becoming an aesthetic object that I disinterestedly experienced. And whether I gained pleasure from that moment, or whether I then went on to learn to sharpen my own knives to try to recapture it, or even decided to change professions and go to cooking school (e.g. whether my aesthetic actions came to involve affect, or specialization and expertise as Lopes depicts) are separable from, and indeed contingent upon, this core, necessary, initial encounter – a relation that incorporates both relata – which begins any further aesthetic engagement or activity. In answer to

Sparshott's last question, it is the '*x*' – disinterested attention – that makes the phenomenon aesthetic.

This suggestion needs certain qualifications. First, 'aesthetic object' is an ambiguous term in the literature and leads to a variety of often conflicting theoretical approaches. Sparshott notes that reasons for this ambiguity include (i) that 'any perceptible thing can be an object of sensory contemplation', which has long dismayed those who identify the aesthetic object with works of art; (ii) 'that contemplation as such regards appearances and not realities', which dismays realists about aesthetic qualities like beauty; and (iii) 'that aesthetic objects are more properly thought of as constructs from qualities than as selected substances'. This leads to epistemological and metaphysical debates about whether an object is a construct from perceptions or a permanent thing-in-itself that may be the object of perception and cognition.[60] My use of 'intentional' to describe as object whatever is the focus of our attention (and for as long as it remains the focus) is meant to side-step some of these deeper metaphysical and epistemological concerns, as well as opening out the aesthetic to include anything that we experience with disinterested attention. The 'in itself' does not restrict our attention to only some formal features, or to only some properties (aesthetic properties) but captures the transformation of the quotidian into the aesthetic due to the structure and direction of our attention itself. Nevertheless, my construal does exclude some

---

[60]Sparshott, *Theory of the Arts*, 479–80, and see *fn.* 22.

things: if similar experiential qualia were induced by drugs, dreams or hallucinations, for instance, this would not count as an aesthetic experience because there is no genuine encounter being had with the world around us. What is necessary for an experience to be aesthetic is a first-hand, perceptual encounter with the sensory properties of a phenomenon.[61] But this also casts the net quite wide. By properties or features to which we may attend, Antonia Peacocke includes, for instance, 'representational features (e.g. a picture's depicting the Virgin Mary), affinities (e.g. a tune's being in the style of Britten), and some relational properties (e.g. a monument's being located in Rio)'.[62] They may also include such things as rhyme, prosody and so on, with the experience of (oral or written) literature, the values in a mathematical equation, and features that become apparent only in active engagement and use, such as the glide of a bicycle on

---

[61] This demand for a first-hand encounter has become known as the 'acquaintance principle' and has been criticized recently by Konigsberg and Robson. Because most of their objections have been directed towards experiences of works of (particularly conceptual) art, I will bypass them here. See Amir Konigsberg, 'The Acquaintance Principle, Aesthetic Autonomy and Aesthetic Appreciation', *British Journal of Aesthetics* 52, no. 2 (2012): 153–68, and Jon Robson, 'Appreciating the Acquaintance Principle: A Reply to Konigsberg', *British Journal of Aesthetics* 53, no. 2 (2013): 237–45. For a defence of the acquaintance principle, see Richard Wolheim, *Art and Its Objects* (Cambridge: Cambridge University Press, 1980), and Malcolm Budd, 'The Acquaintance Principle', *British Journal of Aesthetics* 43, no. 4 (2003): 386–92, to name but two. C. Thi Nguyen, 'The Uses of Aesthetic Testimony', *British Journal of Aesthetics* 57, no. 1 (2017): 26, makes the interesting point that 'the more we describe ... cases in terms of personal aesthetic experiences, the more likely we are to resist the use of aesthetic testimony' and rely instead on the need for acquaintance. I think this is correct: in an account of the aesthetic experience of an individual, it must be *theirs* and this requires a first-hand encounter with the object.
[62] Peacocke, 'Let's Be Liberal', 165.

new pavement, or the sound and feel of the wind rushing by while peddling at speed.[63]

Second, the object 'in itself' is not a wholly independent entity: a knife is a knife, one might say, in the way that a stone is a stone but this would be incorrect. Much of the furniture of our quotidian lives – artefacts in particular – are situated within frameworks of tradition, culture and history. There are as many different configurations of knives as there are culturally learned chopping movements, and this situatedness forms one of the conditions within which we function. The knife becomes an aesthetic object when we abstract from our personal, pragmatic or instrumental interests, but disinterested attention does not render that object suddenly foreign; 'in itself' describes its becoming (at least momentarily) the focus of our attention, but it does not become a brute object 'in itself', separated from the framework within which we understand and use it.[64]

The 'curiosity' that Riggle suggests develops in our encounters I thus do not read as rendering an object 'extraordinary', as Thomas Leddy has called it, nor 'strange' in Arto Haapala's more Heideggerian

---

[63]To be an object of aesthetic experience, it must have perceptible features, although these can be fairly broadly characterized. Kris Goffin, for instance, suggests that literature and mathematical proofs are 'non-perceptible' but says nothing about how they may still be distinguished from dreams and hallucinations. See 'The Affective Experience of Aesthetic Properties', *Pacific Philosophical Quarterly* 100, no. 1 (2019): 288. One way to make the distinction is to claim that dreams are wholly private and cannot be shared. They can be described and reported but they are not in principle part of the world around us. One of the reasons that mathematics and literature are shareable is that they *do* have perceptible features, even if these are language or specialized systems of notation. Whether one can have an aesthetic experience of a mathematical proof, for instance, is an open question that turns on whether it can be experienced disinterestedly, or whether one's attempts to solve it – one's cognitive goals – remain at the forefront of one's attention.

[64]By 'culturally learned', I do not advert to Lopes' notions of competence and specialization: one can be a ham-fisted chopper while still employing the implement in a localized and recognizable way.

terms.[65] The aesthetic objects come into focus, but are still taken for what they are, as they appear, in all of their particularity, without anticipation of categorization, knowledge, use or reward. Nanay, for instance, correctly suggests that aesthetic experience allows us to attend to the world differently, in a way that we would not, and could not, do otherwise. But he errs in linking this difference to 'defamiliarization', or to seeing something for the first time. He notes that 'if an object is unfamiliar, we do not know how to approach it, and we therefore tend to attend to a number of its properties to *figure out what to do with it or what can be done with it*'.[66] This sharply contrasts with his notion of distributed attention as being disinterested, where what we are doing is precisely *not* trying to figure anything out in particular; there is neither searching nor finding in the initial encounter – there is merely looking at (listening to, etc.) an object/occasion as it emerges in this particular way. The object becomes aesthetic, yes, but neither thereby alienated nor *aestheticized* in the way the Everyday movement suggests, where its features are rendered pleasant (or positive) and the action necessarily pleasurable.

Still, one can ask whether disinterest is something that needs to be attained. Peacocke, in her discussion of Beardsley, notes

---

[65]See Thomas Leddy, *The Extraordinary in the Ordinary: The Aesthetics of Everyday Life* (Peterborough: Broadview Press, 2012), where he states that 'only when the everyday leaves the merely ordinary ... does it become aesthetic' (76–7); and Arto Haapala, 'On the Aesthetics of the Everyday: Familiarity, Strangeness, and the Meaning of Place', in *The Aesthetics of Everyday Life*, eds. Andrew Light and Jonathan M. Smith (New York, NY: Columbia University Press, 2005), 39–55. Haapala suggests that traditional aesthetics has focused on 'strangeness', where an object is somehow special rather than ordinary but seeks to counter this tradition with an aesthetics of the familiar (40). See Forsey, *The Aesthetics of Design* for a critical discussion of this attempt (223–36).
[66]Nanay, *Aesthetics as Philosophy of Perception*, 34–5, 130 (my italics). And see Hopkins, 'Review', 343.

that he conditions his hedonism: aesthetic value arises only in the 'correct' experience of an object,[67] which Shelley calls an 'epistemic qualification' because it specifies a 'capacity' that is relevant to experiencing an object aesthetically/finding it valuable.[68] If disinterest were a 'capacity', it would be preparatory for the experience rather than constitutive of it. Instead, on the first construal, disinterest is a descriptive rather than prescriptive term that seeks merely to characterize an experience. Even on the first construal, though, can we know if/when we are 'disregarding' a relation to the object that is interested, or that is not fully object-directed? And is there a sense in which we can say whether we are doing this adequately or *enough*? There are two answers to this. First, I think that to a sufficient extent we can know this. That is, given that we have self-awareness, we do seem to be reasonably cognisant of our interests and intentions, such as when we are studying a work of art to prepare for a test; examining a toad to determine its species; or inspecting a washing machine with an eye to its purchase. Equally, we do seem to be cognizant of those times when these interests are in abeyance, and our attention is more object-focused. But it is hard to prove a negative, and I do not think it self-evident that we can be sure when *no* other interests contribute to our perceptions.

Similarly, it cannot be the case, as we saw with Bell, that we take *nothing* with us from our lives in our attentions, or that we achieve some transcendent state of complete purity: perception is a complex notion and will be complicated by any number of cultural, psychological, environmental or contingent factors. As Paul Ziff has well noted,

---

[67] Peacocke, 'Let's Be Liberal', 164.
[68] Shelley, 'Beyond Hedonism', 258.

the 'conditions of attention may be infelicitous' and undermine an ideal 'harmonious relation between the person and the object', as, for example, when traffic drowns out birdsong, or in Ziff's example, when attention to a clump of seaweed is interrupted by our being 'savaged by a school of sharks'.[69] In these cases we 'fail' to be disinterested but not through a lack of achievement on our part, or an absence of a certain prerequisite and/or trainable capacity, or indeed a certain motivation. Other conditions can just get in the way. And these impediments can also be quite individual: fear of wasps has always barred me from viewing them with anything approaching disinterest. But for the sake of understanding the common construal of aesthetic attention, we can surely recognize disinterest and understand what it amounts to, even while admitting that empirical evidence of this kind of attention may be hard to accrue, or leaving its accruement to some other field (such as Nanay's foray into the philosophy of perception). The point is that attention is disinterested – not that it is *purely* disinterested, or that the purity of disinterest can be empirically measured. An aesthetic theory need not demand purity or one-hundred-percentness to gain traction; some of the details will need to be left to other fields. But if conceptual sense can be made of the notion of disinterest, then we have the beginnings of a description of aesthetic experience.

To suggest that we are not otherwise engaged, interested or occupied in our contemplation of or interaction with perceptual phenomena is less conceptually or phenomenologically onerous than trying to identify a given hedonic state, or to pinpoint a certain kind of pleasure when or as we are feeling it, or to identify a specific sort of

---

[69]Paul Ziff, 'Anything Viewed', in *Aesthetics*, eds. Susan Feagin and Patrick Maynard (New York, NY: Oxford University Press, 1997), 26–7.

preparatory attitude. Can we be sure we are *completely* disinterested in any given instance, or that we are paying attention to an object *solely* as it is in itself? No, of course not. But we do seem to know what it means to pay attention to something without self-interest, while we do not know, for instance, what so-called aesthetic pleasure is supposed to be.

The second answer to this question is more methodological. A philosophical analysis of the elements of aesthetic experience – of what is aesthetic about some ways of encountering or engaging with the world – does not necessitate that we be aware of or self-consciously notice these elements on top of giving our attention to our surroundings. The non-philosopher can stumble upon a toad, give it their immediate attention and then move along. It is the philosopher who wants to know how/when we do this in some instances and not in others, and whether a cogent account can be made that carves out a particular aesthetic dimension to our lives. In this, I am indebted to Kant's project, which sought an *analytic* of judgements of the beautiful rather than an empirical study of them, and even to Hegel's distinction between phenomenal consciousness – that is engaged in knowing the world – and what he called the phenomenological consciousness of the philosopher who, retrospectively, and from the outside, as it were, comprehended the structure of that phenomenal consciousness's attempts to do so. Something different is going on when we pay disinterested attention to what we've just noticed, than when we identify, categorize and label that thing, and, while an individual does not need to – and may not care to – reflectively distinguish the elements that make up these different encounters with

the world, the philosopher must, if there is to be such a thing as an aesthetic theory. In moments of disinterested attention the subject is not aloof or unconcerned, but rather open to what perception of an object might bring, absent the usual pragmatic and quotidian preoccupations that make up daily life. The relation between subject and object becomes closer in this encounter rather than farther apart: the subject opens herself to what she perceives, and the object is approached without preconceptions, not to be known or used or controlled but simply to be *met*. Disinterest captures this encounter, and in this it can be identified as a recognizable phenomenon – it passes the first question of the Sparshott Test.

Turning finally to Sparshott's second question, it asks whether disinterest is invariably connected to the aesthetic – or only contingently so. The interpretations of disinterest I have just canvassed would all answer in the affirmative. In every instance, when we pay this kind of attention to an object, our attention has an aesthetic dimension or character. One can argue that this is just what aesthetic perception is, or an aesthetic attitude amounts to, and a conceptual analysis of aesthetic experience will require that we begin by engaging in the perceptual consideration of an object as it appears in its individuality. It is difficult to imagine a cogent theory of aesthetic experience that could begin elsewhere: that we can gain aesthetic pleasure, for instance, without such attention, or that we can gain it in some other way, as by private associations, where we are triggered by nostalgia, or personal preference or liking – in these cases it would no longer matter that the particular object is being noticed at all. (If I think the mountains are beautiful because they remind

me of my childhood home, I am not attending to the mountains themselves but to what feelings are contingently triggered in me at the sight of them.) (This is Dickie's failure to attend.) One of the reasons for hedonism's 'epistemic qualification' is that without demanding a 'correct' way to experience an object, any source of pleasure would net the same aesthetic value. Absent the notion of pleasure, no further qualification to aesthetic attention is needed. When I run through the notions of aesthetic judgement and aesthetic value in the next chapters, I will find that at their core is this primary encounter with an object, and our perception of it, without which there would be no *aesthetic* element to any subsequent perorations.

What is minimally required for aesthetic experience is that we have some object (in a loose sense) before us that we engage with, that is perceivable by our senses, and that our perception of it is directed to its appearance, or properties, without that attention being guided or influenced by an interest outside of the object itself. Paul Ziff's formulation is that 'a person $p$ performs certain relevant actions $a$ in connection with ... an entity $e$ under conditions $c$' which allows him to conclude that '[a]nything that can be viewed is a fit object for aesthetic attention'.[70] My analysis here would alter that only slightly: anything that can be experienced with disinterest is fit to be described as an aesthetic object. Disinterest is necessary for an experience to be aesthetic, but the attention described is grounded in both the performance by the subject and the conditions under which it is performed.

---

[70]Ibid., 27, 29.

Let me sum up this section's discussion. Disinterested attention as it has been construed is not a requirement for having an aesthetic experience: it is the core of that aesthetic experience. One further question is whether it is *enough*. While it is sufficient for a minimalist conception of aesthetic experience, other factors obtain and can combine in different ways in more complex depictions of aesthetic experience, or in aesthetic experiences of different kinds of things, as will become clear when I turn to aesthetic judgement and value. In terms of aesthetic attention on its own, we can dismiss the idea that disinterested contemplation requires a preparatory state or strategy; we can see that this attention need not be willed but that aesthetic experiences can be quite unexpected; and we need not maintain that such attention requires a certain amount of time or that it must last beyond the moment of our encounter with the object in front of us. (The idea that this experience is 'contemplative' is a logical rather than temporal description.) We further do not need a Deweyan criterion of unity or consummation to render this *an* experience as distinct from others, since disinterest is enough to differentiate them. Nor do we need to delve into ontological questions of whether our attention picks out specifically aesthetic properties of significant form, grace, beauty, and the like: we simply do not and cannot know in advance what the *result* of such attention will be, as little as we can predict or know what will *cause* us to pay this attention in the first place. I have been here delineating a certain kind of perceptual experience: whether there are real aesthetic qualities in the world is a separate – and should be a separable – matter more relevant to metaphysics.

Further, it should be apparent that an emphasis on disinterested attention liberates aesthetic experience from an underlying moral impetus that I had noted in Chapter 1. Freedom from instrumental and personal concerns in the moment of aesthetic attention perforce requires that we be freed, too, from the hope of any resultant harmony or reconciliation – in fact, from any moral gain at all. We are, in the moment, 'just looking' (hearing, smelling, tasting, touching) simply *because* the phenomena have confronted us – or we have confronted them – and we engage with what is immediately at hand. An aesthetic experience then is objective in two ways: first, it is object-oriented, or directed towards some phenomenon; and second, we are objective in the sense of being at least initially impartial, without a specific, personal interest beyond that of the object itself at the moment of our encounter. One might object that this kind of disinterested attention involves or leads to alienation from the objects with which we are surrounded but as Eva Schaper has again noted of Kant, it would be 'quite wrong' to think of his reliance on disinterest 'as advocating detachment, aloofness, and non-involvement of the person who judges aesthetically'[71] in the way that perhaps Bell and Bullough had insisted. Rather than alienating us from our surroundings, this in fact brings us closer to them, in that in the moment we actually pay attention to things that we might otherwise easily overlook. And this attention, far from being esoteric, is simply one of the ways we engage with the world, or the world reveals itself to us: different, but no less

---

[71] Schaper, 'The Pleasures of Taste', 50.

important, than a cognitive act, or a moral judgement about the things around us.

My distillation of the notion of aesthetic experience to one of disinterested attention here clarifies some of the ambiguities that concerned Sparshott with this set phrase, where experience has often been taken to mean 'life-as-one-lives-it', in terms of its 'inward and passive aspect', where we are concerned with what 'happened to me … from my point of view alone'.[72] One sees this particular usage more and more often, as when my university refers to students' 'learning experiences' instead of their learning, or as when at a recent restaurant outing I was asked how my 'dining experience' had been, rather than my dinner. I will continue to use the term 'experience' here, on the qualification that I mean a kind of attention, which restores to the notion an outward, object-directed, *active* sense that has nothing, initially, to do with our responses to that action, or with our personal points of view. While this might clarify the ways that the notion of disinterested attention has been used as regards the Sparshott Test, the task of this chapter is not yet complete, for, with the exception of Mary Wiseman's formulation, all other interpretations of disinterest use the term to modify *pleasure*, rather than as a manner of attention alone. And in this, my analysis appears only partial. To complete the minimalist account, it is necessary to meet head-on the notion of pleasure and its tie to aesthetic attention.

---

[72]Sparshott, *Theory of the Arts*, 473.

## Disinterest and Pleasure

Why is an aesthetic attitude of disinterested attention understood to be pleasurable, or accompanied by pleasure? Stated baldly, the question is in fact baffling. To claim that a kind of attention necessarily has a hedonic tone or quality in this case but not in others does not illuminate the moment of attention itself but seems to confuse a perceptual issue with a psychological one. Other perceptions or kinds of attention – when we are trying to see if we're driving north; identifying a toad as a Cane toad rather than a Mexican Burrowing toad; or determining whether we like that sofa for the living room – may or may not be linked to emotional states – satisfaction, disappointment and so on – but the relation between the (interested) attention and the feeling is contingent. Further, no other case specifies which feeling will be part of – or the result of – our experience *except* in aesthetic theory. And here it has long been the norm. Paul Guyer, in the introduction to his history of aesthetics, suggests that 'the core of the subject is a concern with a certain kind of experience' but then traces theories of that experience in terms of a triad of ideas that suggest it is 'an experience of key truths, of the most fundamental emotions of human experience, and of the free play of the imagination'; the history of the discipline, he claims, 'will have to define the field for us', suggesting that truth, feeling and free play have been part of aesthetics since its inception *and so* define it.[73] But as I had noted with regard to Parsons and Carlson earlier, that historically this has been the case is not itself a defence of its veracity or descriptive authority. In a review of

---

[73]Guyer, *A History of Modern Aesthetics*, 3, 27.

the first volume of Guyer's work, Timothy Costelloe argues that the triad forms a 'normative criterion' for Guyer, of what will emerge as theories providing us with 'more insight' and 'greater value' (in Guyer's words) than any singular approach can give. But Costelloe notes that this normative conviction on Guyer's part is neither fully defended nor adequately justified.[74] What is needed is an argument as to the conceptual connection between the experience and its affective element – rather than a history or a dogmatic conviction – and this has been hard to find. It seems that hedonic/affective theories take a couple of approaches: that pleasure/affect is, at least in part, constitutive of aesthetic experience, or that, while not constitutive, at least necessary for that experience to be aesthetic. I will briefly consider representatives of both approaches as I argue that pleasure, or feeling of any kind, is instead a contingent response to, or accompaniment of, the aesthetic rather than internal to its conception.

If I more fully describe some of the various partial accounts I have canvassed, I find that there is no convincing argument deployed to justify or defend the connection between disinterest and pleasure. For Beardsley, for instance, it is *analytically* the case that the perception of certain properties (unity, intensity, complexity) brings with it aesthetic enjoyment:[75] remember that 'aesthetic experience is pleasurable, and indeed essentially so'.[76] These properties are the grounds of aesthetic value, and aesthetic value as Beardsley defines it just is the capacity to provide aesthetic enjoyment. He claims that there is 'no circularity' in

---

[74]Timothy Costelloe, 'Review of A History of Modern Aesthetics, Volume I: The Eighteenth Century', *The Journal of Aesthetics and Art Criticism* 75, no. 1 (2017): 83.
[75]Monroe Beardsley, 'The Discrimination of Aesthetic Enjoyment', in *The Aesthetic Point of View*, eds. Michael J. Wreen and Donald M. Callen (Ithaca, NY: Cornell University Press, 1982), 35–45.
[76]Beardsley, 'Aesthetic Experience Regained', 88.

'defining aesthetic value in terms of aesthetic enjoyment and defining aesthetic enjoyment in terms of the properties enjoyed'.[77] But in fact the qualities he defines as aesthetic are *already* and *only* those which he believes provide us with pleasure, and we experience aesthetic pleasure *if and only if* we attend to those qualities and not others. While his account is more sophisticated than Bell's, as an analytic definition of aesthetic experience it remains stipulative. Beardsley aligns himself with Socrates' 'safe course' in the *Phaedo*, who says simply that 'beautiful things are beautiful because of the beautiful itself',[78] which is hardly an informative or expansive response to the question I have posed here.

For Levinson, there are two elements required for characterizing aesthetic experience: the aesthetic attention I have mentioned, and a 'positive *response* or *reaction* toward that core attending or perceiving, one of a hedonic, affective or evaluative nature' which moves it beyond a minimalist account. This response is 'required to turn an occasion of aesthetic *perception* into an occasion of aesthetic *experience*'.[79] The justification for this second requirement Levinson leaves to a footnote: 'perceiving aesthetic properties, especially expressive ones, without responding to them affectively in any way is not only unlikely but in some cases perhaps even impossible. For some properties plausibly require, for their very perception, some sort of affective response on the perceiver's part.'[80] This is an interesting and problematic claim.

---

[77]Beardsley, 'The Discrimination of Aesthetic Enjoyment', 42.
[78]Ibid., 42.
[79]Levinson, 'Towards an Adequate Conception', 39.
[80]Ibid., 42, *fn* 34.

First, if some perception just *is* affective, then Levinson does not need two separate necessary elements for aesthetic experience but only the first, as aesthetic perception will perforce include affect on its own. Second, while in the body of his essay Levinson states that the affective response must be 'positive', in this footnote he softens it to 'some sort' of response that is affective in 'any way'. Now, if the response must be positive, Levinson's claim is closer to Beardsley's and even Bell's, where certain properties like unity cannot be perceived without pleasure. And this seems unlikely: I can acknowledge that a weapon is elegant but react to it with horror; or see that a painting is unified and intense but also disturbing. Beardsley separated these so-called aesthetic properties into primary and secondary criteria, where the former ground a definition of aesthetic enjoyment (analytically) and the latter are connected to it 'in a synthetic and contingent way', where the connection must be established by argument.[81] But as Nick Zangwill has noted, it is an open question which properties (he calls these 'substantive properties') will be aesthetically 'good-making' or positive: some porcelain figures, he states, are 'horribly dainty', while 'neolithic sculptures of women' are 'wonderfully dumpy'.[82] How can it be known a priori – analytically – which properties ground aesthetic value and hence bring pleasure in their perception? Is the key of B flat Minor *always* or *necessarily* sad? Is the perception of unity *always* pleasurable? Beardsley does not establish this beyond stipulation, and nor, in his way, does Levinson.

---

[81] Beardsley, 'The Discrimination of Aesthetic Enjoyment', 45, 43.
[82] Nick Zangwill, 'The Beautiful, the Dainty and the Dumpy', *British Journal of Aesthetics* 38, no. 1 (1998): 323.

If we were instead to read Levinson as claiming more broadly that some properties 'for their very perception' require some kind of affective *response*, then (a) pleasure is no longer necessarily linked to aesthetic experience – it could be painful, sad or disturbing; and (b) we are no longer speaking of the initial perceptual experience itself, but of a subsequent response we have to that attention we have paid, which is another thing altogether. And still we remain in questionable philosophical territory as we now need to consider whether some perceptions cannot be had without an affective response, as Levinson suggests. That is, is it possible to perceive an object with an aesthetic attitude, while remaining emotionally unaffected by it? Primarily, Levinson's claim would seem to run counter to the notion of disinterest itself, which his idea of aesthetic attention also includes. For if we are actually disinterested from our personal, contingent concerns, it would follow that our perception will not necessarily elicit an affective response (any more than a cognitive or moral one), and that this absence, as we have established, is what makes the attention aesthetic in the first place.

Perhaps it can be argued, however, that there is a difference between a personal, contingent (interested) response and a disinterested one, as when I cry during a sad song not because of some personal associations but because the music has the property of sadness that elicits that reaction in me. If the song makes me sad because it reminds me of a lost love, then I am not attending to it with disinterest. But if, on its own, the song evokes sadness in me, we could say that my affective response is coincident with my aesthetic attention to the

music. The problem here is in maintaining that the connection is *necessary*. As I had noted earlier, if we construe pleasure (and pain) as only contingently connected to the aesthetic, we could build a theory of aesthetic experience without these obstacles. It seems right to me to say that we can listen to a song with aesthetic attention, even agree that it is sad music, but not feel sad ourselves. We can perceive or use an object without being thereby affectively influenced by it. To say that an aesthetic experience of that sad music will necessarily evoke or give rise to sadness in all of its listeners at the time of hearing it seems both false and impossible to prove. And to say that I cannot even *perceive* this property without having a specific emotional response is to hypothesize some unusual form of aesthetic blindness: Is it a defect in the rods and cones of the eye? In the cochlea of the ear? Or, as we will see, a lack of sensitivity or some empathetic capacity that leaves me cold to the emotive effects of an object, and hence incapable of having a bona fide aesthetic experience of it. John Hospers has noted that '[w]hat a person feels and what qualities he attributes [to, in this case, music] are two different things'. Hospers calls the sadness of music a 'phenomenally objective' quality, while a person's sadness when hearing it is 'phenomenally subjective, belonging to him and not to the music'. Hospers argues, and I agree, that '[t]here is no reason why the two phenomena should even accompany each other'. Just as we can recognize grief without grieving (while reading the obituaries), we can recognize sadness without ourselves feeling that emotion at the time of the experience. Hospers concludes that to say music expresses sadness, or is sad, 'is to say something about a felt quality of the music itself, rather than about how it makes

listeners feel'.[83] To entertain the idea of some kind of sensitivity as being required to experience an aesthetic property is to revert to the interpretation of aesthetic attitude that I had earlier discarded: a disposition, capacity or preparatory frame of mind that puts us in a position to then have a 'correct' aesthetic experience, rather than an account of what goes on when we are actually having one. Or else it is to invoke the idea that feeling is a way of revealing those properties themselves.

As though anticipating Levinson's claims, John McDowell, in a much earlier paper, suggested that the connection between aesthetic experience and pleasure generates a problem that can be articulated in the following question: 'how can a mere *feeling* constitute an experience in which the world reveals itself to us?'[84] His response to this question is of course affirmative, and his sensibility theory is determined to show that values (aesthetic, moral) are akin to secondary qualities in the sense that, as Charles Taylor put it, 'if we were absent, value attributions could get no purchase' on the world.[85] One can agree with this but still disagree that feeling the emotion at the time is our only mode of access to the value (rather than, say, making a judgement, which is what I will maintain). McDowell makes an interesting and ambiguous comment: some properties 'are not conceivable independently of sentient responses to them'[86];

---

[83]John Hospers, 'Art as Expression', in *Aesthetics*, eds. Susan Feagin and Patrick Maynard (New York, NY: Oxford University Press, 1997), 173.
[84]John McDowell, 'Aesthetic Value, Objectivity, and the Fabric of the World', in *Pleasure, Preference and Value*, ed. Eva Schaper (Cambridge: Cambridge University Press, 1983), 16.
[85]Charles Taylor, 'McDowell on Value and Knowledge', *The Philosophical Quarterly* 50, no. 199 (2000): 243.
[86]McDowell, 'Aesthetic Value', 5.

again, that these values are not 'adequately conceivable except ... in terms of dispositions to give rise to subjective states'.[87] His example is that of amusingness, which he argues cannot be constructed 'detached from the idea of the responses that constitute finding something amusing'.[88] I would argue that, while McDowell might be correct that amusingness cannot perhaps be *conceived* or *explained* absent reference to the *idea* of our being amused, it can be *experienced* or *perceived* without an individual feeling the corresponding emotion. I can see that a joke or a *New Yorker* cartoon is amusing without feeling amused at the time of viewing, even though I perhaps cannot have a conception of the amusing without knowing what it means to be amused. But the 'sentient response' need not be mine, at the time, and need not be interpreted as a capacity or sensitivity that allows me to 'correctly' have an aesthetic experience. Being amused is a sentient human trait, and so if we were 'absent', it could indeed 'get no purchase'. But it is another thing altogether to argue that we need to feel it to recognize it. Read this way, the affective requirement is much weaker than Levinson demands.

Kris Goffin, in a recent paper, would disagree. Goffin makes a distinction between 'savouring' beauty and 'judging' beauty where the former is an experiential attribution of an object's features and the latter is a judgement that results in a belief (a non-experiential state). For Goffin, certain features of objects ('aesthetic properties') are best understood as being affectively experienced, indeed, necessarily so.[89]

---

[87]John McDowell, *Mind, Value, and Reality* (Cambridge, MA Harvard University Press, 1998), 136, quoted in Taylor, 'McDowell on Value and Knowledge', 243.
[88]McDowell, 'Aesthetic Value', 5.
[89]Goffin, 'The Affective Experience of Aesthetic Properties', 286.

This would include the amusingness of cartoons, the sadness of a piece of music or the gracefulness of a dancer's pirouette. Affective experience is a 'consciously experienced affective representation'[90] and not mere feelings, on the one hand, or an emotive response to an experience, on the other. Affective experience is an 'experiential attribution' of certain features over others. And this seems to bolster Levinson's idea that some aesthetic properties cannot be perceived at all without an affective dimension (this can be positive or negative for Goffin).

Read more closely, however, affective experience actually combines an 'objective representation' of an object's features (such as red, or 'drinkable' [potable] for water) with what Goffin calls a 'perspectival state', both of which are jointly necessary for the aesthetic experience of certain of an object's features.[91] A perspectival state refers to the subject: it 'does not have to be a desire; it can be a goal, a preference, a disposition, a norm, a value ... [It is] concerned with what is significant or valuable' for the individual.[92] It is, in other words, an interest, and thus Goffin's claim is that some of an object's features cannot be experienced in a disinterested manner at all. While perspectival states 'are not to be reduced to desires or mere preferences', they are nevertheless subjective, or involve a 'personal association':[93] they are not, for instance, the general values of a community of which we may not be consciously aware. That is, the perspectival state does not imply merely the sorts of contributing social or cultural factors

---

[90] Ibid., 289.
[91] Ibid., 289–90.
[92] Ibid., 290.
[93] Ibid., 292, 290.

that can structure the perception of an intentional object, as with the knife, above, nor the sorts of localized circumstances that, for Ziff, can impede or aid an aesthetic experience: instead, Goffin claims that we cannot experience (represent) for example water *as* refreshing unless we are, personally, at the moment, thirsty.

'Refreshing' is an experiential property – unlike 'drinkable' it cannot be learnt second-hand or through testimony. It is also 'not just the representation of its "drinkability" combined with the representation of its "desirability"' but instead the two are 'linked' through the (in this case positive) 'affective experience we undergo'[94] and only through which we have access to the relevant property. This claim is stronger even than Levinson's, for the affective element is not a response to our perception but constitutive of that perception, first; and second, Goffin seems to deny that certain features can be perceived without it, which renders a large part of aesthetic experience purely subjective and also problematizes the idea that aesthetic experiences can be shared, or even clearly communicated (our 'perspectival states' would need to be the same, for us to each find water refreshing). Goffin also refers to the perspectival state as a form of 'aesthetic sensitivity',[95] which implies an element of correctness or preparation required before the aesthetic experience can be 'undergone' and, once achieved, characterizes that experience as passive even while informed by, or framed by, personal dispositions. But being thirsty does not seem to me to make me more sensitive but less: almost any liquid would probably seem refreshing to the parched; and indeed slaking one's thirst is an instrumental, rather than an aesthetic, act. The notion of aesthetic

---

[94]Ibid., 290.
[95]Ibid., 292.

attention that I am considering here is precisely the *lack* of such an advanced primer that a perspectival state, disposition, interest or preparatory attitude would require: in an aesthetic experience we attend to the object itself, without prior expectation or instrumental purpose (like wanting to be amused or refreshed).

Further, Goffin on the one hand characterizes affective experience as an 'evaluative mental representation' and on the other seeks to distinguish it from judgement itself.[96] Yet it is hard to see how a representation or an experience can be evaluative without at least, in part, involving an evaluation, which elides a minimalist account with a more complex or robust one. I am sympathetic to Goffin's intuition that we do not 'see' gracefulness, refreshingness and so on in the same (apparently) straightforward manner in which we see redness or squareness but I do not think that combining perception with both perspective and evaluation into one action is any more informative than merely claiming an analytic link between properties and affective responses, or claiming that pleasure itself is our mode of access to some features of the world, as though it were a sensory faculty of its own.[97] In the following chapters, I will claim that it is straightforwardly an evaluation itself that leads us to determine an object's property of grace, for instance, and that this is not a matter of our initial contact with the object, nor a way of experiencing it, whether disinterestedly or not, but rather a subsequent action we perform in some cases but not all.

---

[96] Ibid., 290.
[97] Even were one to argue that pleasure is a sensory faculty, this would not make that faculty aesthetic without the kind of 'treatise on pleasure' that Sparshott found so problematic.

If we encounter an object without expectation (or prior disposition) but with disinterest, our responses to that object can vary widely between pleasure, pain, offense or, importantly, without affect at all. Yet even a softer reading of Levinson would suggest that although the perception is initially disinterested, it is not fully an aesthetic experience without an affective *response*. McDowell's comment shows a way to circumvent this claim, as he has been interpreted by C. Thi Nguyen. As I had noted, McDowell claims that some properties are not 'conceivable' independently of a 'sentient' (affective) response to them but this does not mean that they cannot be experienced individually, at the time, without those affects, only that our (philosophical) understanding of, for instance, amusingness involves the idea of what it would be like to be amused for someone, even if we are not, provided that we share the very human openness to being amused. In contrast to Goffin, we may need to know thirst and its quenching to understand the notion of 'refreshing' but we need not be personally thirsty at the moment to be able to pick this out as a feature that is the object of our disinterested attention.

Nguyen, like Goffin and Hospers, makes a distinction between a subjective and objective component in the aesthetic which, in his reading of McDowell, he describes as the difference between an object's 'inspiring' a feeling and its 'meriting' that feeling: 'I can speak of the object's meriting being found graceful even if I do not personally find it graceful.'[98] Given a certain socio-cultural situatedness, I may know or 'see' that *New Yorker* cartoons are meant to be, or should be, amusing, or that they merit my being amused. But whether or

---

[98]Nguyen, 'The Uses of Aesthetic Testimony', 31.

not I actually *am* amused is, first, not a constitutive element of my initial aesthetic attention to them, nor, second, is it a necessary factor in my having experienced them as being (meritoriously) amusing. One need not explain my not being amused in terms of a failure on my part (lack of sensitivity, a bad mood), or a circumstantial impediment (being ravaged by sharks while reading): one could give any explanation (the joke is not to my taste) or none at all and still preserve the idea that my initial encounter with the object is one of disinterested attention, regardless of what the subsequent response to that attention might be. Nguyen's argument can counter Levinson's suggestion that it is impossible to perceive certain properties without an affective response.[99] Indeed, returning to the breadth of features Antonia Peacocke listed as those to which we might attend, we could simply claim that 'amusing', 'refreshing' and so on are *relational* properties of objects, and in so doing capture the sociocultural constraints on attention without needing to render those purely subjective or concomitantly affective.[100]

Nguyen's goal was to find a way between optimists and pessimists about aesthetic testimony and the need for acquaintance; in this regard he writes of our 'knowledge' of an object's beauty or grace rather than

---

[99]Note that this does not make any commitment about the truth or 'reality' of a given property, or indeed of any kind of metaphysical position. McDowell's distinction between primary and secondary qualities or properties is not without controversy but I will side-step it here. One could object that, without being thirsty, a drink can at best *seem* refreshing but we don't know that it is. The reply to that is that the minimalist account is not a cognitive theory, and is uninterested in truth or knowledge but merely in an attentive activity of the perception of phenomena as they appear. And a drink can indeed appear to be refreshing whether we are thirsty or not. The advertising industry banks on this.

[100]Of course, in this sense, redness would also be a relational property, related, as it is, to the rods and cones in the human eye as opposed to that of other animals. This speaks to the primary/secondary quality distinction noted above.

our experience of it. And in this, he is writing of aesthetic judgement and value, further elements of a robust account of aesthetic experience that I will turn to in the following chapters. For the moment, though, we can see that his suggestion has application to the present argument. We can say of a piece of music that it is sad (and know what we mean) without thereby being personally saddened by it, and do so with disinterested attention (we may hear notes and harmonies that sound sad).[101] Aesthetic experience, as I have noted, is objective in two ways: that we are disinterested or impartial, and that the experience is about the object rather than about us. This is the 'objective' aspect in both Goffin's and Nguyen's accounts, and the phenomenally objective aspect Hospers refers to. What is subjective is not that I personally feel a certain way but merely that the experience is *mine*. My point here is that the subjective aspect as they understand it – as interest, disposition, perspective, inspiration, feeling and so on – is contingent to that core experience rather than one of its constitutive parts. We can experience sad music without feeling sad; we can further claim that the music is sad without being able to explain *why* it is so, or what musical properties contribute to our identifying it as such. We need not be able to pick out Levinson's 'low-level' perceptual features of the music *and* the way that its sadness supervenes upon them in order to have an aesthetic experience of that music. We need to make a distinction between how we experience an object and how we – separately – conceive of or explain that object (or that experience).

---

[101]Hospers suggests that sad music '*embodies* sadness as a property' when it exhibits qualities that are similar to the way sad people behave: the work 'may be said to have a specific feeling property when it has features that human beings have when they feel the same' ('Art as Expression', 174).

The latter – the explanation – is a cognitive and philosophical act rather than an aesthetic one, and would thus perforce also be interested. There is nothing in Beardsley's or Levinson's or Goffin's accounts that demonstrate an affective response constitutes – or even necessarily contributes to – our particularly aesthetic attention when we perceive an object with disinterest. What is further subjective in experience is our felt reaction to the encounter, and Nguyen helps us to see that this reaction – at the moment, by the individual – need not be affective for the features to be perceived and represented. Absent this affective condition, Levinson's account of aesthetic experience can be reduced once again to disinterested attention, or what he calls 'aesthetic perception' without needing any further element to qualify it.

Again, this is not to say that a disinterested attitude must be cold, or aloof, or that aesthetic experiences are not – or are never – accompanied by emotional responses. Of course we take pleasure in the beauty of a sunset, just as we are moved by music, and disturbed by some provocative works of art. As Wiseman notes, '[c]learly not all aesthetic experiences please. Some cause disgust, others horror, others any of a whole range of human responses',[102] including, I would suggest, the absence of any emotional response at all. To tie the emotional response so strongly to the experience itself denies the great variability and breadth of what those responses could be, both between encounters and between individuals. It instead demands that to perceive a certain property we must do so affectively, and that all of us do so in a particular, and identical, way.

---

[102] Wiseman, 'Damask Napkins', 141.

Aesthetic experience as a kind of attention is, as I have noted, not a disposition that we can voluntarily adopt or control; perception, as Sparshott notes, is an 'achievement' word, whereas attitude is not: 'no one uses "aesthetic perception" for a scrutiny that fails to discern its target'[103] – no one, that is, except perhaps Goffin. Attention and perception are just that – we do not fail to experience when we are experiencing. When the conditions do not obtain, or our interests are in the forefront, we simply do not have *aesthetic* encounters with the objects but this does not constitute a failure that can be fully corrected by conscious effort, or cultural training, any more than we can control when we see an animal *and* seemingly automatically note that it is a squirrel rather than a cat. If our perceptual and epistemological encounters with the world are not essentially affective or self-consciously controlled, neither are our aesthetic encounters, and this does not thereby diminish them or make room for a notion of failure in the sense of failing to achieve something we set out to do, as, in the way that I am using the term, aesthetic experience need not be something we intentionally do at all.

Let me sum up this discussion. As I stated at the beginning of this chapter, I would do two things simultaneously: provide the descriptive components for an experience to count as characteristically aesthetic, but demonstrate that they can do so without a reliance on pleasure or affect as one of those elements. As to the first, I have argued that disinterested attention can be seen as the core element of a minimalist aesthetic experience, and that it passes the Sparshott Test. As to the second, my argument has been a negative or deflationary one: none of

---

[103]Sparshott, *Theory of the Arts*, 476.

the accounts I have thus far canvassed give us any compelling reasons to believe that an aesthetic attitude need be accompanied by a positive hedonic response, nor indeed that feelings of any kind are essential to aesthetic experiences, even though they may be contingently coincident with a great many of them. This may seem to be splitting hairs: Can we not say that we have an aesthetic experience of a landscape *and* that we enjoy it? We *can* say this, and we often do. But for the variety of philosophical reasons that I have outlined, we *need not* say this, and we need not exclude from the realm of the aesthetic those experiences that fail to bring us pleasure, or that do not move us emotionally. To do otherwise is not just to run into the paradox of negative emotion but to exclude a great many of our encounters with the world from being aesthetic at all.

The minimalist account of aesthetic experience that I have explored here is tied to our perception of the sensory qualities of a phenomenon (both broadly construed), and as such is grounded in the activity of the subject as she engages with the world around her. It does not divide perception itself into different types or kinds as the notion of aesthetic pleasure sought to do, nor does it divide the features of the object into those which can be perceived objectively (with disinterest) and those that must be affectively represented. Instead, it qualifies this perception by a set of negative constraints – a *lack* of strict moral, practical, economic, personal or epistemological interest. It characterizes aesthetic attention as perception 'in spades' which pays tribute to the etymological roots of the Greek notion of *aisthesis*. Without beginning with this attention, this perceptual encounter, there would be no aesthetic theory at all, and this is one

reason that the notion of disinterest is such a strong theme running through the history of modern aesthetics.

I have suggested that this is necessary for aesthetic experience but it is also sufficient on a minimalist account: one of the ways that we engage with our surroundings is to provide them with our unmediated attention, or to have them demand that attention from us. In doing so, the phenomena are not substantively changed by us but revealed, as they are in their own particularity: if they are changed at all, it is to become aesthetic objects, however fleetingly. What we make of this experience, whether we value it, whether it moves us, or enlightens us, or enriches or diminishes us, are separate questions that I have suggested are largely extra-aesthetic and that imply some instrumental values that the aesthetic might have for us. But why and whether we should have aesthetic experiences is beyond the scope of this project. At minimum, paying this kind of attention does not accord objects with a specific value – it does not make them beautiful, for instance. Nor does it substantively alter us either – it does not make us smarter, kinder, better, more sensitive, more tasteful. This is not to suggest that aesthetic experience cannot be transformative, just that in this primary encounter it need not be: we can give something our attention for a moment – or something can intrude upon us and demand that attention – and then we can simply walk on.

One can ask why we should be motivated to seek out this kind of encounter, as the paradox of negative emotion has been wont to do. I have tried here to show that this is the wrong question: we need not seek it out, we may not have control over it, and we cannot prepare for it: it is merely one of the variety of ways that we all engage with

the world.[104] Nevertheless, this is a minimalist account for a reason: we often do aesthetically engage with the world in more complex ways than mere attention can adequately describe, and the relation between subject and object can become more complex as a result. Aesthetic attention might be the core of aesthetic experience, but we also react to these encounters, respond to these objects, and here two further '*aesthetic x's*', of judgement and value, are needed to fill out the initial sketch as I have presented it.

---

[104] The dissolution of the paradox of negative emotion opens up the field of potential reasons *why* we might confront troubling works of art and also *what* we might gain in the viewing of them. That is, we might not go prepared to an exhibit (the 'why') with any particular motive in mind, or we might go in order to be enlightened about, for instance, the history of Dorset sculpture. The experience is aesthetic if and when we take the works on their own terms, or in themselves. Similarly, 'what' we take from that experience is equally open: we might find cognitive, moral or instrumental value in the experience. These effects, I claim, are extra-aesthetic: a weakness in responses to the paradox of negative emotion is to suppose that they are part of the aesthetic experience itself.

# 3
# Aesthetic Judgement

It is not surprising that many theorists locate the aesthetic within the act of judgement, for it is here that ascriptions of beauty and ugliness, gracefulness and clumsiness arise, and we enter terrain that is familiar to the more common understanding of the notion of the 'aesthetic'.[1] My identification of the aesthetic as initially coincident with a prior act of attention is meant to serve a couple of purposes. First, it provides us with an aesthetic object that is the proper focus of a subsequent evaluation. Only when we consider the object absent any relation to our own purposes 'formulated without regard to the object itself', as Sparshott put it, can we be clear that the target of our evaluation *is* that object, as it appears in its own particularity, and that our judgement will hit its mark. Assessing tapestries as a means to cover a hole in the wall, or to keep out a draft, will render any value they have as *relative to* some pre-determined purpose that is more about our own intentions or needs than it is about the actual tapestry, just as using those mountains as directional indicators really has little to do with the mountains themselves. The notion of an

---

[1] I have also in the past located the aesthetic in a form of judgement. See Forsey, *The Aesthetics of Design*, Ch. III.

object 'in itself' as the focus of aesthetic evaluation is often implicit in discussions of judgement, as being about aesthetic objects, without the provision of a necessary explanation of what an aesthetic object is, or of how it comes about. Conflations between various *'aesthetic x's'* are as prevalent here as anywhere else in the discipline. In one sense, then, the previous chapter was preparatory for a consideration of judgement, and its related notion, aesthetic value; these quickly become enormously complex and intertwined, and my (artificial) separation of them is for purposes of clarity of exposition only. At the very least, a clear sense of their target and how it arises will provide a foundation for the following chapters.

The second reason for an initial minimalist account of aesthetic experience is to highlight the contingent nature of aesthetic judgement: we do not invariably render a judgement upon that to which we attend but we cannot make an aesthetic judgement without having first – and already – paid that attention else there would be nothing to judge. As with the washing machines that began this account, in some cases we can experience an object with disinterest, take in its features and do so without then – or thereby – also evaluating it or making a judgement about what we have encountered. And a lack of evaluation does not render that encounter un-aesthetic or non-aesthetic, or *mere* perception because, as disinterested, it is already a (pre-evaluative) aesthetic act of its own. What the addition of judgement to the minimalist account provides is a further form of engagement with the world, one that responds to the object in a specific way, and that deepens the initial experience as it entangles the subject and object more intimately.

These preliminary remarks help to indicate the line of argument in this chapter and the next. In response to the questions of the Sparshott Test, I will maintain (i) that aesthetic judgements are recognizable phenomena, or an *'aesthetic x'* that distinguishes them from, for example, cognitive or moral judgements; (ii) that aesthetic judgements are not invariably tied to aesthetic experience – their occurrence is not necessary but contingent; and (iii) in answer to Sparshott's last question, that aesthetic judgements make the phenomena aesthetic, not merely making them aesthetic objects, as accomplished through disinterested attention, but more specifically claiming objects to be beautiful, ugly and the like. The extension of an aesthetic judgement is aesthetic *value* which is ascribed in/arises from the act of judging, and which I will take up in Chapter 4. Finally, (iv) I will argue that pleasure need not factor into, nor arise from, the act of judging aesthetically. To begin, it will be helpful to canvass some attempts to describe this evaluative act.

## Aesthetic Judgement

'The phrase "aesthetic judgement"', Sparshott notes, 'was virtually patented by Kant'; anyone using this particular *'aesthetic x'* 'may be taken as announcing' that they are 'inserting' themselves 'into the philosophical heritage of the *Critique of Judgement*.'[2] This remains as true today as when Sparshott made the comment nearly thirty years ago. Kantians, neo-Kantians, quasi-Kantians and the like share

---

[2]Sparshott, *Theory of the Arts*, 482.

in making judgement central to their aesthetic theory, and describe this judgement in somewhat similar ways. Gorodeisky and Marcus, to take a recent example, claim that aesthetic judgements, while sharing the same 'normative-explanatory nexus' that is broadly indicative of rationality, are nevertheless 'categorically' distinct from other kinds of rational judgements, making the aesthetic domain an 'irreducible' one.[3] Eva Schaper claims that aesthetic judgements take a particular form that 'must exhibit the logical difference of aesthetic judgements from moral, epistemological, economic, social and generally pragmatic judgements and thus confirm ... the autonomy of aesthetics'.[4] Kant himself claimed that although aesthetic judgements employ our cognitive faculties, those faculties are in 'free play' in judgements of taste, making them merely 'reflective' on the appearance of an object, rather than determinative of the way things really are, or a form of cognition. Lopes defines them like this: 'a state is an aesthetic evaluation = the state is a mental representation of some item as having aesthetic value'.[5] While for Lopes, this is not a circular claim but is intended 'to signal that the aesthetic question remains open',[6] it is nevertheless uninformative. First, of course, it is unhelpful for an account that precisely seeks to *not* 'punt' on the aesthetic question, although it is a reminder of a fine line that needs to be taken: while an adequate account of judgement cannot be circular, as per the Sparshott Test, neither, Lopes notes, should it reduce the aesthetic to some non-aesthetic phenomenon if it is to be a unique

---

[3] Keren Gorodeisky and Eric Marcus, 'Aesthetic Rationality', *The Journal of Philosophy* 115, no. 3 (2018): 114.
[4] Schaper, 'The Pleasures of Taste', 39.
[5] Lopes, *Being for Beauty*, 34.
[6] Ibid., 49.

'*aesthetic x*' of its own.[7] Second, though, an aesthetic judgement seems to involve more than a 'state' of 'mental representation', as these include all perceptions, imaginings as well as cognitive beliefs. Mental representation can too easily imply the idea of a state of mere passive reception of data as experienced rather than an action performed. In this regard, I am sympathetic to Nick Zangwill's formulation, who calls aesthetic judgements 'verdictive'[8] to highlight both their active and evaluative aspects: we render a verdict upon an object due to an assessment we make, and that verdict is normative if it results in a valuation rather than a belief or a cognition per se. Verdicts need not be final or binding: they can be provisional and tentative. They also need not be reducible to statements or verbal communications. Lopes writes that we are often unable to verbalize our evaluations: 'many grope for words even as they are in a state that vividly represents the very feature in question'.[9] And Zangwill notes that 'we do not always voice aesthetic judgements out loud; we often just *think* them … Whatever we say about the *word* "beauty", what is important is that there is a *mental act* of making a pure judgement of aesthetic value or merit'.[10] Verdicts need not be verbal but they must be communicable in principle, to allow for discussion, agreement and disagreement about aesthetic matters. As being intentional acts, or about the world, judgements retain an element of objectivity. They are also responses

---

[7]Ibid.
[8]Zangwill, 'The Beautiful, the Dainty and the Dumpy', 317.
[9]Lopes, *Being for Beauty*, 34.
[10]Zangwill, 'The Beautiful, the Dainty and the Dumpy', 318–19.

to the objects we experience, and are attendant upon the initial encounters we have.[11]

D. W. Prall claims that aesthetic judgement can be distinguished from that initial attentive experience 'by the simple fact that it follows and records such experience after the experience has been had and with reference to what was experienced'; it makes this record 'explicit' and communicable.[12] (And Prall, more poetically than I, describes aesthetic experience as 'a transaction in the flux of nature'; 'the experience of the surface of our world directly apprehended' by 'casual truant glances at our surroundings' that are 'the antithesis of practical activity, moral or economic'.)[13] But Prall suggests that judgements are rendered after an experience has passed, while I suggest that they remain part of the aesthetic experience itself; more than a record, they are an aesthetic act but an evaluative one. For Gorodeisky and Marcus, the normative-explanatory nexus frames judgement as one that gives reasons why one *does* value, appreciate (and so on) an object, and, prescriptively, why one *should* do so. For them, aesthetic judgements are reducible 'neither to a judgement about what to believe, nor to a judgement about what to do' but contain elements of both.[14] Schaper highlights the explanatory element when she claims that aesthetic judgements are neither capricious nor idiosyncratic: 'reason-giving is a legitimate move in the game'.[15] She

---

[11] A question that I will leave open (or will defer to philosophers of mind) is whether aesthetic judgements are occurrent or enduring states of mind. I am interested in their modal status when and if they are made, rather than in their duration as commitments after that occurrence.
[12] D. W. Prall, *Aesthetic Judgement* (New York, NY: Thomas Crowell Company, 1967), 5.
[13] Ibid., 10, 20, 31, 10.
[14] Gorodeisky and Marcus, 'Aesthetic Rationality', 114, 116.
[15] Schaper, 'The Pleasures of Taste', 44.

characterizes them as on a continuum, sharing a similar structure to both culinary and moral judgements (the former being subjective and the latter more objective) and states that they are 'rational in a way that culinary ones are not' for which 'there are no reasons ... which could possibly support them'.[16] A culinary judgement (as indicative of a kind) is one about which she claims there can be no debate, about which one cannot be wrong, and for which one cannot and need not give reasons. To say that cherries are delicious is to express a mere subjective response to an object, one that says something about the subject – she likes cherries – rather than about the object, and thus one that is almost entirely self-referential. What the subject really means is that 'cherries are delicious to me'. This can lead to an invitation – 'try them, they're delicious' – but it would be odd to suggest that someone ought to find them delicious, just as it would be odd to imagine a reasoned debate about whether they in fact really are. For Schaper, aesthetic judgements also differ from moral judgements, in that, while both can demand reasons for one's position, moral judgements have more prescriptive force – that one *ought to* concur with them and act accordingly – and demand consistency, in that they may be in conflict or give rise to a contradiction. (If I claim that suicide is wrong but support euthanasia, I can, first, be required to give reasons for, or justify, my position; second I can be accused of inconsistency (if not hypocrisy) and my position must be defended (and can be revised, or even abandoned, in the face of stronger opposing reasons).) Moral judgements, especially for Kant, are considered to be categorical: final, or absolute, and are also often based on a priori principles of, for

---

[16]Ibid., 44, 43.

instance, the nature of the good or the right, that can be appealed to in individual cases, and that determine specific decisions. For Schaper, aesthetic judgements are also in part objective, and outwardly directed, but they are 'never strictly inconsistent with one another', even while they are 'yet justifiable by reasons'.[17] With the aesthetic, any reasons given are post-facto: for the Kantian line there are no a priori principles to guide us, and to which individual judgements must adhere, and different judgements do not lead to contradictions that must be resolved.

Gorodeisky and Marcus, as well as Schaper, place the normativity of aesthetic judgements in a certain muted prescriptivity; they are exhortations to others, suggestions that an object ought to be viewed in the same way. 'Aesthetic judgement is not a private, subjective feeling of pleasure, but … a feeling merited by the object' where the reasons we give 'explain why we in fact judge the object to be beautiful … and also why one ought to so judge it'.[18] In this they follow Kant's claim that a judgement of taste 'does not itself postulate the accord of everyone' (as a cognitive judgement would do) – 'it only ascribes this agreement to everyone' where the confirmation of the judgement comes not from concepts or facts 'but only from the consent of others'[19] in the context of reasoned debate. The normative force of aesthetic judgements lies in part in the demand that others judge

---

[17]Ibid., 43.
[18]Gorodeisky and Marcus, 'Aesthetic Rationality', 115, 117.
[19]Kant, *Critique of the Power of Judgement*, AK 5: 216.

the object as we do, or if they do not, that disagreement is possible and reasons can in principle be given.[20]

This provides the structural or formal characteristics that can distinguish aesthetic judgements: they are normative acts that are prescriptive rather than wholly descriptive, and while they may involve what Lopes calls a 'belief-like' state,[21] they do not themselves result in determinate beliefs about the world. Another way to describe them is to refer again to the relation between subject and object and see that here it is closer, or more pronounced, in the aesthetic realm; aesthetic judgements require direct experience of the object, and while they are *about* the object, the subject is equally implicated in the making of them. As James Shelley puts it,

> when you say 'O is beautiful' you stake yourself in a way you do not when you say 'O is supposed to be beautiful' ... there is a difference in the kind of commitment you make to O's being

---

[20] Some recent work on aesthetic discourse highlights engagement instead of agreement or a convergence of opinion or values. C. Thi Nguyen, for instance, writes that '[w]e do not actually care about just having correct judgements about art. We care about being plunged into the process of aesthetic engagement' ('The Engagement Account of Aesthetic Value', *Journal of Aesthetics and Art Criticism* 81, no. 1 (2023): 92). And see his 'Autonomy and Aesthetic Engagement', *Mind* 129, no. 516 (2020): 1127–56. Nick Riggle argues that 'the end of aesthetic discourse is not convergence but a distinctive form of community, a kind of harmony of individuality [which he calls "vibing"]' ('Convergence, Community and Force in Aesthetic Discourse', *Ergo* 8, no. 47 (2021): 615, 641). While focused more on socially embedded discourse, neither Nguyen nor Riggle deny that the original aesthetic judgement is made by the individual. The analysis of judgement I advance here is thus compatible with a broader conception of post-judgement discourse. See also Nat Hansen and Zed Adams, 'The Hope of Agreement: Against Vibing Accounts of Aesthetic Judgement', *Mind* 133, no. 531 (2024): 742–60, who argue that the Kantian subjective universality of judgements of taste and their concomitant hope for the agreement of others can counter the versions of convergence that Riggle and Nguyen criticize, where convergence presupposes 'a unique normative standard' for Riggle in particular ('Convergence', 642), which my account denies.
[21] Lopes, *Being for Beauty*, 34.

beautiful in each case, a difference underwritten by the difference in the way you risk yourself in one case but not in the other.[22]

That risk does not play out the same way in the moral realm, where there are often larger principles to which one can defer. When making an aesthetic judgement one is not merely reporting a subjective experience or preference, nor stating some fact about an objective world, as in the case of cognition: one is making a kind of commitment, or taking a stand, in a way that makes these judgements unique, and that carries with it a demand, or challenge to others. As Prall notes, aesthetic judgement requires our engagement: 'whether the rug is beautiful or ugly, whether the gardens or the buildings are fine to look at, we can only tell by looking ourselves'.[23] Gorodeisky and Marcus claim that aesthetic judgement is thus both object-directed and subject-directed equally; '[t]he logical form of appreciation is simple, not conjunctive'.[24]

Schaper, following Kant, suggests that one who echoes another's judgement is making a mere 'prudential assessment' where 'what the person actually prefers is irrelevant to his pronouncements'.[25] She stresses that '[t]he formal turn here is again to the *kind* of judgement it is'[26]; Kant's more technical term for this is to describe judgements of taste as having the form of 'subjective universality', or 'subjectively universal validity ... which does not rest on any concept'. Judgements of taste are 'singular judgements' where we must immediately hold the

---

[22]Shelley, 'Beyond Hedonism', 267.
[23]Prall, *Aesthetic Judgement*, 16–17.
[24]Gorodeisky and Marcus, 'Aesthetic Rationality', 119.
[25]Schaper, 'Pleasures of Taste', 49.
[26]Ibid.

object up to our own experience: 'by means of a judgement of taste I declare that the rose I am gazing at is beautiful', whereas to claim that 'roses in general are beautiful is no longer pronounced merely as an aesthetic judgement' but is a 'logical' judgement in Kant's terms, or a straightforwardly cognitive one.[27] And Shelley describes aesthetic judgement as being in this sense importantly non-inferential: 'we non-inferentially judge a thing to be beautiful in virtue of experiencing it to have features in virtue of which it is beautiful in some particular way that it is'.[28]

A comparison with cognitive judgements may heighten the formal contrast here. As non-inferential, aesthetic judgements are immediate, in the sense of unmediated, and require direct first-hand experience. The judgement follows from, or responds to, the initial aesthetic encounter we have had, and would not be possible without it, while empirical cognitive judgements about the world are all (or almost all) made on the basis of inferences where we can claim to know, for instance, that Moscow is in Russia without ever having been there. Whether the initial encounter is described as a prior, separate act, as the minimalist account does, or as rolled into the concept of judgement itself, as it seems to be for both Kant and Schaper, all in the Kantian line hive these judgements off from cognitive and other kinds of judgement in part because of the demand for first-person acquaintance with the phenomena. (While culinary judgements also require personal experiences of taste, moral judgements do not: I need not experience or witness murder in order to claim that it is wrong.)

---

[27]Kant, *Critique of the Power of Judgement*, AK 5: 215.
[28]Shelley, 'Beyond Hedonism', 267.

As being unmediated, the role of reasons also differs from cognitive judgements. Reasons do not provide, or amount to, evidence or proof that a phenomenon is, for example, beautiful. By unmediated here, I mean unconstrained by a priori concepts or principles that govern cognitive and moral judgements.[29] Gorodeisky and Marcus distinguish aesthetic judgement from aesthetic belief, where the latter is a doxastic attitude towards a proposition that takes it to be true. Using fear as an example, they argue that fear 'presents an object as being a certain way' and does this directly, whereas belief is a 'mediating representation of a state of affairs that might or might not depict reality accurately'.[30] We can be wrong that a thing is dangerous, but we cannot be wrong in the same way when we claim it is scary or fear-inducing. The reasons we may give in response to being questioned about our aesthetic judgements may be in part justificatory but, as Schaper notes, they 'would not amount to a means of assessing the objective validity of individual judgements'.[31] As Kant puts it, '[i]f one judges objects merely in accordance with concepts then all representation of beauty is lost. Thus there can also be no rule in accordance with which someone could be compelled to acknowledge something as beautiful … no one allows himself to be talked into his judgement about that by means of any grounds or fundamental principles.'[32] Kant calls aesthetic judgements 'reflective' as a way of

---

[29]While there is no question that we can 'stake ourselves' in cognitive judgements too, I would suggest that the commitment is of a different order, in that evidence and facts 'have our backs' and proof is more largely possible. We are more vulnerable in our aesthetic judgements precisely because we initially stand alone.
[30]Gorodeisky and Marcus, 'Aesthetic Rationality', 137.
[31]Schaper, 'Pleasures of Taste', 47.
[32]Kant, *Critique of the Power of Judgement*, AK 5: 215–16.

highlighting their responsive nature to phenomena experienced, and to contrast them with the conceptual framework that guides cognitive 'determinate' judgements that, in effect, serve to determine the way the world is. For Schaper, again, aesthetic judgements 'are justifiable by reasons' in that they make claims to correctness and are directed toward objects, but these reasons are not universalizable principles or rules that can be applied to the world, that would serve as proof or evidence of our claims: 'there are no criteria determining true or false judgements of taste'[33] as there are for determining whether an animal or plant is indeed dangerous. Again, the demand of reasons, Schaper acknowledges, are post-facto: our initial response to the object is 'the basic datum. Only afterwards do we start looking for reasons'.[34] And it may be that we cannot give them – there is no articulacy requirement here – and while aesthetic judgements are a form of rationality in their invocation of the use of our rational faculties, this does not mean that we can always supply a rational *explanation* for why we find something to be, for instance, beautiful. Schaper allows that giving reasons 'may modify our responses' in communication with others and even provide for 'the cultivation and education of taste' as those reasons become, perhaps, more detailed and refined.[35] But they need not do so.

The particular structure of aesthetic judgements also militates against certain forms of aesthetic realism that would hold that beauty, and so on, are mind-independent properties or qualities that objects possess quite apart from our interactions with them. Such a strongly

---

[33] Schaper, 'Pleasures of Taste', 43, 46.
[34] Ibid., 44.
[35] Ibid., 44, 47.

realist position faces metaphysical hurdles, in terms of how to characterize these properties, or determine what ontological status they would have, as well as epistemological difficulties in explaining how we would have cognitive access to them, if we cannot see them directly. I will return to this when I take up the notion of aesthetic value, as the extension of aesthetic judgements, or what they are about. For the moment, note that from a realist standpoint, aesthetic judgements would have to be straightforwardly cognitive, which the Kantian line denies, and would not need characterization as having a unique structure or logical form that stresses their normative aspect, and that restricts their justificatory reasons from providing anything like evidence or proof.

For those most indebted to the Kantian account, this sketch should provide a provisional response to Sparshott's first question, showing that aesthetic judgements are indeed a unique '*aesthetic x*'. The inclusion of the notion of judgement in a theory of aesthetic experience moves beyond the minimalist account described in Chapter 2 but does not leave it behind: while we can pay aesthetic attention to some phenomenon and then simply walk away, we quite often react to it, evaluate it, make a claim about it and stake ourselves in the process of doing so. I can look at a tree or use a bicycle with disinterest and pay attention to its various properties without venturing any further. But quite frequently, I do so venture – I claim that the tree is graceful or gnarly or squat – and in doing so I am clearly judging that tree, responding to the object arising from the attention I have paid, and this response is a further commitment, or entanglement, that I have with the world in which I live. Such judgements are aesthetic not only

because they stem from disinterested attention but also because that perceptual, non-cognitive attention leads to their particular logical form. As aesthetic experience in its minimalist guise is unique in being unmediated by prior conceptions and pre-occupations, so too does aesthetic judgement exhibit a unique form that is not solely explanatory, nor solely prescriptive but that rather steps lightly between the two and shows itself to be incommensurable with other evaluative forms. It too is immediate as an unconstrained reaction to the attention already paid, but one that further employs reason or rational faculties such that it is a more complex evaluative rather than perceptual act. However, the partial sketches provided here tell only one part of the story, for many theorists see pleasure, or a 'sensory-affective'[36] element as equally necessary to distinguish aesthetic judgements as unique kinds, and this element demands consideration.

## Judgement and Pleasure

For Kant himself, pleasure is central to the notion of aesthetic judgement. What he calls 'taste' is 'the faculty for judging an object or a kind of representation through a satisfaction or dissatisfaction' that is not grounded in 'any private conditions' such as personal preferences or interests but that is the result of the free play of universally held cognitive faculties when they do not determine what an object is through concepts but instead 'reflect' on it, or respond to it: '[t]he object of such a satisfaction is called beautiful'.[37] The

---

[36] Gorodeisky and Marcus, 'Aesthetic Rationality', 114.
[37] Kant, *Critique of the Power of Judgement*, AK 5: 211.

judgement, as subjectively universal, must precede the pleasure, else the feeling 'could have only private validity' and not be communicable. Nevertheless, the feeling of the free play of the faculties is itself one of pleasure – the reflective judgement 'is the ground of this pleasure in the harmony of the faculties' and beauty 'is nothing by itself, without relation to the feeling of the subject'.[38] Judgements of taste proper are affective but also importantly disinterested, for Kant, and I will return to disinterest below.

Schaper follows the Kantian line most closely when she claims that it is 'axiomatic' that a theory of aesthetic judgement be concerned with 'a subject's experience of something or other and the consequent pleasure' this experience engenders.[39] She, like Kant, seeks to capture both the subjective and objective aspects of aesthetic judgement: '[o]n the one hand we believe that taste is bound up with the immediacy of feeling ... [and on] the other hand we believe that ... taste judgements are reasoned appraisals'.[40] Any reason a subject provides for a particular judgement 'must justify *his* feelings and not what, perhaps, he *thinks* he ought to feel'[41] to make that judgement his own, or part of a unique and individual aesthetic experience. Prall echoes this, when he states that 'we never make the direct judgement that this or that was beautiful, with regard to what we ourselves have seen, unless what we judged about satisfied or pleased or charmed or attracted us'.[42] And Gorodeisky and Marcus state that '[w]e hold that "O is

---

[38]Ibid., AK 5: 217–18.
[39]Schaper, 'Pleasures of Taste', 40.
[40]Ibid.
[41]Ibid., 42.
[42]Prall, *Aesthetic Judgement*, 16.

beautiful" expresses an aesthetic judgement only when it expresses a distinctive kind of pleasure.'[43]

It is not enough that verdictive appraisals have a particular logical structure: they must involve a feeling to make them uniquely aesthetic. The question is whether this feeling is *necessary* to an account of aesthetic judgement, and I will argue that it is not. First, however, note that the Kantian line does not need to describe pleasure as of a particular kind: it is enough that, whatever its phenomenology, it emerges from and depends upon the making of a judgement. Second, note that the descriptions of this feeling are largely couched in terms of pleasure or satisfaction, or a positive affect of some kind. If the harmony of free play is necessarily pleasurable, these accounts of judgement will have the same difficulties I have already enumerated, of trying to make room for experiences that are negative, or non-pleasurable, never mind those that do not require an affective response at all. Kant scholars have particularly struggled to include the possibility of the ugly in his account because of this strong link to pleasure: the paradox of negative emotion plays out again within the Kantian framework.[44] Kant mentions displeasure only in passing, without further elucidation[45]; for Schaper, it is often parenthetical ('pleasure (or displeasure)');[46] and for Gorodeisky and Marcus, it is

---

[43]Gorodeisky and Marcus, 'Aesthetic Rationality', 22.
[44]A comprehensive overview of works on Kant and the ugly can be found in Johnson, 'Understandings of Ugliness in Kant's Aesthetics', in *On the Ugly: Aesthetic Exchanges*, 47–66. Johnson cites the main players in debates about ugliness, including Mojca Küplen, Henry Allison, Paul Guyer, Paris Panos, Christian Wenzel, Alix Cohen and David Shier, to name a few.
[45]Kant, *Critique of the Power of Judgement*. See AK 20: 232, and AK 5: 189, for instances of this.
[46]Schaper, 'Pleasures of Taste', 50.

relegated to a footnote, as we saw with Levinson earlier ('a negative aesthetic judgement is a feeling of dislike').[47] The inclusion of feeling in the Kantian line is largely restricted to a dichotomy – if not pleasure, then displeasure – with the beautiful and the ugly occupying each pole, and this limits the range and variety of the accompanying affective responses that can be had, if indeed they necessarily must be had.

Why aesthetic judgements must include pleasure or affect is generally unclear. For Schaper it is 'axiomatic' in the way that it was 'analytic' for Beardsley. For Kant, the link between judgement and pleasure is assumed through the larger architectonic. The rational faculties or capacities of 'the soul' can be reduced to three: cognition, which is legislated by the understanding and by which we know the world; desire, legislated by pure reason 'in accordance with the concept of freedom' that gives us our moral objectives; and the feeling of pleasure. '[B]etween the faculty of cognition and that of desire there is the feeling of pleasure, just as the power of judgement is contained between the understanding and reason.'[48] If pleasure legislates our evaluative capacities, aesthetic judgement must perforce have an affective element. For the most part, that affective element is assumed rather than argued for in aesthetic theories that focus on judgement, which makes it difficult to assess. The exception may lie in sensibility theories such as Nguyen's and the work of Gorodeisky and Marcus, for whom pleasure does not legislate or ground the judgement but is merited by it, and hence intimately connected with the evaluative act.

---

[47]Gorodeisky and Marcus, 'Aesthetic Rationality', 119, *fn* 12.
[48]Kant, *Critique of the Power of Judgement*, AK 5: 177–8.

Nguyen proposes that we consider an object as having two distinct properties which are nevertheless intertwined: 'whether something is found beautiful, and whether it merits a beauty-response'. The former is 'the subjective aesthetic property' of beauty, and the latter is 'the objective property of merit'.[49] To 'know' or 'believe' that an object merits a beauty-response is a 'cognitive matter', hence also a matter of inference, or one that can be found through the testimony of others.[50] Such a judgement, then, does not have the particular structure of an aesthetic judgement as described above but would be akin to any other garden-variety cognitive judgement. As to the subjective aesthetic property, Nguyen is less clear. On the one hand, he writes that '[a]n object is graceful if it actually inspires a feeling of gracefulness in me' which is a 'first-personal requirement' that cannot be passed on by testimony.[51] This suggests that gracefulness is directly experienced, as with Goffin's 'affective representation' and hence not the product of a judgement at all. The affective response renders it uniquely aesthetic, but not a unique kind of judgement. On the other hand, Nguyen writes that 'my knowledge or belief that [an object] is graceful is justified only if I both have the feeling and the object truly merits that feeling'[52] which instead suggests that, as giving rise to a belief, the subjective property *is* the product of a judgement, but one that is non-inferential and cognitive at the same time. In these cases but not in others, there would be an affective element to our cognitions, in fact an evidentiary one. And again, presumably this

---

[49]Nguyen, 'The Uses of Aesthetic Testimony', 31.
[50]Ibid.
[51]Ibid.
[52]Ibid.

affective element would make some beliefs aesthetic. But it is difficult to make the case that a feeling can play an evidentiary role, or solve disputes in aesthetic matters; it in fact seems to reduce the aesthetic to Schaper's notion of the culinary, where reasons and justification are not possible. Nguyen seems undecided about whether to characterize the aesthetic in terms of judgement and concomitant feeling, or as two coincident judgements made about two different properties (and does not explain why they must be made together).

Even were Nguyen correct to make a distinction between meriting a response and actually engendering or 'inspiring' that response, which I had noted earlier held some promise, there is as yet no argument to defend the claim that the experience need be affective in any way. This has been taken for granted in his work. How Nguyen characterizes this feeling is further unclear: What is a feeling of gracefulness? Do different properties have separate and concomitant feelings that they arouse? Are these recognizable, and can they be so individuated? Do we all 'know' gracefulness only if we invariably have this specific feeling instead of another? And must we all have the same feeling, or feel it in the same way? This, again, greatly reduces the breadth and variety of affective responses possible in our experiences of objects, while at the same time relying on some as yet unanalysed notion of aesthetic emotion/pleasure as a particular kind. And this takes us further away from an understanding of what aesthetic judgement might be, when it occurs.

The 'subjective criterion'[53] that Nguyen sought to capture can already be seen in the accounts I have canvassed, from Schaper's

---

[53]Ibid.

claim that the individual's response is the 'basic datum' of an aesthetic judgement, to Kant's notion of 'singular' as opposed to 'logical' judgements, to Shelley's idea that we 'stake' ourselves in our aesthetic evaluations – the subjective aspect of the judgement is that it must be *ours*, the product of *our* assessments rather than what the testimony of others might say, and this can be characterized without the need for the inclusion of pleasure, displeasure or any particular affective element at all.

Gorodeisky and Marcus make an argument similar to Nguyen's, with perhaps more clarity but without greater strength. For them, aesthetic judgement is singular and just *is*, or is defined as, 'appreciation'.[54] This they variously describe as 'a sensory-affective disclosure of, and responsiveness to, merit', as 'a specifically aesthetic form of liking', and as 'a positive affective attitude towards the object'.[55] What makes aesthetic judgements distinct is that they are in part cognitive (Gorodeisky and Marcus also support McDowell's sensibility theory) but this liking is not grounded in the 'appreciator's idiosyncratic constitution and circumstances' (as with Goffin's perspectival state): instead the 'aesthetic pleasure presents the object as meriting that very feeling'.[56] The logical form of aesthetic judgement is 'simple': the feeling is not separable from a belief about the object's properties but it is 'through the feeling itself that one both becomes aware of the

---

[54] I take the following discussion from their paper 'Aesthetic Rationality' but see also Keren Gorodeisky and Eric Marcus, 'Aesthetic Knowledge', *Philosophical Studies* 179, no. 8 (2022): 2507–35.
[55] Gorodeisky and Marcus, 'Aesthetic Rationality', 114, 115, 117.
[56] Ibid., 118.

merit of the object and is responsive to it as worthy of this specific feeling.'[57]

What the authors advocate is not two separate judgements (one theoretical or cognitive and one affective), nor one judgement with an attendant affective response: the liking *is* the judgement itself, qualified by the idea that the object has features that merit this response, or that it is fitting to feel a certain liking with respect to it. Aesthetic pleasure, they write, 'is like perception in its power to reveal the world', but it is unlike perception because it 'does not simply reveal the object to have a certain property', such as beauty or grace; it 'reveals the beauty of the object in relation to those features that confer beauty on it'[58] – in relation to the features that merit the feeling of pleasure. In this way, 'while aesthetic pleasure reveals aesthetic value no less than perception reveals certain non-evaluative properties, it is a different kind of state and it belongs to a different domain of rationality', rendering aesthetic judgements unique.[59]

While I agree that aesthetic judgement is simple rather than compounded, and that its logical structure makes it identifiable as a unique kind, I do not agree that it can be reduced to appreciation, if that means liking, pleasure or a positive endorsement. Some other term is needed to guard against the apparent symmetry of negative judgements being a disliking – Would this be a non-appreciation? A failure to appreciate? – to maintain the breadth of the kinds of aesthetic judgements we can make. Gorodeisky's and Marcus's main

---

[57] Ibid., 119.
[58] Ibid., 120–1.
[59] Ibid.

premise – and Nguyen's – is not supported: that feeling a certain pleasure is revelatory of the aesthetic features of an object. Again, as I had suggested in the last chapter, one could read McDowell as claiming that we need to *conceive* of some properties in terms of 'sentient' affective responses without our also needing to actually *feel* those affects ourselves. In what I had tentatively referred to as relational properties, something like amusingness could be understood in terms of what (some) people actually find amusing, or in terms of what it means to be amused, without a given individual experiencing, at the time, this effect. Amusingness could enframe the encounter just as certain cultural or traditional practices enframe the use of a knife and thereby guide our experiences of it. This does not diminish the requirement for first-hand acquaintance, which Gorodeisky and Marcus also endorse, because the property of beauty or gracefulness remains the product of an individual's own judgement, rather than a belief formed on the basis of the testimony of others.

At different points in their article, Gorodeisky and Marcus refer to the question of an object's 'quality' or 'aesthetic value',[60] and herein lies an alternative to the notion of appreciation with its affective baggage, which points the way forward. 'Appreciating' is often used interchangeably with 'valuing' in the sense of liking, or positively endorsing, and in this feeling or affect creeps into the account. But if 'valuing' is understood instead as 'assigning a value to', in the sense of appraising, estimating or assessing, we can retain the idea of aesthetic judgements as having a specific logical structure, indeed

---

[60]Ibid., 132, 140.

as having a prescriptive character (that we ought to 'see' the object in the same way, or concur in its beauty). We can even retain the idea of merit, if by that we mean the object's *deserving* the assigned value, whatever it might be, instead of understanding merit as a synonym for excellence, reward or inherent worth. The notion of desert allows for the giving of reasons or justifications for one's judgement, although these would not be evidentiary, or amount to anything like proof. Lopes makes a similar suggestion. Appreciation, he notes, 'is more than aesthetic value attribution'. It is a 'savouring of the value' – a further act that goes beyond the original assessment which might involve conservation, preservation, collecting and the like.[61] Lopes calls for the discipline to 'police the distinction between aesthetic evaluation and appreciation' and to acknowledge 'how much room there is to attribute aesthetic value without appreciating it'.[62] To savour or appreciate an object is to have already made an evaluation, and to move beyond it to endorsement, liking, valorization. But once affectively committed in this way, it seems that there is as little room for debate or disagreement here as there is with the taste of cherries. (To appreciate Venetian glass, for instance, is to make it 'one's thing', to perhaps collect it, certainly to savour it, and to have moved beyond a mere appraisal of its delicacy to an actual liking that might ignore or be antagonistic to contrasting judgements.) Lopes notes that 'only aesthetic evaluations give agents access to aesthetic reasons'[63] because, as Schaper noted, reason-giving is a 'legitimate

---

[61] Lopes, *Being for Beauty*, 105.
[62] Ibid., 106.
[63] Ibid.

move' in aesthetic judgement, which no longer need apply once that judgement has been made and simple enjoyment – appreciation – takes its place. This suggestion obviously needs to be fleshed out, which I will do in the next chapter when I discuss aesthetic value directly.

The change in emphasis from appreciating as valuing to appraising as evaluating allows us to see that pleasure or affect are not necessary to an understanding of aesthetic judgement, and that their absence does not diminish any of the various ways that it has been characterized as unique. Aesthetic judgement is like perception in its power to 'reveal' the world as having certain qualities or values, and to reveal them non-inferentially. It is not like perception, however, in that gracefulness and the like are not 'seen' or felt directly but are instead ascribed to an object in the process of an appraisal of it. This process, or mental act, has as little need for an emotive or affective element as perception itself, or cognition, in the normal course of events. It may inspire appreciation, liking or some sort of feeling but this feeling is not a necessary component of – or internal to the act of – making an aesthetic judgement.

The point of separating these different elements – and different acts – has been to enable a clearer analysis of each of them. Perception, or aesthetic attention, is not yet – and is prior to – aesthetic judgement. Either act can be accompanied by an affective response, but that response is contingent, not part of the act itself, and so unnecessary to its characterization. Can we judge an object to be beautiful or ugly and react to it emotionally? Of course we can. But the point is that we *need not*. The further point is that a particular emphasis on pleasure flattens the great variety of possible affective responses we

can have in our aesthetic lives. A judgement of ugliness need not inspire a 'dislike': it could motivate hilarity and laughter instead. There is no one-to-one relation between the result of an evaluation and its (contingent) emotive response; there is no particular feeling of 'gracefulness' that we can identify, and we do not err in our judgements if we do not also have some appropriate (merited) feeling. Judgement, like perception, seems to be an 'achievement' word, where it would be hard to claim we didn't find an object beautiful because we were 'doing it wrong'. We can judge hastily or harshly, for instance, but in either case a judgement has been successfully made. What characterizes aesthetic judgement is that it is normative rather than cognitive, prescriptive rather than descriptive, that it functions within a space of reasons that can justify that judgement but that cannot offer proof. Aesthetic judgement is objective in the sense of intentional, or about an object but it is also subjective in that it is an act of evaluation that signals a commitment, a verdict, a stake by which we at least provisionally make a stand, and which we can be willing to – or be asked to – defend. The final element to consider in a characterization of aesthetic judgement is that of disinterest. It would be straightforward to suggest that, just as aesthetic attention is conditioned negatively by a lack of other concerns, so too is the reasoned appraisal of an object's value. Schaper had indicated as much, and the notion of merit in Nguyen's, and Gorodeisky's and Marcus's, accounts of aesthetic judgement would seem to imply the same. However, Kant's own account of aesthetic judgement seems to argue otherwise, in its own complex way, and a closer consideration of his theory may prove fruitful.

## Judgement and Disinterest

Schaper's continuum, from culinary to moral judgements at either extreme and aesthetic judgements in the middle as a separate kind is meant, I think, to mirror a tripartite division in Kant's own work between the agreeable, the beautiful and the good. For Schaper, all aesthetic judgements are conditioned by the 'criterion of disinterest': she interprets Kant as claiming that 'disinterestedness functions as a criterion concerning the origin of pleasure or what pleasure (or displeasure) is consequent upon'[64] and marks out the aesthetic in this way. Nick Zangwill, more recently, put the point boldly: 'Normativity is essential to judgements of taste; they would not be what they are without it. And disinterestedness is essential for normativity.'[65] This is so because the 'subjectively universal validity' of judgements of taste requires that they refer to what we all share in terms of faculties and capacities; the source of the aesthetic 'is separate from anything that is a merely contingent feature of us' (what Zangwill calls our 'empirical psychology' which includes Kant's notion of 'private conditions' such as our idiosyncratic tastes and intentions).[66] Without disinterest, the 'validity of a judgement of taste would become relative to whether a person *happened* to possess the interest or desire. And with that, the normative claim would be lost.'[67] To be a bona fide aesthetic judgement, it must be disinterested.

---

[64]Schaper, 'The Pleasures of Taste', 50.
[65]Nick Zangwill, 'Disinterestedness: Analysis and Partial Defense', in *Disinterested Pleasure and Beauty*, ed. Larissa Berger (Berlin: De Gruyter, 2023), 72.
[66]Ibid., 79.
[67]Ibid., 71.

However, what Schaper does not comment upon, and indeed what problematizes her depiction of Kant's account is that for Kant the agreeable and the good are *also* aesthetic judgements albeit, in fact, interested ones, and this complicates the picture in a number of ways, if it does not completely undermine it. What makes a judgement reflective, or aesthetic, for Kant is that its 'determining ground cannot be other than subjective' such that it 'contributes nothing to cognition': 'even if the given representations were to be rational but related in a judgement solely to the subject ... they are to that extent always aesthetic'.[68] The good, then, is not like a moral judgement as Schaper has described it, with categorical force and perhaps a priori principles: the good, as much as the beautiful and the agreeable (or the culinary) is also aesthetic. The form of these judgements remains that of an immediate (non-inferential) evaluation of an object in which the subject makes a commitment, or renders a verdict, and by which she stakes herself in some way (she is the 'determining ground' of these evaluations). Aesthetic judgements for Kant also carve out a domain of rationality – or a specific operation of our rational faculties – that is different in kind from cognitive and moral judgements. But then disinterest apparently cannot be the central indicator of their formal particularity. The question is whether this tension undermines the account of aesthetic experience I have been developing. I will argue that it does not, that a careful reconsideration of Kant's notion of disinterest will make the various kinds of aesthetic judgements consistent, and will yield the possibility of greater nuance and breadth in the kinds of objects and experiences that can be

---

[68]Kant, *Critique of the Power of Judgement*, AK 5: 207.

judged aesthetically. But this consideration requires a deeper look at the technical complexities of the Kantian account.

Kant's 'analytic' of judgement in his third *Critique* is not only complex but depends upon the entire analysis of the *Critique of Pure Reason*. Just as a theory that focuses on pleasure, as we saw in Chapter 2, would need an extra-aesthetic 'treatise' on pleasure to make its account good, so too does Kant's theory of aesthetic judgement rely on his critical philosophy to ground it; accepting his account means accepting the majority of his architectonic. In Schaper's terms, this requires 'an exploration of issues in the philosophy of mind, epistemology, logic, and much else besides'.[69] And this is one of the reasons for the enormous Kant industry of interpretation, reconstruction and revision of his work, which I cannot reprise here in any detail. Kant's theory rests on a now largely questionable division of the powers of the mind into discrete operations: the lower, sensibility (or perception), and imagination; and the higher: understanding, judgement and reason.[70] The discussion of these lower powers takes up the first part of the *Critique of Pure Reason*, which is not coincidentally entitled the 'Transcendental Aesthetic', paying tribute to the Grecian legacy of *aisthesis* and presumably not needing a reiteration when he later turned his attention to judgements themselves. As such, Kant does not discuss an initial aesthetic experience prior to a responsive judgement, although his account does depend upon first-person encounters with, or perception of, phenomena. While remaining sensitive to the complexity of Kant's

---

[69]Schaper, 'Pleasures of Taste', 39.
[70]Kant, *Critique of the Power of Judgement*, AK 5: 171–6 and see Guyer's introduction to the volume, xxiii.

work here, I will focus only on the question of disinterest in aesthetic judgements and its fallout, absent its relation to pleasure, and absent the relation of the aesthetic to his broader goals.

In contrast to Schaper, the Kantian continuum occurs within the aesthetic itself, and ranges from the more subjective (the agreeable) to the more objective (the good), with points along the way. In fact, with the inclusion of 'dependent' or 'adherent' beauty and the sublime, along with the beautiful, Kant allows for five kinds of aesthetic judgement rather than the Schaperian one, and this polysemy is an under-acknowledged but attractive aspect of his account, as it provides for an aesthetic theory that is more multi-dimensional, and ranges across a broader variety of our interactions with the world.

Of these aesthetic judgements, only judgements of beauty are 'pure'. This has led many scholars to focus on them as paradigmatically aesthetic and has contributed to a general neglect of the agreeable and good as lesser and more problematic forms.[71] But beauty is best understood in contrast with these other forms; its purity (and their impurity) is due in large part to its disinterest, as Schaper had noted. However, an important distinction must be made here: for Kant, disinterest is a specific technical term (call it 'K-disinterest') and, pace Schaper, impure judgements of taste need not exclude the standard sense of disinterest as I have been using it, as absent any particular interests formulated without regard to the object itself (or prior to an encounter with it) – call this 'S-disinterest'. The Kantian

---

[71]Some attention paid to the so-called 'lesser' forms of aesthetic judgement can be found, for instance, in Nick Zangwill, 'Kant on Pleasure in the Agreeable', *Journal of Aesthetics and Art Criticism* 53, no. 2 (1995): 167–76, and Rachel Zuckert, 'A New Look at Kant's Theory of Pleasure', *Journal of Aesthetics and Art Criticism* 60, no. 3 (2002): 239–52.

breadth of the aesthetic can be made compatible with my account of judgement thus far, if we see that all forms of aesthetic judgements are S-disinterested, with only the beautiful being K-disinterested as well. What will provide a greater challenge to that compatibility lies in the concomitant subjectivity of the agreeable in particular and I will address this as I contrast Kant's three main forms.[72]

As I had noted earlier, in judgements of beauty 'one does not want to know whether there is anything that is or that could be at stake … in the existence of the thing'. K-interest by contrast refers to the 'representation of the existence of an object'[73] and judgements of the agreeable and the good are interested in this way: the judgement depends upon the object actually existing for the subject in order for the judgement to be rendered. Instead, 'to say that it is beautiful … is what I make of this representation in myself, not how I depend on the existence of the object … One must not be in the least biased in favour of the existence of the thing, but must be entirely indifferent in this respect in order to play the judge in matters of taste.'[74] With the beautiful, one could respond to an image or representation, and make a judgement based only on its appearance; with the agreeable and the good, the object itself must be present, and we must interact with it, although in different ways. As Zangwill put it, if I judge a flower to be beautiful but discover it to be a hologram that deceived me, nevertheless the 'image or representation might still retain its

---

[72] I will pass over dependent beauty and the sublime in this account; I have discussed the former at length in Forsey, *The Aesthetics of Design*, Ch. IV, and the latter is so particular, and involves the greater Kantian system to such a degree, that it is beyond the scope of this Chapter.
[73] Kant, *Critique of the Power of Judgement*, AK 5: 204.
[74] Ibid., AK 5: 205.

beauty ... I might be disappointed in other ways to find out that it lacks existence, but not aesthetically'.[75]

The agreeable, Kant writes, begins with 'sensation'; the object 'presupposes not the mere judgement about it but the relation of its existence to my state insofar as it is affected by such an object'.[76] Judging a beverage, for instance, that it is 'refreshing', or a food that it is delicious, depends upon the subject having the direct sensation of drinking the beverage, and actually experiencing its qualities. The agreeable 'belongs to subjective sensation'[77]; it is grounded in a 'private feeling' of the individual in response to the object, one 'restricted merely to his own person', and while Schaper's and Kant's examples are culinary in particular, Kant also notes that 'this is so not only in the case of the tongue, palate and throat, but also in the case of that which may be agreeable to someone's eyes and ears' (i.e. to the distal as well as proximal senses).[78] In all cases, the agreeable is K-interested because it is grounded in actual sensations caused by our direct interactions with tastes, sights and sounds, rather than representations of them.

Judgements of the good, by contrast, are not grounded in sensation but are formed 'by means of reason alone, through the mere concept'. Things can be mediately or inherently good (good for something; good in themselves) but in either case 'I must know what sort of thing the object is supposed to be, i.e., I must have a concept of it'.[79] Judgements of the good are also K-interested because they are

---

[75] Zangwill, 'Disinterestedness', 64.
[76] Kant, *Critique of the Power of Judgement*, AK 5: 205, 207.
[77] Ibid., AK 5: 206.
[78] Ibid., AK 5: 212.
[79] Ibid., AK 5: 207.

'determined not merely through the representation of the object but at the same time through the represented connection of the subject with the existence of the object'.[80] To judge whether a snow shovel, for instance, is (mediately) good requires an actual shovel, and not the mere representation of one, or a sketch, idea or design. Only if it exists, and can be used, can a shovel be judged good.

The first question is whether these judgements can also be S-disinterested. With the good, this is immediately plausible: one can assess a shovel as it is in itself, and ascribe to it the value 'good' without wanting to buy it or without immediately needing to use it. Such evaluations happen within the context of knowing what a shovel is, or is for, just as attention to that knife was enframed by certain information and practices. But the judgement is aesthetic when it assesses the object as it is, absent the influence of intruding personal interests at the time of so judging. It is made through a 'connection of the subject' to the object because it remains a verdict made by the subject in which she stakes herself, rather than an actual act of cognition.

With the agreeable, this is less apparent. Kant writes that the agreeable, through subjective sensation, 'excites a desire for objects of the same sort'; it 'gratifies' the subject because 'inclination is thereby aroused'[81] such that 'delicious' comes to mean that it 'tastes like more'. Further, when Kant notes that K-interest 'presupposes *or produces*' a desire, and again that 'hunger is the best cook',[82] he seems to also suggest that such judgements cannot be S-disinterested because they

---

[80] Ibid., AK 5: 209.
[81] Ibid., AK 5: 207.
[82] Ibid., AK 5: 210, my emphasis.

involve our needs and intentions. I think that Kant is wrong about this, just as Goffin earlier was mistaken to claim that thirst leads to sensitivity in aesthetic matters. Hunger, far from being the best cook, is a need that seeks satisfaction and, depending on its urgency, will find it regardless of its object. There is a reason why we can say of someone that they 'didn't taste their food' because their action was not one of tasting at all but of, perhaps, refuelling, and in this it was driven by an S-interest, and so it had no aesthetic element.

Kant is correct that to judge a food as (actually) delicious we need to have a direct sensation of its qualities. But we need to *taste* the food, not merely eat it, and here the item does become an aesthetic object through attention to its flavours and textures. Just as, in a hurry to cook dinner, I may pay no attention to the knife or the sensations of chopping, when hungry we often pay no *aesthetic* attention to the food on our plates. But when we do pay that attention, the subsequent judgement becomes aesthetic, and indeed S-disinterested, in that it need not have desire or need as its precondition. On a recent walk I was exhorted by a neighbour to 'try this!' of what looked like a weed, and in doing so I paid attention to the sensations of my palate. And I did this without being hungry, or without any interest outside of a curiosity in the thing itself. Finding it 'delicious' or 'sweet', or 'honey-like' and so on need not arouse an inclination to have more of it, or to eat it again, and did not lead me to foraging the boulevards of my neighbourhood. There is no compelling reason why tastes, just as other experiences, cannot be S-disinterested, even while they involve the subject in a more intimate way.[83] Kant is wrong, too,

---

[83]On the possibility of culinary judgements being disinterested, see Elizabeth Telfer, *Food for Thought* (New York, NY: Routledge, 1996) and Alexandra Plakias, 'The Aesthetics of Food', *Philosophy Compass* 16, no. 11 (2021): e1–e12.

(and inconsistent) when he adds that the agreeable 'is also valid for nonrational animals',[84] as though it were a mere physiological sensory response to stimuli. It is not: it is a judgement, as he asserted, and as such uses our rational faculties, which Kant did not believe animals share. A mechanistic description of the agreeable in fact undermines his inclusion of it as a form of aesthetic reflective judgement from the start.

If my (brief) analysis here is correct, we can see that the agreeable and the good along with the beautiful are the result of S-disinterested aesthetic judgements, and we can maintain that disinterest is equally a necessary component that makes these judgements unique. While the former two are K-interested – in one our attention requires direct sensation and in the other some amount of conceptual knowledge, and in both the object must exist – Kant's particular technical use of the notion can be made compatible with the historical interpretations of disinterest in general that have been part of the aesthetic tradition and that indeed are largely indebted to his work. That disinterest should be part of a more robust account of aesthetic experience is no surprise but neither is it mere repetition: grounding the initial pre-evaluative act in disinterest located the aesthetic primarily and necessarily in a kind of attention, and allows me to maintain that judgement is only contingently part of aesthetic experience. But if and when aesthetic judgements are made, they will consistently be marked by disinterest as well.

The Kantian continuum of aesthetic judgements allows for variability and breadth but it also leads to a further difficulty that

---

[84]Kant, *Critique of the Power of Judgement*, AK 5: 210.

needs to be addressed: the agreeable in particular, as involving private sensations, seems to be wholly subjective and exclude the possibility of the discussion and debate that make these judgements communicable, and perhaps shared. Indeed, Kant writes that '[i]t would be folly to dispute the judgement of another that is different from our own in such a matter with the aim of condemning it as incorrect', and concludes that with the agreeable 'everyone has his own taste'.[85] However, the difference between the agreeable at one extreme and the good at the other should not be read (as Schaper did) as one between judgements for which *no* reasons can be provided and one for which they can, but instead as a more nuanced matter of what kinds of reasons can be given, and how much debate can occur. As aesthetic, all of these judgements can be justified – reasons remain a 'legitimate move' in the game – differing only in degree, and so all judgements remain of the same rational and logical form.

The good, because it involves reason and concepts rather than (private) sensation, is more objective, or object-oriented, and so also allows for finer reasons and greater debate. Two people can argue about whether a snow shovel is good (provided they both know what it is) and do so in detail and at length. One may point to the size and shape of the scoop as lending efficiency, while another may argue that the material is too heavy for ease of lifting, or too

---

[85]Ibid., AK 5: 212. But note that in the Dialectic Kant writes that while we cannot dispute about taste – 'nothing can be decided about the judgement itself by means of proofs' – we can still *argue* about taste: arguing and disputing are alike in that they 'try to bring about unanimity in judgements' but they differ in that only 'the latter hopes to accomplish this in accordance with definite concepts as grounds of proofs'. Thus '[i]t is possible to argue about taste', AK 5: 338. With my broadening of the Kantian continuum on the grounds of S-disinterest it seems we should equally be able to argue about the agreeable as well as about the beautiful and the good.

frequently cracks in extreme cold. There are facts of the matter that can be referred to in order to bolster a position, and some of them can be empirically tested (such as weight, height and so on). The verdict – the ascription of 'good' – will still be staked by the subject in relation to the shovel's qualities, and will perhaps prioritize some qualities over others in the evaluation. That is, the judgement is still aesthetic in that it is an individual response to the phenomenon, and not an objective finding of material fact for which evidence can make the case one way or the other. But because of the Kantian emphasis on a concept, it is likely the case that greater and more detailed *explanation* for the judgement can be made, when and if the subject is called upon to give reasons for her assessments.

With the agreeable, because it is grounded in sensation, there is a clear stopping point to possible debate and discussion, and a narrower range of reasons that can be provided. But some debate can occur, some reasons can be given and some explanation can be demanded for our judgements, even if, at the end, our taste is our own. We see this frequently with culinary judgements: of candy floss I may say it is disagreeable because it is too sweet; of rapini I may say it is delicious precisely because it is bitter. When asked, 'what is wrong with it?' after making a negative assessment of your latest culinary experiment, I can be expected to provide some sort of reason or explanation for my judgement. There are even facts of the matter that can be empirically verified (with the right scientific equipment): one person may be a 'supertaster', especially sensitive to some flavours (particularly sweet and sour), and the different number of taste receptors on their tongue will affect their judgements (although they may not be

aware of this and unable to explain it). Conditions can also intrude upon taste sensations: having a cold, for instance, muffles flavour; drinking coffee before sampling a food item will alter some flavours in particular (caffeine increases the sour taste of foods) and these conditions can be made explicit in discussions of taste.[86] While Kant is correct that it is 'folly' to dispute matters of the agreeable as though they can actually be incorrect, it is just as much folly to suggest that judgements of the good or the beautiful tend towards correctness or finality: that simply is not the bar against which aesthetic judgements are measured, which is why Schaper emphasized that there are 'no criteria' that determine the truth or falsity of these judgements, or provide anything like evidence in their favour. But Schaper was too hasty in declaring that in culinary matters there are *no* reasons that could possibly support them; the subjectivity of sensation may limit debate but it does not eliminate it altogether.

With this discussion, we can conclude that, despite having notable peculiarities, the judgements on the Kantian continuum all share the same logical form, are all disinterested and hence are all legitimately aesthetic. The expansion of aesthetic judgements from the Schaperian one to the reconceptualized Kantian five is important in that it both broadens the scope of objects that can be legitimately part of a more robust aesthetic experience and also better reflects the variety of current preoccupations in the discipline. More attention lately has been paid to the proximal senses (the aesthetics of food, perfume,

---

[86]Carolyn Korsmeyer, *Making Sense of Taste* (Ithaca, NY: Cornell University Press, 1999) discusses the physiology of taste in Chapter Three, 'The Science of Taste', and see also Linda Bartoshuk and Valerie Duffy, 'Chemical Senses: Taste and Smell', in *The Taste Culture Reader: Experiencing Food and Drink*, ed. Carolyn Korsmeyer (New York, NY: Berg Publishers, 2007), 25–33.

smells and touch),[87] as well as to a number of more quotidian objects and activities such as design, video games, rock climbing, chess playing and computer coding.[88] Contemporary aesthetics has further branched out into such areas as terrorism, violence, ruins and grief.[89] What has been lacking is a broader conception of what fundamental characteristics bring this variety together such that they are *all* forms of aesthetic experience, or aesthetic objects, and are *all* aesthetic in the same way. Disinterest, both in attention and judgement, can be the key that unites them. Until the fundamentals of aesthetic experience are formalized, each foray into a new area gropes to explain what is aesthetic about *that*, and is often obliged to 'reinvent the wheel' and provide some hasty notion of the aesthetic that seems to fit their particular object.

Two final points need to be made before closing out this chapter. First, just as I had asked earlier whether we can be sure that we are

---

[87]On food, see Telfer and Plakias, *Food for Thought*, and also Korsmeyer, *Making Sense of Taste*. For perfume, see Larry Shiner, 'Art Scents: Perfume, Design and Olfactory Art', *British Journal of Aesthetics* 55, no. 3 (2015): 375–92 and Chiara Brozzo, 'Are Some Perfumes Works of Art?', *Journal of Aesthetics and Art Criticism* 78, no. 1 (2020): 21–32. For an aesthetics of smell more generally, see Larry Shiner, 'Opening the Way for an Olfactory Aesthetics: Smell's Cognitive Powers', *Rivista di Estetica* 6:13, no. 78 (2021): 8–26 and Marta Tafalla, 'Smell and Anosmia in the Aesthetic: Appreciation of Gardens', *Contemporary Aesthetics* 12 (2014): article 19. For the proximal senses more generally, see Mădălina Diaconu, 'Reflections on an Aesthetics of Touch, Smell and Taste', *Contemporary Aesthetics* 4 (2006): article 8.

[88]See for example Forsey, *The Aesthetics of Design*, and James Paul Gee, 'Video Games, Design and Aesthetic Experience', *Rivista di Estetica* 63 (2016): 149–60. For rock climbing and chess (as well as other 'arts of action'), see C. Thi Nguyen, 'The Arts of Action', *Philosophers Imprint* 20, no. 14 (2020): 1–27; computer coding and gardening are two examples in Lopes, *Being for Beauty*.

[89]The journal *Contemporary Aesthetics* 7, (2019) was dedicated to the aesthetics of terrorism; Robert Ginsberg wrote *The Aesthetics of Ruins* (New York, NY: Rodopi, 2004); and Kathleen Marie Higgins more recently offered 'Aesthetics and the Containment of Grief', *Journal of Aesthetics and Art Criticism* 78, no. 1 (2020): 9–20.

completely disinterested in our attention, we can ask the same of aesthetic judgement, and the question applies to the beautiful as much as the agreeable and the good – or, to K-disinterest as well. For Kant, a 'judgement of taste is pure only insofar as no merely empirical satisfaction is mixed into its determining ground', and it is pure 'only if the person making the judgement either had no concept of [the object] or abstracted from it in his judgement'.[90] To make a judgement of beauty there must be a free play of the rational faculties, where they work in harmony without the admixture of either sensation or concepts. But it would be a mistake to suggest that such judgements can only be made when the faculties play in *full* freedom, or when the existence of the object is *completely* disregarded. Marcia Muelder Eaton notes that 'pure' uses of beauty are 'rare': 'it has been a mistake for aestheticians to take this sense of beauty as the paradigm aesthetic concept'.[91] Robert Wicks would agree: 'it is undeniable that in concrete circumstances, our judgements of beauty are typically mixed'.[92] Paul Guyer stands alone in more forcefully claiming that purely K-disinterested aesthetic judgements are simply not possible:

> Perhaps we come *closest* to having an experience that is just a harmonious free play of the imagination and understanding in the experience of isolated objects of nature such as humming birds, crustacea, and crystals, and from such cases we can extrapolate to the idea of a simple harmony between imagination and

---

[90]Kant, *Critique of the Power of Judgement*, AK 5: 223, 231.
[91]Marcia Muelder Eaton, 'Kantian and Contextual Beauty', *Journal of Aesthetics and Art Criticism* 57, no. 1 (1999): 13.
[92]Robert Wicks, 'Dependent Beauty as the Appreciation of Teleological Style', *Journal of Aesthetics and Art Criticism* 55, no. 4 (1997): 388.

understanding as a necessary condition of any purely aesthetic experience; but in the end ... our experiences of beauty, just like those of the ugly and the sublime, are impure rather than pure.[93]

The requirement of disinterest is not stricter with judgement than it was with attention, and in both cases does no harm to their depiction.

The second point returns us to the beginning of this chapter, where I set out to argue that the aesthetic is not to be located in judgement alone, and indeed that it is a contingent matter as to whether the minimalist experience will lead to judgement at all. On a more robust account, judgement is one element of aesthetic experience: what holds them together as part of the *same* experience, rather than two separate experiences, or one experience and a response to it as Prall had suggested, is the aesthetic object: paying attention to a knife and then judging it are both actions directed at that knife, or about it, as an intentional object. The separation of attention and judgement has a further benefit in that it allows for – and makes sense of – a possible temporal gap between the two acts. Kant's (and Schaper's) location of the aesthetic in the act of judging forecloses against the variety of ways the elements of a singular experience can arise. Evaluation needn't be concurrent with the initiating attention; Kant's account suggests that we render a judgement at the moment of the encounter ('the rose I am gazing at is beautiful'), and with the agreeable this is most pronounced, as though the sensation immediately causes a response without the intervening use of reason. But we may not be able to decide that a flavour is delicious, often and

---

[93]Paul Guyer, 'Kant on the Purity of the Ugly', in *Values of Beauty: Historical Essays in Aesthetics* (Cambridge: Cambridge University Press, 2005), 162.

especially if it is unfamiliar (and the temporal gap is wider with so-called 'acquired tastes'). Between tasting and the judgement there can be time for consideration, reflection, comparison and discussion with others: the individual acts can be separable while still remaining part of the same complex experience of that flavour. The good, by contrast, seems to imply reasoned deliberation, when this also need not be the case. I can pick up a knife and chop with it, and immediately judge it 'good'. Reasons and explanations, as Schaper had noted, always are post facto. The temporal gap, along with a distinction between specific acts, allows for greater freedom in how aesthetic experience is described, and greater flexibility in emphasis between one element and the other. But the robust account of aesthetic experience is not yet complete: a full treatment of aesthetic judgement must also consider the product of that judgement, or what it picks out. This will provide an answer to the final question of the Sparshott Test.

# 4

# Aesthetic Value

'Value', I will be the first to admit, is an infelicitous term. Aesthetic value came into use as a replacement for beauty, presumably because it would allow certain works of art to be notable or 'appreciation-worthy' without also being beautiful, and to allow for more inclusivity in aesthetic theory. We saw in Chapter 2 that de Clerq, while using the term 'beauty', found it to be 'equivalent to aesthetic value'[1]; value has become the term of choice over the last twenty years or so. Its recent currency is why it does not appear in Sparshott's appendix, although it suffers many of the problems he pointed out there. I have retained the term here partly in acquiescence to contemporary usage, but more particularly to stress that it is the product or outcome of an act of *evaluation* which is aesthetic judgement as I have construed it. The infelicity of the term stems in part from its positive connotation. When we value something, or judge something to have value, this is understood as positive: it is implicit that we are endorsing it, or preferring it, or liking it, or esteeming it – pleasure subtly remains here, even if only as some sort of lingering vestigial tail. What I seek to

---

[1] De Clerq, 'Aesthetic Pleasure Explained', 122.

do is cut off this tail: if we can conceive of value without a connotation of positivity, we can understand it as merely the result of a judgement, the product of an evaluation, that which is depicted by, or assigned to, an object through a specific normative-explanatory act. In this it need not be constitutive of – or contributive to – excellence or merit, need not induce or provide or accompany pleasure but will be that which makes a phenomenon aesthetic in a specific way because we have evaluated it to be so. And in this sense, I will also claim that aesthetic value is not singular, as denoting excellence, but plural: there are many aesthetic values, just as there are a plurality of aesthetic judgements that we can make. In this, I will counter Beardsley's claim that aesthetic values can be reduced to an analytic few, and Stolnitz's 'list' of aesthetic values with the more contentious claim that aesthetic values can be multiplied without seeming end, and without some kind of commitment to an ontological status that renders them unique. They are, instead, whatever the results of our aesthetic judgements deem them to be.

Instead of referring to value, Sparshott commented on 'aesthetic qualities' and saw a similar infelicity there as well. He noted that one sense of the term refers to 'those that contribute to aesthetic excellence and are by definition good-making characteristics' (as with Beardsley's notion of some qualities as analytically linked to the pleasure of aesthetic experience). Some qualities seem to 'denominate special virtues or vices' that allow us to distinguish between the 'beautiful', the 'sublime' and the 'obscene'.[2] That aesthetic qualities appear to have degrees of evaluative force makes the term redundant

---

[2] Sparshott, *Theory of the Arts*, 478–9.

for more current theories as a separate 'aesthetic *x*' because it appears to enfold the notion of value as it is now used. A further concern with the term 'quality' (or 'property' as a near synonym) is that it can indicate a commitment to a certain form of aesthetic realism – that these are things that objects possess independently of our interactions with them – and this sense brings with it the metaphysical and epistemological difficulties I referred to earlier. As this is not a work of metaphysics, I seek to remain non-committal about the ontological status of value, while allowing my account to be consistent with a realist approach for those who may seek to pursue one.[3]

Nevertheless, there are questions that the current emphasis on value must answer: How can we describe aesthetic value? Is it of a discrete kind? And how does it arise? Sparshott laments that the 'Greek derivation of "aesthetic" might lead one to expect "aesthetic qualities" to be perceptible qualities, perhaps qualities available only to perception – what are usually called secondary qualities. But this usage is not found'.[4] It is something like a descendent of this usage that I will consider here: aesthetic values can be understood as values only through or because of their occurrence in aesthetic evaluations. They need not have special ontological status but they will be those which make a phenomenon aesthetic in the specific way that it is in virtue of the fact that we have evaluated or judged it to be so. An object is beautiful, for instance, only through an interaction with it, and only once it has been judged to *be* beautiful, rather than ugly,

---

[3]For a good overview of aesthetic realism, see Nick Zangwill, 'Aesthetic Realism I', in *The Oxford Handbook of Aesthetics*, ed. Jerrold Levinson (New York, NY: Oxford University Press, 2005), 63–79; and John W. Bender, 'Aesthetic Realism II' in the same volume, 80–98.
[4]Sparshott, *Theory of the Arts*, 478.

or obscene. The use of the term 'value' cannot be value-neutral – an oxymoron here – but it can be used without an implicit commitment to positivity, excellence, merit and pleasure. In this chapter I will consider two different approaches to aesthetic value as the problems with each are instructive, and it is in juxtaposition with them that I will better articulate the line I wish to take.

## Verdictive and Substantive Values

Nick Zangwill, in his article 'The Beautiful, the Dainty and the Dumpy', holds that verdictive judgements are those that determine whether things are 'beautiful or ugly, or that they have or lack aesthetic merit or value'.[5] Elsewhere, he calls this a *'generic* sort of aesthetic excellence'.[6] He falls into the Kantian line: 'there is a *mental act* of making a pure judgement of aesthetic value or merit',[7] but his position is a realist one, even though he does not argue for realism specifically in this paper.[8] Verdictive judgements are evaluative as I have shown, but more than that, for Zangwill they are particularly *final* verdicts of merit or demerit that we render upon phenomena, and Zangwill sees these judgements as in fact the ultimate step in a more complicated process which it is his goal to describe in this work. He contrasts verdictive

---

[5]Zangwill, 'The Beautiful, the Dainty and the Dumpy', 317.
[6]Nick Zangwill, 'Beauty', in *The Oxford Handbook of Aesthetics*, ed. Jerrold Levinson (New York, NY: Oxford University Press, 2005), 327.
[7]Zangwill, 'The Beautiful, the Dainty and the Dumpy', 319.
[8]I am interested here in Zangwill's distinction between kinds of judgements and the way that values are differently determined by them. His language slides from judgements to properties in the course of the paper but I will attempt to side-step his metaphysical commitments in my discussion of him.

judgements with what he calls 'substantive judgements' and seeks to set out the relation between the two.

Substantive judgements are descriptive rather than verdictive: they 'describe that which determines merit'.[9] He gives us a partial list of them: 'we judge that things are dainty, dumpy, graceful, garish, delicate, balanced, warm, passionate, brooding, awkward and sad'.[10] They have '*no evaluative content whatsoever*' although they 'imply' an evaluation.[11] As we have seen, Zangwill differs from Beardsley in that he leaves it an '*open question* as to whether something with a substantive aesthetic property is aesthetically good or bad'.[12] Nevertheless, there is a strong relation between the two: 'there is *some* connection with evaluation' but it 'is not that the descriptions have evaluative content'.[13] Instead, Zangwill describes this relation as one of determination: 'the issue is about *determination*, not about *reasons*'.[14] Unlike Schaper's view, where we can be asked to give post-facto reasons for aesthetic judgements that we have already made, Zangwill conceives of a more direct relation, which he fills out with what he calls a 'three layer cake': 'we have three determination relations: they run from non-aesthetic properties to aesthetic properties, from non-aesthetic to substantive properties, and from substantive properties to verdictive properties'.[15] That is, Zangwill describes a relation of supervenience, similar to Levinson's account of aesthetic experience

---

[9]Ibid., 327.
[10]Ibid., 321.
[11]Ibid., 322.
[12]Ibid., 323.
[13]Ibid.
[14]Ibid., 327.
[15]Ibid., 324, 326.

from Chapter 2. The difference is that, while for Levinson we needed to be able to 'apprehend' and explain how aesthetic merit arises from low-level properties, for Zangwill it seems we do not. '[A] thing has a certain merit property *because* it has a certain substantive property. But this is the "because" of determination,'[16] rendering his account a metaphysical explanation about how aesthetic excellence arises, and from what, whether we can articulate this relation or not, and whether or not we can give reasons for our final judgements of merit or demerit.

However, because it is an open question which substantive property is 'good-making' or not, it is hard to square this with a strong determination relation, in order to arrive at an aesthetic verdict. If daintiness is a merit in some objects but not others, how does it determine the beauty of one and not the other when it is equally present in both? And how – and when – do we understand its particular determinative power? Zangwill notes that '[s]omeone blind to the beautiful would also be blind to the dainty and the dumpy; and someone blind to the dainty and the dumpy would also be blind to the beautiful'.[17] But this cannot be the case, if the dainty is not always contributive to beauty, and the dumpy not always contributive to ugliness. If we instead understand verdictive judgements to be acts by which *we* determine aesthetic value, this alters the account because the determination would come from us, *not* from the substantive properties themselves, and the chain of reasons would flow the other way, making Zangwill's theory more like Schaper's (and my own), where the substantive claims would be post-facto reasons we give to explain a verdict we have already made. That is, the first thing to note

---

[16]Ibid., 327.
[17]Ibid.

about Zangwill's theory is that, whether or not it provides an adequate metaphysical explanation for the determination of the beauty of an object, it does not tell us anything that will help to explain our aesthetic *experience* of beauty, which is the present goal.

A different set of concerns arise with Zangwill's division of aesthetic judgements into two different types. As he admits, '[i]t is no small embarrassment that at present we lack a rationale for including the substantive judgements together with judgements of beauty in the class of aesthetic judgements'. His response is to 'put aside that question here'[18] but the question is central to his account, and requires a response. If substantive judgements are descriptive, they seem to be more straightforwardly cognitive than evaluative, and so would lack the normative-explanatory form of a bona fide judgement of taste. If they are cognitive, and pick out a property of an object, the link between the two judgements remains to be made: How does description determine evaluation in any kind of direct sense when the role of that description is an open question? What need would there be for the final evaluation if we are not 'blind' to the substantive descriptions that determine beauty?

If aesthetic excellence is determined by the perception and description of substantive properties, the entire process would be cognitive rather than normative, first, and second, Zangwill would still need to address certain epistemological hurdles that arise from his account. His three-layer cake amounts to the claim that we somehow 'see' grace and delicacy by seeing shape and colour, which is a more complicated way of claiming that we somehow know beauty when we 'see' it, without the required philosophical explanation of

---

[18]Ibid., 321.

how we do so. On the one hand Zangwill follows the Kantian line in describing verdictive judgements as normative, and on the other hand he slips into more directly realist talk ('[v]erdictive *properties* are those described by verdictive judgements').[19] But as normative, a verdictive judgement should ascribe a norm or a value as its extension, rather than a property. If Zangwill is committed to some notion of a 'normative property', his account also faces grave metaphysical hurdles as to what the ontological status of such a property would be, and how beauty would be of a different kind from the graceful, dainty and sad. He would further need to provide some account of how the judgements differ, where some pick out descriptive properties, some normative properties, and how they all remain aesthetic despite these differences.[20]

---

[19] Ibid., 325, my emphasis.
[20] It seems to me that if you claim a sculpture is dumpy you have indeed evaluated it rather than merely described it. 'Dumpy' is not a purely descriptive term. If it were, then notions of 'true' and 'false' would pertain, and that seems difficult to square with the act of interpreting a sculpture, if that is indeed what we are doing in the act of appreciation/critical examination and discussion or disagreement with others. (It would also raise troublesome epistemological and metaphysical questions about how we can 'know' dumpiness, and about how real dumpiness actually is). Susan Feagin, in 'Incompatible Interpretations of Art' (in *Contemporary Readings in the Philosophy of Literature*, eds. David Davies and Carl Matheson (Peterborough: Broadview Press, 2008), 197–210) makes the case that in interpretation we are not 'describing' anything because artworks 'do not provide cryptic messages which we have to decipher' as though engaged in a 'puzzle-solving activity' (201, 209). Instead, she refers to interpretation as 'imaginative' rather than 'analytical' and as 'creative' (209). While I am hesitant about her claim that literary works in particular do not refer to anything (and by extrapolation, neither do any works of art), I am sympathetic to the idea that interpretations are evaluative, and hence normative (and prescriptive) claims. 'Dumpy', like 'tall' cannot be understood outside of a context that, while not providing a priori rules, does nevertheless suggest some at least relative standard against which the judgement is being made. And that *does* make it normative rather than purely descriptive. Robert Stecker, in 'Art Interpretation' in the same volume (217–36) mentions in a footnote that the notion of 'interpretation', as seeking to understand a work that one does not, can have two different trajectories: trying to 'figure out what the actual maker of the thing was trying to do', which would result in description, and trying to 'seek *an* understanding of

Some of these problems stem from the elevation of beauty or aesthetic excellence to be above – and different from – the amusing, sad, dainty and so on. In doing so, Zangwill has reduced the product of an actual aesthetic judgement to just one aesthetic value (or two, if we include its converse), and so has reduced the possible plurality of aesthetic judgements from the Kantian five to the Schaperian one. He is not alone in this. Robert Stecker, for instance, writes that aesthetic value is autonomous, in the sense that it is 'not defined by, derived from, or … a function of other values'; it is *sui generis*, 'independent from other values and of the type of object experienced'.[21] But the idea that beauty, for instance, must be singular, a merit or an excellence, limits the scope of the aesthetic responses we can make to phenomena to those that imply pleasure or preference, and by default renders any inverse judgements as displeasurable or painful in some way. Why, though, should beauty be singled out as ontologically and/or normatively different from so-called 'lower' judgements when we judge a fabric to be garish or a flower to be delicate? This seems to require a theory – indeed an entire metaphysics – of aesthetic values as either of a singular kind in the case of excellence or as diffuse, as in the case of differing products of verdictive as opposed to substantive judgements if both are to be aesthetic. As James Shelley has put it, the question should not be one 'about what sort of *value* there is,

---

a work: *a* way of taking a work that makes sense of its different parts as parts of a whole'. (234, *fn* 1). It is this latter, with the ascription of 'dumpy' and the like, that I think aesthetic evaluation is striving towards, in its focus on the object itself rather than its genesis or modes of production. Stecker suggests that such judgements are prescriptions. (ibid.)
[21] Stecker, 'Aesthetic Autonomy and Artistic Heteronomy', 32, 34.

but … rather about what sort of *valuing* there is.'[22] To separate the two notions is to then need to provide a synthetic link between them to connect them once again, which remains as unexplained in Zangwill's account as his division between the kinds of judgements themselves and the relations between them. Judgements of the kind 'x is beautiful' seem to be an overall 'thumbs up' or 'thumbs down' for him, where the heavy lifting has been done at the substantive level, and at this level is not even clear that an aesthetic – as opposed to cognitive – process has been undergone. While I have singled out 'value' for the purposes of analysis here, it has not been to accord it a separate status of its own.

One of the things that are instructive about Zangwill's account is that it demonstrates the difficulties inherent in multiplying the steps involved in what should be one kind of aesthetic response, and shows us that we do not need to do so. We stake ourselves just as assuredly when we judge something to be amusing or tacky as we do when we make Zangwill's so-called final verdict. These other judgements have the same subjective universality, muted prescriptivity and normative-evaluative form as verdictive judgements themselves. And this suggests that 'amusing' and 'tacky' are aesthetic *values*, rather than mere descriptions of properties that we know or 'see' and that determine our eventual judgements. Aesthetic values arise from and are inscribed by our evaluative activities; rather than their depiction being a cognitive act, I would suggest that an ascription of the beautiful or the garish is a normative one, and equally so. Our aesthetic judgements, rather than describing a state of affairs, instead *create* that state of affairs, in

---

[22]James Shelley, 'Against Value Empiricism in Aesthetics', *The Australasian Journal of Philosophy* 88, no. 4 (2010): 716.

a reversal of Zangwill's flow of determination, one that collapses two of his three layers and remains agnostic about the bottom third. As Shelley again notes, we cannot reduce the value of an object to that of its properties: 'the properties of the object have no value'[23] – they are evaluatively inert, as it were, and the difficulty arises when trying to move from property to value – description to verdict – in an account of aesthetic judgement and its extensions.

Instead I would like to suggest that aesthetic values (rather than Sibley's list) are any and all values ascribed to an object in the making of a bona fide aesthetic judgement. And, if aesthetic judgements are contingently part of a fuller account of our aesthetic experiences, then aesthetic values will be equally contingent in the realm of the aesthetic. Or, to put this another way, I would like to claim that there *is no* circumscribed set of values in Sparshott's restrictive sense of being necessarily and characteristically aesthetic but instead some (e)valuations are aesthetic as opposed to practical or moral, instrumental or cognitive. And given an evaluation of the appropriate kind, it will result in the ascription of value. Zangwill concludes that '[b]eauty is the icing on the aesthetic cake',[24] but I suggest instead that the cake can remain un-iced yet equally palatable.

Let us see how this plays out. Responding to a gun, after having given it my disinterested attention, I might declare it elegant. This is an aesthetic evaluation, and 'elegant' is the result of it, or its extension. This implies no approbation, or final verdict as to its aesthetic merit. I might react to it with horror; I might find its elegance a demerit if the gun was intended to be menacing and powerful. But, further, I

---
[23]Ibid.
[24]Zangwill, 'The Beautiful, the Dainty and the Dumpy', 328.

do not need to make a final or categorical determination of the gun at all. *Of* a given object, I might judge it elegant and dainty but that its colours are garish. I do not need to weigh these out to conclude, in its final assessment, that it is beautiful or ugly. I may not be able to decide, in the end, or my conclusions may change over exposure or through discussion with others. Having judged the gun elegant, I have ascribed to it a value that is the result of my evaluation, and I see no reason why I cannot stop there. It may be a provisional judgement, but it is not a partial or incomplete one. It also may be accompanied by pleasure (for certain gun enthusiasts) or displeasure (for those looking for something more 'macho'), or by no emotional reaction at all. If we understand aesthetic values as extensions of aesthetic judgements, there will be no hierarchy among them or valuational difference between them. Beauty would be a value among others, as verdictive as the rest, and not in fact a final determination at all, or the result of a further 'all things considered' weighing up of other options. An object can be elegant without being beautiful – one of the merits of Zangwill's account – but it can also be beautiful without being at the same time many other things, and without its beauty being somehow final or our needing to make a final determination about it.

How many aesthetic values are there? Zangwill's account is further instructive in showing us that they can be multiplied seemingly without end: if I judge a thing to be garish, garish is an aesthetic value that I have ascribed to the object. Thomas Leddy has also recently advocated for an expansion of the number of values in our aesthetic 'bestiary', especially those most germane to everyday contexts, such as neat, messy, cute, comfortable, fun, pretty, dreary, nasty, sparkly

and so on.²⁵ Claiming that aesthetic value is whatever results from our aesthetic judgements does, however, fly in the face of a long-standing tradition that adheres to the notion that *some* values or properties are particularly aesthetic and some are not. But this tradition is what I seek to challenge here. Because there are no a priori principles or criteria that govern aesthetic judgements, there can be a great deal of openness, complexity, and inventiveness to the results of the judgements we make. We are not limited to Beardsley's finite number, in the way that I am limited to letters F through A when I evaluate students' work, or zero through four when my university calculates their GPA. Declaring there to be some finite set of values among which we can choose in our aesthetic determinations overly constrains the freedom that governs our engagement with, and response to, the world. At a dinner party, for instance, a guest exclaimed after a sip, 'that's a big merlot!' – I took this to be an aesthetic judgement about the wine (it had nothing to do with the size of the bottle), and accepted it as a normative evaluation about the object, or a claim to its having, in this case, the value of 'bigness'. Is 'big' one of a finite list of aesthetic values an object can possess? Surely not. The issue seems to be one of relevance and context. In the context of wines, it was aesthetically relevant to the guest that the merlot was big, and in this case was also used as a sign of merit. In the context of painted miniatures, big would also be relevant and not necessarily meritorious. But it would be a value nonetheless. What makes the value aesthetic has to do with our evaluative engagement with the world and our way of using terms

---

²⁵See Leddy, *The Extraordinary in the Ordinary*, Chapter 5, entitled 'A Bestiary of Aesthetic Terms for Everyday Contexts'.

to pick out an object's properties that we find germane in the very act of evaluating it.

One of the pleasures of reading critics' reviews of the arts (including cuisine) is the imagination and specificity of some of their judgements. A recent reviewer of a production of *Don Giovanni* judged the protagonist's descent into hell as having a 'proto-Romantic roar', while the 'relentless, nearly colourless austerity' was tiring, and the voice of Leporello 'gruffly adequate'.[26] These were not, pace Zangwill, mere descriptions of substantive properties, and the review did not conclude with an overall verdictive judgement about the merit of the work. As Shelley had mentioned earlier, Sibley's list, like Beardsley's, is a lexicon of terms; what makes their application aesthetic – what makes them aesthetic values – is their use in aesthetic evaluations. Shelley notes that 'many terms having aesthetic uses also have non-aesthetic ones ... A list will tell you only that certain terms function aesthetically at least some of the time. It won't tell you when ... the properties they are picking out are aesthetic values.'[27] For this, a conception of aesthetic judgement is needed.

Zangwill suggests that some aesthetic predicates are metaphorical, and others are not; in aesthetic contexts, he claims, daintiness, elegance and so on are literal, while balanced, warm (and presumably big) are used metaphorically. Further, aesthetic predicates are used metaphorically only in nonaesthetic circumstances.[28] I am not sure that we need this distinction, as it seems to raise more questions

---

[26] Alex Ross, 'The Pit and the Podium', *New Yorker* XCIX, no. 15 (5 June 2023): 83.
[27] Shelley, 'Punting', 215. Note that Shelley takes a more cognitivist and objectivist stand than I am suggesting here.
[28] Zangwill, 'The Beautiful, the Dainty and the Dumpy', 321.

than it answers, and leads into another nest of metaphysical issues, such as whether objects actually possess the properties that are non-metaphorical, but do not really possess those that are used metaphorically, and to epistemological issues of whether we can – or need to – tell the difference. To say that this is a 'beautiful' hand of cards, for Zangwill, is a metaphorical use of an aesthetic predicate (and property) in a non-aesthetic situation. It is unclear if he means I am describing the hand in a substantive judgement here but not in an aesthetic context or if I am making a verdictive judgement that is the same in both situations. We can avoid these difficulties if we allow, for instance, that a 7 no-trump hand in bridge is directly and non-metaphorically a beautiful thing and that we ascribe to it the value of beauty in a direct and literal way, just as the merlot was announced to be big, the gun elegant, the production relentless and austere.

We need not make some kind of metaphorical/literal distinction, just as we need not divide values into particular virtues and vices. There is ease and freedom in claiming that aesthetic values are all those assigned by aesthetic judgements; we need not 'layer' them, or try to distinguish their status: they are all the result not of cognitive but of aesthetic assessments. The breadth of scope of what might count as an aesthetic value mirrors the polysemy of aesthetic judgements themselves and indicates a modesty as to what their aim is: some normative evaluation of some part of an object's features that ascribes to it some value but that is not necessarily attempting to reach a final closure. Not all evaluations are final; no aesthetic values are restricted to a set few. It may be that our aesthetic vocabulary is elastic and evolving, but this is not to suggest that aesthetic

judgements are *merely* a matter of what we *say*, as though language had no conceptual or epistemological import. The line I am taking here suggests that the valuation of 'big' or 'elegant' and the like is still disinterested and object-directed, still *about* the perceptible phenomenon even though it is determined by the subject, and is an opening for discussion and debate about the extension's validity and accuracy. Whether there are *real* aesthetic values seems, again, a separate and separable issue.

We can see that an explicit connection to pleasure drops out of this account, as only contingently connected to our aesthetic judgements. Can we take pleasure in an object we judge to be beautiful? We can and we do. But we need not, and we can equally experience displeasure, or no emotional response at all. That a gun is elegant, for instance, does not make it pleasing to me, does not raise its stake in my eyes. Feeling can accompany judgement, but plays no role in a philosophical analysis of it, just as it plays no role in an account of aesthetic value. The (contingent) place of pleasure seems more often to accompany a minimalist aesthetic experience or perception itself, when we are struck by something that appears before us, before we become intellectually engaged in evaluating it. For aesthetic judgements are still a way of rationally engaging with the world, even though they are not straight-forwardly a way of cognizing it. But while the explicit role of pleasure drops out of this account, it remains implicit in the lingering connotations of merit and positivity. To further this account, I will consider recent empiricist theories of aesthetic value, where pleasure (explicit and implicit) remains relevant for all that its principals have tried to finesse it.

## Value Empiricism

What Shelley calls 'value empiricism' is, as I noted in Chapter 2, a position that holds an object 'has whatever aesthetic value it has because of the value of the experience that it affords'.[29] He links this to the work of both Stecker and Levinson, of which he is critical. Shelley sees these accounts as grappling with the normative question of what makes aesthetic value a value and claims the response is a form of hedonism: 'the view according to which the aesthetic value of an object is the value it has in virtue of some pleasure it gives'[30]; aesthetic experience as pleasurable is thereby valuable, and in this, aesthetic value lies. In another paper, which Shelley wrote with Michael Watkins, they couch value empiricism in terms of response-dependence: 'to have aesthetic value is to be disposed to bring about a particular response for a particular audience'; one of the problems of response-dependent accounts is that they 'are reductive'.[31] What they call the 'prevailing view' (again they include Levinson and Stecker here) 'holds aesthetic value to be a species of instrumental value, the aesthetic value of an object being instrumental to the value of some experience (typically described as a pleasure) that the object is disposed to bring about'.[32] But if the aesthetic value can be reduced to the value of an experience, there is no reason why something else –

---

[29]Shelley, 'Against Value Empiricism', 707.
[30]Shelley, 'The Default Theory of Aesthetic Value', 1.
[31]Michael Watkins and James Shelley, 'Response-Dependence about Aesthetic Value', *Pacific Philosophical Quarterly* 93, no. 3 (2012): 338.
[32]Ibid., 343.

'a drug or a knock on the head, for example'[33] – cannot bring about the same experience and thus have the same value. Lopes, in his discussion of aesthetic hedonism, puts the point like this:

> If the relation in which an item stands to an experience is a relation that makes it a mere means to the experience, then the item's aesthetic value is nothing but its instrumental value as a means to the experience. Presumably, the problem is that purely instrumental values are fully fungible ... Yet an item's aesthetic value is not fully fungible.[34]

The questions value empiricists need to answer are how does aesthetic value arise, and, moreover, what role does pleasure play in its ascription?

Here is Stecker: 'Aesthetic value is first and foremost the value of a type of experience.'[35] 'Aesthetic experience is object oriented. It can be directed towards a broad array of features of objects – forms, perceptual qualities, meanings. This sort of experience is valued (valuable) for its own sake.'[36] In his disagreement with Carroll that I mentioned much earlier, the reason that 'Jerome' is having an aesthetic experience, while 'Charles' is not, is not only that Jerome is attending to the object for its own sake but that 'Jerome values the *experience* for its own sake.'[37]

---

[33]Ibid., 344.
[34]Lopes, *Being for Beauty*, 56.
[35]Stecker, 'Aesthetic Autonomy and Aesthetic Heteronomy', 33.
[36]Stecker, 'Aesthetic Experience and Aesthetic Value', 4.
[37]Stecker, 'Only Jerome', 78, my emphasis.

And here is Levinson: 'I want to insist on the utility of a notion of aesthetic experience that ... is that of an experience that is inherently *worthwhile* ... that is found *rewarding* or *valuable* in some way.'[38]

I agree with both Stecker and Levinson that aesthetic experience is valuable but strongly disagree that its value is an *aesthetic* value. None of us would be in the business of philosophical aesthetics were we to think that aesthetic experience was anything other than a valuable part of our lives. But whether an aesthetic experience is valuable is also an *extra-aesthetic* question. To ask why it is good for us to have aesthetic experiences, what they contribute to a life well-lived, or why we so value them when we have them – are all questions best answered within an ethical or existential framework, rather than an aesthetic one.[39] Having an aesthetic experience and *valuing the having of it* are not the same thing, and running them together does nothing to clarify an aesthetic theory, but rather confuses it, especially when the notion of pleasure comes into play. This is the hedonism that Shelley refers to: aesthetic experiences are pleasurable, and their value lies simply in this. He writes that '[t]he value of pleasure does not need explaining. The *tout court* attribution of pleasurability implies value'. That is, you may wonder why I think a given object is beautiful, 'but you can hardly wonder at my valuing what I so find'[40] – *if* beauty is a species of pleasurability. Víctor Durà-Vilà, in his defence of Stecker, notes that 'the aesthetic judgement of an object requires that the aesthetic experience be valued for its own sake *because* of the role

---

[38]Levinson, 'Toward an Adequate Conception', 31–2.
[39]In this regard, one of the questions posed by the paradox of negative emotion is misguided: *why* we intentionally expose ourselves to painful works of art is an extra-aesthetic issue, that cannot and need not be answered by an aesthetic theory alone.
[40]Shelley, 'The Default Theory', 11.

that aesthetic satisfaction plays in our aesthetic judgements.'[41] It is this 'because' that is the source of the problem.

If finding something beautiful can be reduced to pleasure, the objections I have raised throughout recur, first, and second, the notion of aesthetic value seems an unnecessary adjunct to a hedonic theory. Could we not then say that the experience of beauty is necessarily pleasurable, as many have, and leave off the notion of value altogether? Of course we value pleasure, of all kinds, but what does this valuing contribute to aesthetic theory (other than to, perhaps, make it esoteric, as I alluded to in Chapter 1), and on what grounds is this valuing of pleasure an *aesthetic* valuing? There is no clear answer to this, unless we return to the idea that aesthetic pleasure is a distinct kind *and so* valuing it must be an aesthetic valuing. But this does not follow. Even if aesthetic pleasure were different from other pleasures, this does not mean that we value it in a specific and different kind of way. Further, if aesthetic value is the result of an aesthetic judgement, then we perforce must be evaluating the experiences we have, or have had, rather than the objects of those experiences, and I do not think that experiences need necessarily come under rational scrutiny, and certainly not under aesthetic scrutiny. If they did come under such scrutiny, then, on the account I am proposing, their predicates should be aesthetic, which would lead to the absurdity of having a beautiful experience of a beautiful object. But why should we make aesthetic judgements of experiences of objects about which we make aesthetic judgements? Not only is this a redundant move but nothing thus far suggests that

---

[41]Víctor Durà-Vilà, 'Attending to Works of Art for Their Own Sake in Art Evaluation and Analysis: Carroll and Stecker on Aesthetic Experience', *British Journal of Aesthetics* 56, no. 1 (2016): 96.

experiences themselves can become objects of aesthetic evaluations, or why the evaluation of an experience would make its value transitive to the object of that experience. Further, we cannot make aesthetic evaluations of our own experiences, because we live them rather than perceive them: they do not have perceptible properties that we can notice from our own subjective points of view, nor are we for the most part disinterested about our own experiences.

If, on the other hand, the value of the experience is not the result of a judgement, but simply part of the experience itself, this raises further questions. Shelley, in his critique, suggests that one of the faults of this view is 'to confuse the experience of value with the value of experience'.[42] And in this both Stecker and Levinson are implicated. If the aesthetic value of an object arises from, or is determined by, the experience *because* the experience is valuable, then all aesthetic values must be positive, as all aesthetic experiences are – or they are, if they are experiences of pleasure, or necessarily accompanied by pleasure. Further, we must wonder how we have contact with aesthetic value, if not through the judgement of it, and this returns us to various epistemological problems. Do we perceive it, feel it, 'experience' it in some indirect way? Perhaps Durà-Vilà was implicitly adverting to some Kantian notion that aesthetic experience just lies in the exercise of judgement, that we experience a *valuing*, but this does not explain why the act of aesthetic experiencing is necessarily something we value for its own sake, or how this valuing, again, is transferred from experience to object.

---

[42]Shelley, 'The Default Theory', 9.

Shelley's more recent work considers a further complication for empiricist theories that arises when they try to stretch an analytic link between value and pleasure to allow room for displeasure and disvalue in their accounts, only to compound these conceptual difficulties. Both Stecker and Levinson realize that aesthetic experience need not be pleasurable, but attempting to explain displeasure wreaks havoc on their equation of experience with value, and demonstrates that aesthetics traditionally cannot make room for the other-than-pleasurable because it continues to cling to pleasure as the default core of the discipline.

Here is Stecker again: Aesthetic experience 'refers to the *expectation* of finding value ... [t]he experience would always be found valuable in itself, though not always positively valuable in itself. It could be disappointing, and a disappointing experience is one found disvaluable in itself.'[43] And Levinson notes that 'the positive character of aesthetic experience is best understood as a *default* ... For it seems that experiences of the disorderly, the ugly, and the disgusting are naturally conceived as *kinds* of aesthetic experience, if undesirable ones'.[44]

Stecker, in response to criticism from Carroll, adjusts his position to further claim that we can find an experience neither positively nor negatively valuable in itself: 'To find an experience indifferent is to evaluate it. It is to put it at the zero point on a scale of value ... So [my] view is perfectly consistent with the existence of aesthetic experiences about which we are indifferent.'[45] And Antonia Peacocke, also seeking

---

[43]Stecker, 'Aesthetic Experience and Aesthetic Value', 4–5.
[44]Levinson, 'Toward an Adequate Conception', 32.
[45]Robert Stecker, 'Carroll's Bones', *British Journal of Aesthetics* 46, no. 3 (2006): 284.

an alternative to hedonism within an empiricist framework, holds that '[a]n object's aesthetic value is fully grounded in the distinctive value of a correct, complete experience of its sensory features', that need not be pleasurable: '*any* value of that experience can ground aesthetic value of its object', including experiences that are distressing, horrifying, and so on.[46]

But the value empiricists' attempts to account for displeasure fare no better than those theorists who seek to resolve the paradox of negative emotion, in part because of an elision between *valuing* (endorsing, liking or finding worthwhile) and *value* as the product of a judgement. A further confusion lies between valuing and *evaluating* (which we see in the last quotation by Stecker). Levinson notes that valuing is more than simply liking or preferring but involves '*endorsed satisfaction*', such that aesthetic experience is '*to take satisfaction in such an activity for its own sake, while at some level, endorsing or approving doing so*'.[47] Valuing has an implicit positive connotation, for Levinson, and in slips pleasure as a shadow to accompany it. Durà-Vilà's position (in reference to our experiences of fine art in particular) is that there is a '*psychological impossibility* of engaging in certain *evaluative* ... practices without valuing the experience[s] ... for *their own sake*'.[48] But it is unclear how the act of judging or evaluating an object requires any kind of pleasure or satisfaction *while* doing so, nor why the doing of it is *itself* an experience that we cannot help but value. And even if we do value our experience of evaluating, as it were, they remain distinct, and nothing suggests that the value

---

[46]Peacocke, 'Let's Be Liberal', 175.
[47]Levinson, 'Toward an Adequate Conception', 37.
[48]Durà-Vilà, 'Attending to Works of Art', 83.

of that experience is an aesthetic value in particular. Shelley is correct that there is an elementary confusion between valuing an experience and experiencing (or judging or assigning) a value. And, again, part of this confusion lies in seeing what the object of the evaluative practice is: the experience itself, or the object, and I have argued strongly that an *aesthetic* evaluation is of the latter.

As I have noted, valuing something seems to mean to endorse, or approve, or prize it. I am not sure that this involves 'satisfaction', or whether by satisfaction Levinson means 'pleasure' exactly (or if there is any phenomenological difference between the two). And I agree with Levinson that we value our aesthetic experiences (but not that we aesthetically value them, or that we aesthetically *evaluate* them). The confusion between valuing and evaluating is partly a confusion of target – experience or object – and partly a confusion of act. But its more subtle consequence is that it leads us again to the paradox of negative emotion. For if we value (in the sense of 'find pleasure in') all aesthetic experiences, then we have difficulty explaining how we value experiences of horror or pain, or we try to resolve the problem by suggesting that the *object* is horrifying while the *experience* remains pleasurable. If valuing means endorsing (without pleasure) or approving, we can endorse a painful experience as something that it is valuable to undergo for some further instrumental reason; this value will not be aesthetic, then, but of some other kind (moral, perhaps, or cognitive). This is the route that Peacocke takes, but it does not help her case: if the value of the experience is instrumental, some further explanation is needed of how an instrumentally valuable experience grounds or gives rise to an *aesthetically* valuable object.

Trying to explicitly include notions of displeasure or disvalue makes these problems more acute. Levinson needs to change tactics to admit that an experience (or judgement) of the ugly can be 'undesirable', which must mean either that there are some aesthetic experiences that we do not value, which contradicts his thesis, or that we value or 'endorse' experiences that bring no satisfaction, which contradicts only half of it. Either I value and endorse an experience that I do not want to have (if the experience is undesirable like being bitten by a dog, say) or I value an experience of an undesirable object – but why would I? If the object is undesirable in the sense I understand the term, it seems that I would reject it, and if I do, it is hard to see on what grounds the experience itself remains (aesthetically) valuable/satisfying to me. It seems I would reject one with the other, on Levinson's formulation. That 'kinds' of experiences can be undesirable seems to suggest that they are also not valuable, and if not, the inclusion of the negative undermines the empirical approach to value.

With Stecker, the qualifications to accommodate the negative are even more confounding. First, there is the alteration of his formulation from an experience of value to one of an 'expectation' of finding value, and we can ask whether he thinks we value the expectation itself, since we value all aesthetic experience (and indeed is that what we value about aesthetic experience?), or if we value the experience only if we successfully 'find' that value we were looking for (I expected a value, and found it, so the experience was valuable too). Further, it is unclear whether the success is lodged in finding the object to have a positive value (like beauty) or in finding the experience to have been valuable, regardless of what we think of the object itself. From the

quotations above, it would appear that aesthetic experience recedes from being by definition valuable to one of the mere expectation or hope of value, which undermines *his* thesis.

Like Levinson, Stecker does not want to state simply that we can judge an object ugly (a demerit, perhaps, or in their terms a disvalue) yet still have a positive (valuable) aesthetic experience because they adhere to some implicit idea that ugliness as 'negative' must perforce be displeasurable (emotion is always involved) and a pleasurable (valuable) experience of a displeasurable (disvaluable) thing is as hard for them to square as it is for anyone attentive to the paradox of negative emotion. Durà-Vilà's attempt to defend Stecker on this point does him no service. One of the implications of the idea of 'expectation' is that it once again makes aesthetic experience deliberate or intentional, if not planned, and Durà-Vilà is sensitive to the unexpected, in light of an objection by Noël Carroll, who comments that some aesthetic experiences 'force themselves upon us, unexpectedly as they say, as when strolling across a foreign city, we are abruptly taken by a striking facade'.[49] Durà-Vilà's response is that 'an early promise of aesthetic satisfaction might be disappointed as we have the aesthetic experience: the facade, which seemed so attractive at first sight, might yield a negative aesthetic experience as further inspection shows shallow ornamental effects or lack of cohesiveness'.[50] This simply reiterates the problems I am enumerating. Durà-Vilà has not understood that 'unexpected' would mean *without* any promise of satisfaction, that being 'struck' by a facade is not (yet) to evaluate it, that evaluation of

---

[49]Noël Carroll, 'Aesthetic Experience Revisited', *British Journal of Aesthetics* 42, no. 2 (2002): 145–68, quoted in Durà-Vilà, 'Attending to Works of Art', 91.
[50]Durà-Vilà, 'Attending to Works of Art', 91–2.

the facade is not an evaluation of the *experience* of it, and that whether the facade is ugly or beautiful is not internally related to the pleasure or displeasure – or lack of feeling altogether – in perceiving and judging it in the first place. The 'promise' is implicitly tied to the expectation of finding *positive* value, and this implies that the negative value of the object cannot give our experience a positive value.

Finally, we have Stecker's ultimate gambit: that an aesthetic experience is 'always' valuable in itself but not always *positively* valuable, and we must wonder what sleight of hand he offers in these idiosyncratic notions of 'disvaluable in itself', or 'indifferent in itself'. As Carroll notes, the 'valuing approach' (or the empiricist theory) 'seems to imply that aesthetic experiences are always positive':[51] this is the source of Levinson's ideas of endorsement, merit and approval (not to mention satisfaction). It does not appear that Stecker rejects these ideas of the value of experiences in themselves, even while he seems to allow for objects to have negative values more directly. But an experience of disvalue – a judgement of value as I would call it – of an object is not, again, transitive to the value of the experience itself, and when Stecker makes this move, his theory collapses. As Carroll puts it, 'it seems to make no sense at all to talk about the having of experiences that we disvalue for their own sake. Disvaluing does not seem to be an idea that we can conjoin coherently with the formula "for its own sake". Language buckles at the prospect.'[52] For Stecker, aesthetic value is first and foremost the value of the experiences 'in themselves' – for no other instrumental reason (aesthetic value

---

[51]Nöel Carroll, 'Recent Approaches to Aesthetic Experience', *Journal of Aesthetics and Art Criticism* 70, no. 2 (2012): 166.
[52]Ibid.

is, after all, on his account autonomous and *sui generis*). It is the value of the object that is instrumental. But if that is the case, it is unclear how we can be simultaneously indifferent to an experience we value, or displeased/disappointed in an experience that we at the same time take value in. Further, the idea of zero on some 'putative scale' suggests some criteria governing aesthetic judgement, just as the scale of grades governs my marking of student papers. But if, all along, we have seen – even for Stecker – that aesthetic experiences and valuations are without a priori conditions, it does not help his account to introduce one at the eleventh hour.

Part of the problem here is the placement of the predicate 'in itself'. Disinterest, as I have argued, is not a disposition or a prior state of mind but a manner of perception and a manner of judgement. The *object* is taken in itself, on its own terms, not the experience of it. The confusion of experience and object, evaluating and valuing – and the predicate 'aesthetic' applied to them – is further exacerbated when the empiricist view also applies 'in itself' to all of them as well. While I acknowledge that we value aesthetic experiences as an important part of our lives, it is counter-intuitive to claim that we always and only value these experiences 'in themselves'. We might value them because they enrich our lives, because they bring us pleasure (contingently, as I claim), because we learn from them and so on. The *value* of aesthetic experience can very well be pragmatic or instrumental in some way; to claim that it is autonomous is to attempt to move from a theory of aesthetic experience to an aesthetic theory of experience itself, from the claim that aesthetic experience is valuable to the claim that experience is aesthetically valuable. This has led Stecker,

Levinson and Peacocke into the present series of confusions, and this is why Sparshott was so concerned about the careless ways that the notion of the 'aesthetic' has been so often mis-applied. Even if we claim that aesthetic experience is of a distinct kind, nothing in this claim prohibits us from allowing that aesthetic experiences can be 'negative', if by that we mean displeasurable. And so, 'in themselves', they can be (again contingently) accompanied by pain or displeasure (or neither), but they remain aesthetic experiences and whether we value/endorse/approve having had them is not an aesthetic matter, nor does 'in-itself' apply here.

If Zangwill's 'three layer cake' had irresolvable problems in its depiction of aesthetic value, the reductiveness of value empiricism does not solve them. In both, the direction of determination of value in fact goes the wrong way: for Zangwill, the substantive properties or values of objects determined verdictive ones; for hedonists, the aesthetic value of objects is nothing but the instrumental value they have as a means of bringing about – or determining – a certain kind of experience. What I have suggested instead is that we make this experience – here, one involving a kind of judgement – first and foremost, and reverse the direction of determination: judging the object determines its value(s). But the value is an aesthetic value that the subject claims the object to possess (whatever her metaphysical commitments), because the subject has so judged it. And while that value is subjectively determined, it is not determined through a disposition to bring about a certain response. The response *was* the act of judging the object itself, before which and without which the value could not arise, rather than some further experience the

subject undergoes that is by and large pleasurable or affective in some way. With Nguyen and Gorodeisky and Marcus, the separation of merit and our response to it obscures the fact that when we claim an object to be ugly, this is because we have already responded to it; the value is the product of this response, and the object 'merits' being called ugly because we have judged it to be so.

Having given the object our aesthetic attention, we may go on to make a judgement of that object; in both cases, we do so with disinterest and in both cases the subject is implicated in the act. With that judgement, the subject makes a commitment, or stakes herself when she claims of the object that it is ugly or elegant, dumpy or graceful. But, as Watkins and Shelley note, that this value 'is inaccessible to any purely objective view, does not entail that it is response-dependent'; it is 'to admit only that it is epistemically subjective' or that it 'can only be accessed from a subjective point of view',[53] and a theory can make this claim without committing to hedonism, and without making any commitment about the value's metaphysical objectivity. The subject may be called upon to give reasons to justify her judgement, but they will be post-facto because they are *her* reasons that ground *her* experience – the one she initially had, and the more complex experience that judging is.

In the previous chapter I had suggested that there is a polysemy of aesthetic judgements, incorporating the Kantian agreeable and good, and that they can be distinguished in part by greater or lesser degrees of subjectivity and objectivity, due in part to the ultimate privacy of, for example, taste sensations of the one and the more publicly accessible

---

[53] Watkins and Shelley, 'Response-Dependence', 347.

features of objects through concepts in the other. This affects the degree of discussion and the kinds of reasons that it might be possible to provide. Here I would not like to further suggest that aesthetic values can be likewise distinguished or that some values arise only as the product of some judgements and not others. Of course 'delicious' is more often applied to taste sensations than to landscapes, but not exclusively so, if delicious scandals are anything to go by. Nor do I think we need to resort to Zangwill's literal/metaphorical distinction to divvy up aesthetic values into kinds according to their applications. Aesthetic *language*, again, can be imaginative and varied, and is obviously changing. One could advert to some picture of norms within a community that govern its use without needing to make any further claim about the values that are thereby implied. A community of wine enthusiasts might understand judgements of 'big' or 'dirty' as applied to wines, while someone new to wine tasting might not. But there is little doubt that a judgement has been passed, an assessment made – by an individual about an object – the result of which is an aesthetic value.

What this discussion indicates is how important it is to disentangle the ways that we understand and apply the notion of the aesthetic to its various predicates – attitude, perception, pleasure, judgement, experience, value – in order to construct an aesthetic theory that is clear and direct. In this process of disentangling, I have sought to demonstrate that pleasure, in particular, is not necessary to any of its separate elements. By doing so, I would like to suggest that the paradox of negative emotion can thus be dissolved. For we can judge an object horrific and feel horrified (or not). Aesthetic experience

need not provide any satisfaction but can engender the reverse; this does not disqualify it from being aesthetic in the end. And that we might nevertheless value these experiences does not mean we take pleasure in them, but that we perhaps endorse them for some reason – if we even explicitly do – and that this endorsement is beyond the scope of – does not need to be accounted for within – aesthetic theory itself.

Finally, on the accounts canvassed here, not only can we excise pleasure from playing a necessary and central role in any aesthetic act or predicate, we can also let go of the dichotomy of positive and negative, merit and demerit, as a necessary polarity that governs the value of our experiences, or the results of our judgements. For, just as Zangwill's daintiness need not be a 'good-making' property (or value), neither is dumpy necessarily a demerit when ascribed to an object. And we can go further: that *ugly* has long been considered negative is tied to the commitment that our experiences/judgements of it must bring with it displeasure, just because beauty has long been seen to be a form of (pleasing) excellence. But once we have divorced the value of aesthetic experience (as worthwhile, but as extra-aesthetically so) from the evaluations that take place *within* our aesthetic experiences, we can let go of this putative scale of values. Ugliness need not be a demerit or negative evaluation, just as it need not be unpleasant: it can be delightful, or comical, or none of the above. Arnold Berleant, who was perhaps the first to explicitly discuss so-called 'negative aesthetics', made the point that 'identifying a range of aesthetic value between positive and negative poles greatly oversimplifies the normative range and complexity of these values ... [they] are not unequivocal concepts

or opposites but only salient points of a nuanced, non-sequential, and complex range of aesthetic values'.[54] Abandoning the centrality of pleasure, and by extension the dichotomy of value, in fact frees up aesthetic theory to incorporate numerous ways that we encounter and respond to the world around us, which encompasses a shifting range of judgements and values more reflective of the multiplicity of human experiences. It is that freedom that I seek to encourage.

Let me conclude this chapter by returning to the Sparshott Test. Is aesthetic value a recognizable phenomenon – can we differentiate it from other kinds of values? I have argued that we can, if we make a strong link to aesthetic judgement and claim that aesthetic value is whatever is ascribed in the act of judgement and serves as its extension. Is it a single phenomenon, which is the same in all aesthetic instances? Aesthetic values, I have argued, are plural – they can be multiplied indefinitely, limited only by context and relevance. And while daintiness and elegance are the same – recognizably dainty or elegant wherever found – the role they play in judgements, should we make them, is diverse and not necessarily trending towards merit or excellence. Is value necessarily connected to the aesthetic? If aesthetic judgements are contingent, aesthetic values are as well, except that *if* we make such a judgement, it is necessarily the case that we are evaluating a phenomenon, and thus are ascribing a value to it. Finally, the act of judging and ascribing value is what makes the phenomenon aesthetically distinct, as being graceful, garish, ugly or beautiful. We cannot determine these objects to possess these values independently of our engagement with them.

---

[54] Arnold Berleant, *Sensibility and Sense: The Aesthetic Transformation of the Human World* (Exeter: Imprint Academic, 2010), 156.

Questions that I have skirted here are metaphysical: What exactly *is* a value, and does it *really* exist as part of the furniture of the world? If an aesthetic realist wishes to answer 'yes' to this latter question, the onus is on them to provide an ontology of value. It is not part of a description of aesthetic experience itself. A realist will also need to provide some epistemology that describes our cognitive access to values, that does not do damage to the theory of judgement in the Kantian line. This does not seem impossible, as I have noted, except that I maintain it cannot be felt sentiment or pleasure that is the sole avenue for our assigning or recognizing value, nor that an aesthetic judgement can be reduced to a cognitive one.

Peacocke noted two advantages to her 'liberalism' about aesthetic value: that it allows for multidimensionality and transformation. While I find her commitment to empiricism undercuts her position, these advantages are real. She notes that aesthetic experience 'presents or represents the world with many different kinds of properties, along many different kinds of dimensions'.[55] The excision of pleasure as a necessary part of that experience is what opens it up; with hedonism, aesthetic experience is flattened into one dimension, where all that matters is a positive kick and all that is incorporated into our experiences is merely instrumental to providing it. But our aesthetic lives are more nuanced and more textured than the anticipation or achievement of pleasure, and our engagement with the world is more nuanced and multi-faceted than a hedonic account can make room for. Judgements are not a mere 'thumbs up' (or 'down'); they

---

[55] Peacocke, 'Let's Be Liberal', 178.

are inventive and complex – a hedonic theory is reductive and ignores this complexity and freedom. Aesthetic experiences can also be transformative – of both us and the object. Peacocke notes that aesthetic objects can 'change who we are and what we think ... They can help us see the world in ways that were not previously available.'[56] Pleasure alone does not have this kind of power. But if aesthetic experience brings subject and object closer together through interaction and engagement, it follows that both will be affected, and indeed altered, in this exchange. That may just be part of what defines the aesthetic dimension of our lives.

In attempting to answer the aesthetic question, using Sparshott as an able guide, I have found a richness in the discipline's breadth of approaches – and yet have demonstrated that, at bottom, the discipline suffers from clinging too narrowly to a small set of outdated and indefensible shibboleths that have impeded its progress, even while it has tried to incorporate ever new objects, activities and categories within its compass. Even those who no longer explicitly equate the aesthetic with beauty, art or pleasure still have not recognized that the remnants of these precepts dog their attempts at original conceptions of what the aesthetic means, or how it can be understood. Providing a theory of the aesthetic does not require a wholesale dismantling of its tradition or the construction of an as yet unheard of method of theorizing: it requires merely a recognition of the impediment these vestiges present, and an acknowledgement that, with their removal, aesthetic theory can be enriched and expanded

---

[56]Ibid., 179.

in ways more reflective of contemporary philosophical and cultural realities. Using the tools already at our disposal, I suggest that the discipline can become more open-ended and multi-dimensional than it has heretofore been. In the next chapter I will try to suggest some ways to (re)capture this openness, breadth and theoretical freedom.

# 5
# Aesthetic Experience

In seeking to answer the primitive question that has motivated this work – what is the aesthetic? – I not only framed it in terms of a form of experience but also divided that notion of experience into separate elements for the purposes of exposition and analysis: attention, judgement and value. As I noted at the outset, the primitive question perforce delimits the range of answers it can provide, and I have restricted my account to only these three. This is not to suggest that the aesthetic can be reduced to only these, or that theorists in the discipline haven't a much wider range of interests and preoccupations: they have. But the aesthetic question has seemed foundational to the pursuit of these other interests, the answer to which can only help clarify various conceptual problems, avoidances and elisions that have dogged aesthetic theorizing, and perhaps have hindered its progress. My task in this chapter is to draw together those separate elements into a synthetic whole, and to point the way forward, to how a clear conception of the aesthetic at its root can enhance the discipline. I will do this by ranging broadly over certain themes that have run through the analyses I have presented and that make them more explicit. Two

that stand out for elaboration are attention itself and the subject/object relation. I will begin here with the first.

## Attention

One of the benefits of an emphasis on disinterestedness in attention is that it allows for perception without preconception: absent cognitive or moral or instrumental interests, aesthetic attention is, to follow Sparshott, 'attention in spades', where the focus is on the object in its individuality and immediacy. This disinterested attention is, perhaps ironically, also without aesthetic preconception in the normal sense of the term: without the expectation of pleasure or of the apprehension of beauty as a kind of value. It is thus also perception without specific purpose and this purposelessness is one of the elements that marks a kind of experience as aesthetic in the way I have highlighted the term, on a minimalist account. A more robust theory of aesthetic experience, one that includes judgement and (e)valuation, nevertheless also begins here: disinterested attention is a necessary condition for an experience to count as aesthetic, or is just what the term 'aesthetic' means when used to describe one form of human interaction with the world. There is little that is particularly novel in this usage: it echoes the Greek notion of *aisthesis*, as we have seen, and even the Kantian notion of the aesthetic as non-cognitive perception (or intuition) from the first *Critique*. The important difference is that for Kant, the Transcendental Aesthetic was in the service of cognition, a necessary first step on the way to knowing, while I instead seek to emphasize that

attention here serves no instrumental purpose and no other, higher, goal. The qualification of 'aesthetic' as descriptive of some experiences over others carves out a space where attention maintains a certain amount of autonomy from our otherwise guiding interests. In this, aesthetic experience is not pre-cognitive or leading *to* cognition but importantly *non*-cognitive in that it does not terminate in any kind of determination about the object itself. And this is what sets the aesthetic apart from other experiences, and other kinds of attention, in a way that makes it unique. It is only when we pay aesthetic attention to the object itself that we simultaneously experience a release from our other human concerns.

Empirical knowledge, in particular, while it begins with sensory experience, does not stop there: an effort to categorize, determine or conceptualize the world seeks commonalities between objects as it tends towards an essentializing, even totalizing, goal. What is left behind in the act of cognition is the very individuality and particularity that aesthetic attention fixes on. To determine that this is a cat and not a squirrel is to focus only on the features relevant to the specific category, and to dismiss the rest. Empirical knowledge, in an important regard, requires that we create distance from the rich panoply of our perceptions in order to narrow them down in an act of abstraction that leaves only those features that are germane to a given conceptual category. But, as Baumgarten (coiner of the term 'aesthetics' as a distinct discipline) asked, 'what is it to abstract, if not to throw away?'[1] The colour of a cat's fur, the glint of its eyes, the peculiarity of its gait, the timbre of its meow – all of these are

---

[1] Alexander Baumgarten, *Aesthetica*, § 560, quoted in Mary Gregor, 'Baumgarten's *Aesthetica*', *Review of Metaphysics* 37, no. 2 (1983): 365.

incidental to those features that we identify with its being one kind of animal rather than another. Moral, economic, political (etc.) preconceptions equally involve a focus on only those features of an act or object that are seen as relevant at the time of a given judgement or determination.

What makes an experience particularly aesthetic – and what accounts for its richness and promise – is that, when disinterested, attention is free to move broadly and more inclusively across the features of a given phenomenon. Aesthetic experience becomes, then, our point of contact with the *individuality* and *peculiarity* of an object, paying as much heed to its 'accidental' features as to those that are 'essential' to making it a recognizable kind. It is only through sense perception that we have direct or immediate contact with the world, and it is only through disinterested aesthetic attention that this contact achieves any kind of autonomy when the various perceptible features of the object become equally relevant, or equally germane to our consideration. Our experience is aesthetic when it preserves rather than throws away the details and particularities that emerge from our immediate engagement. And this kind of attention renders the object an aesthetic phenomenon in the broad sense because it becomes – in-itself – the focus of our consideration, without categorization or delineation. And, equally, the breadth of this attention to accidental detail can focus as much on elements of an object that may be judged ugly or horrific or disturbing as it can on those elements that might be contributive to beauty or excellence.

One of the reasons I have preserved the notion of 'attention' to describe this minimalist experience is that it is derived from the

Latin '*ad*' and '*tendere*', or to 'reach toward' to 'bring closer', and this highlights the *active* and interactive aspect of this initial encounter. Cognition, as with moral and prudential judgements, serves to distance us from the immediacy and multiplicity of an object through the enframing of it as a certain kind, as merely a token of a broader and more abstract type. With aesthetic attention, especially as it may involve the proximal as well as the distal senses, the object is brought closer as it comes into our orbit, even more so when, as the Everyday movement stressed, we often have to interact with and use the object in order to have an aesthetic experience of it. Whether we use it or not, though, we do need first-hand acquaintance with a given phenomenon, in order to have an aesthetic experience of it, whereas cognition (and moral judgements) can succeed at much greater remove. The point is that in a bona fide aesthetic experience, we do not and cannot anticipate or pre-determine which features of an object will draw us in: we are not limited to a Bellian emphasis on significant form, or a Beardsleyan analytic set of properties such as unity, intensity and complexity that entail pleasure and value. We may be met with disunity and disorder; we may attend to the jarring and the discordant – aesthetic experience, even while disinterested, draws us *toward* an object's features rather than keeping them or us away, as Bullough's notion of psychical distance sought to do.

*Ad tendere* signifies an attention that reaches *toward* the multiplicity and richness of the sensory world rather than distancing us from it, and in this it implicates the subject as much as the object. But it does not thereby imply that we fail if we do not grasp the whole of it, or its significant or relevant features. While perception, as Sparshott

noted, is an 'achievement' word – we do not fail in the doing of the act – it remains underdetermined which features of an object will strike us or which we will focus on, in any given experience, or even from one experience to the next of the very same object. Indeed, requiring us to grasp the whole would be impossible, as perception is always partial, perspectival and governed by any number of environmental, social and cultural conditions, as Paul Ziff saw. It was in fact Baumgarten's project that a 'science' of aesthetics, as Mary Gregor has noted, has as its goal the *perfection* of what he called 'sense knowledge', through the establishment of rules for developing it found in the nature of perception itself.[2] While I do not disagree that we can learn to become more perceptive or discerning when we consider our surroundings, the notion of aesthetic attention I emphasize here is one that can successfully happen without rules, without training, without even prior intention, but that can arise equally when we are taken by surprise, and/or when our perceptions are indistinct or even confused.

Aesthetic experience occurs, again, without standards or preconceptions, and in this it is freer and more open-ended than cognition, other kinds of judgements, or Baumgarten's science would require. And by this point, it should be clear that there is no necessary role for pleasure to be had in an account of aesthetic experience that focuses minimally on attention itself, or more comprehensively on attention and subsequent judgement and valuation. In fact, the exclusion of pleasure as a condition of such experience is precisely what provides the breadth of scope to the aesthetic that allows it to

---

[2] Ibid., 360.

include experiences that are difficult or disturbing; that can consider so-called 'negative' properties as much as those that might be found to contribute to beauty or excellence of some kind; and that leaves open the sorts of responses that can arise from the initial attention itself. The perceptual autonomy of the aesthetic that I have referred to is equally an *affective* or emotional autonomy from what would limit the freedom and multiplicity that characterizes this engagement with the world.

Attention is key to this account not only because the aesthetic begins here but because the aesthetic is at heart defined by an experience that brings together – and alters – both subject and object through a specific, and often quite intimate, interaction. The object, as I have noted, when taken as it is in itself, becomes an aesthetic object rather than a token of a type, whether that be an example of a concept, an instance of a sort of action or an individual of a species. Its 'nature' or determination is held in abeyance for the duration of our attention; the object in this sense, at least for a time, is free. The subject, too, experiences a certain freedom or autonomy through disinterest; one could say she becomes an 'aesthetic subject' for the duration of this interaction. Her 'nature' as harried pedestrian, hungry cook, meticulous scientist – however her preoccupations define her intentions and actions – when held in abeyance, provide a kind of autonomy in which she stands in relation to the world. If the subject is not disinterested, if other conditions intrude (lateness for an appointment, fear of wasps, hunger), it is not that she will fail to have an experience – she will just have some other kind.

Nothing in my account has made empirical claims as to frequency – or rarity, importance or superfluidity – of aesthetic experiences, nor claims as to how to 'achieve' the requisite disinterest. My goal has simply been to analyse the components that make aesthetic experience what it is. In doing so, I have relied heavily on the notion of disinterest, which has a long history in the discipline, and not a few contemporary detractors. Many of the objections come, not surprisingly, from response-dependence theories, and hedonist ones in particular. As Lopes has noted, they 'accept it as common ground that aesthetic values bear a non-constitutive relation to disinterested pleasure, so the disinterested pleasure theory is false'.[3] This is as it should be, for 'disinterested pleasure', as another iteration of specifically aesthetic pleasure, we have seen, is a notion that is difficult to defend. But if we are truly disinterested, it should be from pleasure as well, which is as influential and binding – as detrimental to freedom in the experience – as instrumental, moral and other concerns would be. 'Disinterested pleasure' seems, on my understanding, to be an oxymoron. When disinterest is divorced from pleasure, however, its 'rehabilitation' (or, perhaps, clear understanding) as a central notion in aesthetics is made possible, and the benefits of its centrality as a way of 'nailing down' what the aesthetic amounts to should by now be clear. Aesthetic value bears a 'non-constitutive' relation to any kind of pleasure – and to the instrumental good – because it is the product of an evaluative act, and cannot be reduced to any other value.

While the Latin roots of *ad tendere*, as bringing closer, also imply the formation of a relation between the subject and object, I have,

---

[3]Lopes, *Being for Beauty*, 45.

throughout, been sensitive to the variability and mutability of this relation, and this is the second theme that needs some elaboration. To do this, I will roughly sketch two relational models – call them 'cognitive' and 'experiential' respectively – and show how a careful understanding of this relation is necessary for a sound aesthetic theory.

## The Subject and Object

When we make an aesthetic judgement, of dumpiness or delicacy and the like, we are more narrowly limiting the breadth and freedom of our initial attention, in that our evaluations have a certain specificity that makes a phenomenon a particular aesthetic object in the stricter sense as having an identifiable aesthetic value. Yet because aesthetic judgements are provisional rather than determinative, normative rather than conceptual, they allow for alteration: they leave open which features of the object will be taken up in the making of them, they leave room for the giving of reasons, for discussion, for the changing of one's mind. So long as disinterest remains the manner of attention, even evaluative attention, so too remains a certain amount of mutability and freedom. If the judgement becomes too rigidly fixed, or does not begin with the specificity of attention to that individual aesthetic object, we move from the aesthetic to something else: logical judgements for Kant ('all roses are beautiful') or even cliché, where what seems like an aesthetic judgement is a parroting of (or acquiescence to) some general public opinion, the authority of

experts or the testimony of others. How often have we heard that 'the Mona Lisa is beautiful, or excellent, or [insert value of choice here]', even by those who haven't seen it? Yet the conditions at the Louvre make it impossible to attend to the painting with anything like disinterest, or even to clearly make out its features: such a judgement becomes hollow and inauthentic. Genuineness in evaluation requires, first, aesthetic attention, and second, that the subject herself make the assessment and in doing so stake herself, and leave herself open to providing reasons that are *hers*. The subject remains the determining ground of aesthetic value.

The move from pre-evaluative to evaluative act remains aesthetic so long as the primary conditions of active engagement and disinterest pertain, and these include the freedom and mutability I have described. It is when one or other of the relata in this encounter are neglected or dismissed that an aesthetic theory falters.

Of course, cognition and other forms of judgement also imply a relation between subject and object, but these depict the relation quite differently and have informed a number of aesthetic theories. With cognition, for example, the relation is rigidly designated and inflexible, governed by (often) a priori standards and principles, and the object is often characterized as inert. Kant, for instance, described judgement as 'the faculty for thinking of the particular as contained under the universal', for both cognition and moral assessments. He noted that '[i]f the universal (the rule, the principle, the [moral] law) is given, then the power of judgement, which subsumes the particular under it … is determining'.[4] For Kant, our faculties are legislative,

---

[4]Kant, *Critique of the Power of Judgement*, AK 5: 179.

or rule-governing, and the rules are provided a priori to be merely applied to the perceptible object at hand. Epistemology beyond the Kantian context still adheres to certain set standards or principles, such as those governing truth and justification, and non-Kantian moral (or political or economic) theories are often couched in terms of the application of prior principles to particular cases or situations. In these instances (and, perhaps, depending on one's metaphysical commitments) the object is inert, lying ready for apprehension and categorization and the subject perceives it from a conceptual and existential distance.

This 'cognitivist' relational model can be found in a number of aesthetic theories, such as Carroll's, who notes, 'attending to formal properties, aesthetic properties, or expressive properties is disjunctively sufficient for counting the experience aesthetic' whatever interests or purposes may have been brought to bear at the time.[5] Levinson requires, as we have seen, that we attend to an object's 'forms, qualities and meanings' as well as the 'low-level' perceptual features upon which they supervene; for Zangwill, substantive properties determine the object's (final) aesthetic value. For Bell, significant form is the only aesthetic value; for Beardsley, there are analytically a set few. Hogarth famously reduced beauty to 'one precise line ... the *line of beauty*' that accounts for the 'different degrees of beauty belonging to those objects that possess it' and equally accounts for the ugliness of those that don't – in art, nature and artefacts alike.[6] In

---

[5]Carroll, 'Recent Approaches to Aesthetic Experience', 173.
[6]William Hogarth, 'Analysis of Beauty, Written with a View of Fixing the Fluctuating Ideas of Taste', in *Eighteenth Century British Aesthetics*, ed. Dabney Townsend (Amityville, NY: Baywood Publishing, 1999), 218–19.

these cases, what we find is a rigidly designated formal relation where the subject perceives the properties of an object, without a further description of the *way* that is achieved (i.e. with disinterest). The apprehension of the properties in some cases merely needs to occur (this is the source of Carroll's debate with Stecker) and the object in this regard can be characterized as lying passively at hand and merely containing features that can be picked out. Further, though, in many of these instances, certain a priori standards or principles pertain in the aesthetic experience, as designating what will count as beauty or aesthetically relevant properties from the start: they are those under which our more detailed perceptions will be subsumed in the apprehension or judgement brought to bear upon them, thus serving to severely clip the wings of the freedom I have already described.

While I have all along maintained that cognitive judgements cannot be aesthetic, what I wish to highlight here is *why*, in terms of the subject/object relation. When the object is inert, merely possessing certain properties, and/or when the subject is guided by some a priori principles or analytic conception of aesthetic value, the relation between subject and object is greatly etiolated and becomes both distant and fixed. Built into this model is also an implicit notion of correctness, or its converse, failure, as when we fail to apprehend the beauty an object possesses, when we lack sufficient sensitivity or when we simply focus on the wrong properties. This rigidity and distance deny the multiplicity, variety and provisionality we find in aesthetic judgements, and for the most part dismiss the active role of the subject as the determining ground of aesthetic value.

The cognitivist model is not wholly wrong; even the robust account of aesthetic judgement has a narrowing effect on the initial

freedom of attention: to judge an object beautiful or ugly does indeed 'fix' it as having certain aesthetic values. What I have sought to stress is that this fixing is provisional and that it is underwritten by the subject, not the object. While aesthetic judgements have a certain formal structure, they are not preconditioned by static rules, or a priori values that have been determined in advance of a specific judgement being made, and under which our perceptions are subsumed.

Aesthetic judgement as I have characterized it is meant to reflect more realistically our everyday aesthetic lives and acts: we sometimes find we cannot form a judgement; we disagree; we change our minds. Aesthetic theories on the cognitivist model do not allow for these situations – or they try to fit them in through complex and circuitous caveats. We saw some of this in the last chapter. Judgement is equally an 'achievement' word, in that we cannot fail in the making of it, in part because it does not contain, even implicitly, any standard of success due to its subjectivity and mutability. On my account, rather than creating distance, aesthetic judgement brings us closer to the object because the particular features that inform our evaluations cannot be known a priori, are not limited to only a select few, and their evaluative force emerges only within the context of a judgement made by the subject that responds to the particularity of what she has noticed with disinterested attention. The variability and multi-faceted breadth of aesthetic judgements – and the ample room for disagreement and critical discussion – stems in part from this open-endedness, where some features will be highlighted in one person's evaluation over another's, and where *what* is relevant in the process is almost wholly undetermined. If a neolithic sculpture (to take Zangwill's example)

is beautiful because dumpy, it is not because of some supervenient relation that dumpiness has to beauty but because I have noticed that dumpiness – brought it closer – and found it to be relevant, if not central, to my assessment of the sculpture. If you have not noticed this feature, or noticed it but disregarded it in favour of, say, uniformity or fierceness, this will alter your judgement and provide grounds for the post-facto reason-giving that may arise in our disagreement over the sculpture's aesthetic value(s). But in no way is there *truth* to my assessment, and in no way can I claim to have knowledge of some independent property that an object possesses. Aesthetic theories that cleave to a cognitivist model lose out in flexibility and also tend to exclude the great many things that have aesthetic value, and the sheer breadth of aesthetic values that there are. They highlight the workings of the subject (under certain conditions) while neglecting the role that the object plays in initiating and opening us up to the possibilities in our encounters.

At the other extreme, the subject/object relation can be characterized as one of the dissolution of the former through immersion in the latter. In a recent article, Harri Mäcklin has described this as '*aesthetic forgetfulness*' where one is so 'immersed in the aesthetic phenomenon' as to forget oneself as the subject of the experience, or even to achieve 'the annihilation of the individual', and Mäcklin finds this formulation prevalent in one guise or another throughout modern aesthetics.[7] Here, 'the aesthetic object consumes

---

[7] Harri Mäcklin, 'Aesthetic Self-Forgetfulness', *British Journal of Aesthetics* 61, no. 4 (2021): 526–7. Mäcklin takes the 'annihilation of the individual' from Nietzsche's *Birth of Tragedy*. In his paper, Mäcklin is critical of some of the more extreme forms of this relation, although he endorses it overall.

the subject's attention to the extent that the reflective separation of the subject and the object becomes impossible'; 'it is the aesthetic object that takes the active role, occurring on its own and taking control over the perceiver'.[8] Mäcklin finds echoes here of certain formulations of mystical and religious experiences, as well as so-called 'flow' experiences, where in certain activities such as dancing, tennis and other sports, one becomes so immersed as to 'lose' oneself in the moment.[9]

Allusions to this kind of experience can be found in Everyday Aesthetics, as when Sherri Irvin mentions Zen practice in the context of drinking a cup of coffee or scratching an itch,[10] and Yuriko Saito refers to Zen enlightenment where 'we "enter into" or "become one with" the object with our entire being', collapsing the two almost entirely.[11] Mary Wiseman also adverts to self-forgetting when she describes the aesthetic element of going to the dentist: 'the person in the dentist's chair can focus so intensely on the pain that they are absorbed into it and no longer feel it. It is as though the pain is all there is.'[12]

The contrast with the cognitivist model lies in the emphasis on this experiential component. In this case the object is not inert but active: it impinges upon the subject's attention to such a degree that not only does it no longer matter what features the object possesses but both subject and object seem to dissolve into an immersive experience itself

---

[8]Ibid., 530, 531.
[9]Ibid., 528–9.
[10]Sherri Irvin, 'Scratching an Itch', *The Journal of Aesthetics and Art Criticism* 66, no. 1 (2008): 31–2.
[11]Yuriko Saito, *Aesthetics of the Familiar* (New York, NY: Oxford University Press, 2017), 17.
[12]Wiseman, 'Damask Napkins', 141.

where the 'actual world recedes into the non-thematic background of the experience',[13] and all conceptual and existential distance is abandoned. This experiential model cannot be governed by any a priori principles or criteria brought to bear upon the phenomenon, and in fact aesthetic judgement becomes impossible. As Mäcklin notes, adopting a 'reflective stance' towards the object that is required for evaluation 'effectively terminates immersion in the object as it [re]introduces the subject-object divide'.[14] While the experiential model emphasizes the intimacy of aesthetic attention, it cannot proceed beyond it to a fuller conception of aesthetic experience that includes our normative and valuational responses without doing damage to that attention; it perforce remains minimalist. At its extreme, there is no longer a specific object whose features we give our attention *to*; we are no longer 'perceiving' in any normal sense of the word, and it is the subject who becomes passive under the onslaught of the world. This formulation does indeed become quasi-mystical, as the subject loses all reflexivity and self-awareness, if not agency altogether.

Experiential accounts do not offer analysis in terms of principles, norms or conditions: they cannot. In this they also tend not to argue for a position and cannot really be called aesthetic *theories* at all. They rely on description – if not poetry – for the most part (and we can see this with much of the literature on the sublime from the nineteenth century). In this it is difficult if not impossible to assess, support or refute them: one intuitively feels their force or one does not. Nevertheless, the experiential model does highlight some aspects of the minimalist account, in its focus on the intercession of the

---

[13]Mäcklin, 'Aesthetic Self-Forgetfulness', 532.
[14]Ibid., 536.

object in our lives, providing an 'unsolicited aesthetic interjection' in Riggle's words, that shakes us from our preoccupations and initiates a disinterested experience. It also highlights experiences that do not require judgement, yet remain legitimately aesthetic nonetheless. The cognitive model, while it does provide the means for aesthetic judgement, seems to provide them at the price of immersion in the experience itself.

I have painted these two models with a very broad brush, in order to contrast them at their extremes and highlight their features as well as their application to aesthetic theories that will be incompatible because of their adherence to one over the other and impoverished thereby. Certainly there have been attempts to bridge the divide between the two, as we saw with Stecker's debate with Carroll, where the former sought to add an experiential component (valuing of the experience for its own sake) while retaining the autonomy of aesthetic value as a sui generis kind. Bell claimed that our access to significant form comes only through 'aesthetic ecstasy' and Goffin's notion of 'aesthetic representation', as with Nguyen's 'feeling graceful' seem to be trying to capture an experiential (although not mystical) element in their theories. One might expect my account of aesthetic experience to claim to provide a better way to merge these extremes, or to call for a balance between them but that is not my goal here, as I find them to be fundamentally irreconcilable. Some iteration of each model can be made coherent, and each has benefits and real world applications: being given a book of paint swatches or a catalogue of lamps and asked to select the one I find most beautiful, I would probably approach the task with the making of a particular judgement in mind. I can also imagine being so struck by an object that I am immersed in the

experience of it to the suspension of judgement altogether, as when seeking an exit from the Louvre, I instead bumped into a Moai head from Easter Island that was so monolithic, I was overwhelmed by the thing.

I am instead interested here in what these two models, while disparate, share at an even more fundamental level, and which I seek to challenge. At their extremes, and for their stoutest adherents, both models are monistic – there is *one* type of subject/object relation, *tout court*, that is definitive of aesthetic experience, and this monism is as damaging and narrow as the claim that there is only one kind of emotional engagement – pleasure – that delineates the aesthetic tenor of our lives. But relations are not immutable or fixed; they can vacillate between points, or between relata, and alter according to circumstance, intention or any variety of conditions, just as relations can also develop, mature or even break down altogether. The openness and multi-dimensionality that I seek for a richer account of the aesthetic requires sensitivity to this, and a more nuanced approach.

To begin, it seems that our attention can be more or less immersive, or more or less attenuated while still remaining disinterested. Surely we do not need to attain complete self-forgetting in order to characterize our experience as aesthetic, yet this is what Mäcklin describes in thinkers as diverse as Diderot, Nietzsche, Schopenhauer and Dewey.[15] And this seems to be the direction of Saito's remarks, as in her problematic conception of everyday experiences as being 'frameless' or without any physical or conceptual boundaries that distinguish a

---

[15]Ibid., 527–31.

particular object as being the focus of our directed attention.[16] But there must be a perceptible phenomenon that we attend to, in order to distinguish an aesthetic experience from that of dreams or drug-induced hallucinations – or from at-oneness with the world. And this object can impinge upon us with greater or lesser force; it can come upon us as much as we can intentionally seek it out. A trip to an art museum requires that the agent play a stronger leading role than when we are surprised by beauty; in one case the subject (and her purposes) will be foregrounded, and in the other the object itself will direct the encounter. In both cases, the experience only becomes aesthetic when it arouses – or is accompanied by – our disinterested attention, however that attention has been solicited, and in both cases disinterest might be inhibited for any number of reasons. A minimalist account of aesthetic experience is not measured by intensity any more than it is measured by affect, and thus the subject/object relation need not be so strictly circumscribed in either one way or the other but can be seen as more dynamic and irresolute as it fluctuates between its two points.

As to a more robust aesthetic experience, my discussion of a continuum of aesthetic judgements has also been meant to capture this variability and flexibility in the subject/object relation. Rather than there being *one* aesthetic judgement, *tout court*, they can exhibit at times greater subjectivity, as with the case of the agreeable, or greater objectivity as with the case of the good. The Kantian sublime, in the initial violence it does to human rational capacities, perhaps hives closest to the experiential model, as does the agreeable with

---

[16]See Saito, *Everyday Aesthetics*, 18–21, and my critique of framelessness in Forsey, *The Aesthetics of Design*, 211–23.

the immersiveness of sensation; the good resembles more closely the model of cognition. In each case, the judgement has a certain logical form that picks it out as aesthetic – normative, prescriptive, disinterested – but this form does not limit the possible fluctuation between subject and object in the (continued) encounter, nor does it curtail all possible freedom in the experience. One of the relata can be predominant and can condition, for instance, the amount and degree of articulation and reasons that can be demanded or provided but the judgement remains aesthetic in spite of this.

Finally, judgements result in the assignation of aesthetic values to the object assessed, whatever the details of the subject/object relation might be. While it might seem as though Kant differentiated the agreeable, the good and the beautiful (as well as the sublime) in terms of their resultant valuations, I do not want here to suggest that an alteration in the emphasis of subject or object need to precipitate or end in a particular value or set of values, nor that aesthetic values can thereby be divided into respective kinds. The open-endedness and plurality of aesthetic values cannot be so easily categorized, nor need they be so strictly circumscribed. What makes something an aesthetic value is only that it is the result of a judgement, not that it has some independent properties of its own. And, if these five Kantian kinds are all forms of aesthetic judgements, then there is no reason why they cannot result in the very same value, whatever their other differences. Elegance, for instance, is elegance wherever it appears, and can be the product of a range of judgements. A flower or a seashell can be 'purely' or 'freely' elegant, as with Kant's notion of beauty. But I can judge a gown elegant, as appropriate for a state dinner and thus

as also 'good' against a conceptual background of the kind of attire one ought to wear to these sorts of events. And, while 'elegant' may sound odd when applied to food tastes, Korsmeyer provides an interesting discussion of the expressive qualities of foods and their relation to taste, as with the agreeable.[17] Nor do I mean to suggest that elegance, for instance, need to be a positive or good-making value in our assessments. That gown's elegance could be detrimental in the context of a camping trip, just as a gun's elegance might detract from the show of force I was hoping for, or the elegance of that dish could detract from its flavour if, feeling down, I had hoped for comfort food instead. The polysemy of aesthetic judgements leads equally to the multiplicity of aesthetic values, and I have all along argued against limiting them to a circumscribed set few, or predetermining whether they have negative or positive force.

This is not to claim that Kant was correct in his particular taxonomy of judgements (or that he has exhausted their possible variety), but his division of aesthetic judgements into subsidiary kinds, as with an easing of the rigidity in our attention, suggests a route towards opening up the notion of aesthetic experience from a monistic account to one that is broader, and more multi-faceted, and that appreciates the subtle ways in which a number of factors can contribute to our assessments. I have all along argued against purity or one-hundred-percentness in the delineations of any of the elements of aesthetic experience, as I find such a demand has more weaknesses than strengths. Judgement is complex, as perception is complex, and a nuanced theory can address this complexity by allowing for flux

---

[17] Korsmeyer, *Making Sense of Taste*, 132–6.

and variability in the way that subject and object come together. Within aesthetic theory, it is both intuitive and promising to suggest that, beyond a primary logical form, our judgements can range from the relatively simple and straightforward to the mixed and the complicated, while still retaining their aesthetic character, just as our attention can be more or less immersive. Here I have described that range in terms of the vacillating relation between subject and object, where one of the relata may have predominance at different times, in different circumstances, and due to different influences or different intentions while retaining the descriptions of the individual elements of aesthetic experience as they stand. And I have done this in the spirit of an invitation to greater breadth in aesthetic theorizing from a monistic model to a more pluralist conception. There is a final characteristic that the cognitivist and experiential models share, that of *harmony* in the subject/object relation, and this too permeates much of aesthetic theory. It also appears to be an implication here, as though some kind of ideal balance can be achieved – even, perhaps with Kantian 'pure' judgements of beauty themselves. I will attempt to dispel this implication and reject the notion of harmony altogether, as I close out this account.

## Discordant Aesthetics

Harmony contains connotations of pleasure as well as positive valuation, and I do not intend here to reprise the arguments against pleasure I have already made. Instead, I would like to return to my

introductory comments, where I adverted to notions of consolation, reconciliation and tranquillity embedded in historical conceptions of beauty, and show how these play out – and need not play out – within the subject/object relation that underwrites aesthetic experience. This harmony is most apparent at the extreme of the experiential model, where our immersion in the moment provides an 'at-oneness' or complete attunement with the world which, even if it involves pain as per Wiseman's example, nevertheless demonstrates the achievement of a harmonic balance between the two relata, if not an obliteration of difference altogether. But harmony also figures in the cognitivist model, just as it does in epistemology more generally, for theories of knowledge are premised upon the idea that the world is in principle graspable, knowable, with the faculties we have: were it not 'fit' for cognition, epistemology as a discipline could not begin. Cognitivist aesthetic theories equally presuppose a harmonious relation between our powers of discernment and the beauty – or aesthetic qualities – that provide comfort and appease the apparent strangeness or 'otherness' of the world around us as they are either found in the world directly, or more indirectly in a supervenient or response-dependent relation.

A staunch cogntivist like Carroll, for instance, suggests that we can be *moved* by nature, where in certain experiences 'a sense of homeyness and repose may be aroused in us' as we reflect on its attributes.[18] Homeyness is central to the Everyday Aesthetics of Arto Haapala, which he ties to the familiar, that gives us 'pleasure

---

[18] Nöell Carroll, 'On Being Moved by Nature: Between Religion and Natural History', in *Arguing about Art: Contemporary Philosophical Debates*, eds. Alex Neill and Aaron Ridley (New York, NY: Routledge 2002), 168.

through a kind of comforting stability' and that makes us feel 'homey and in control'. Adopting the term 'jemeinig' or 'one's own' from Heidegger, Haapala conceives the aesthetic of the familiar as a process of 'home-building' and the forging of connections that are significant, or related to both attachment and belonging, if not as completely immersive as self-forgetfulness implies.[19] Even Paul Ziff, who counseled breadth in his suggestion that anything, whether beautiful or not, can be an apt object of aesthetic attention, nevertheless characterized the relation between 'person' and 'object' as ideally 'harmonious' when he enumerated the adverse conditions that might impede it.[20]

And the notion of harmony is explicit in Kantian theory, as the pleasure of beauty is grounded 'in the harmony of the faculties of cognition' as they engage in free play and find the world 'fit' for cognition in so doing. His exception, the sublime, which does prima facie violence to our cognitive faculties, is nevertheless resolved in the realization of our moral vocations and their efficacy in the phenomenal world.[21] The marked difference in Kantian aesthetics is that this harmony is two-fold: first, it occurs between the subject and object, that renders the (phenomenal) world knowable and the subject able to grasp it, and secondly, there is a requisite harmony within the subject herself, as her cognitive faculties 'play' at cognition in a way that produces necessary pleasure (and that makes fitting the ugly into Kantian theory so difficult to achieve).

---

[19]Haapala, 'On the Aesthetics of the Everyday', 50, 52, 45 and 46.
[20]Ziff, 'Anything Viewed', 26.
[21]Kant, *Critique of the Power of Judgement*, AK: 5: 218, and see in particular §23 for his discussion of the sublime.

Herman Parret finds the emphasis on harmony and beauty in classical aesthetic theory to be couched in terms of an 'anthropological necessity': '[e]veryone seems to have a feeling that our existence is impoverished without the experience of the beautiful' whether because otherwise the world seems foreign, 'abject', incomprehensible, and 'unfit' for our purposes, or merely because it yields the repellent, the ugly and the monstrous. For Parret, this 'existential necessity brings about a *nostalgia* for beauty wherever beauty is absent',[22] or as I put it in Chapter 1, a longing for reconciliation and consolation. But just as the subject/object relation need not be understood as rigid and one-dimensional, neither need it be characterized as conciliatory or hopeful. In fact, I have suggested that this nostalgia provides a false hope and an empty consolation. And yet it is prevalent, in one form or the other, in aesthetic theorizing, and it both underwrites and leads to concomitant emphases on beauty and pleasure as aesthetic goals. And this severely restricts the possible compass of our aesthetic engagement with the world as it presents itself to us.

Relations can equally be acrimonious, aggressive, discordant and dysfunctional; 'play' need not be cooperative but can be antagonistic, competitive and hurtful. *Ad tendere,* as I have depicted it, connotes *attention*, not *communion*; it is quite often the closest relations that hurt us the most. The nostalgia for beauty, or the presumption of harmony, is equally a framing or preconception brought to bear on aesthetic experience, one that violates the condition of disinterest as much as moral or cognitive preconceptions do: in this case, it

---

[22]Parret, 'On the Beautiful and the Ugly', in *On the Ugly: Aesthetic Exchanges*, 27.

requires us to abstract from the jarring and discordant, to leave out that which disturbs or discommodes us, and thereby limits the details and particularity to which we can legitimately attend. The aesthetic thereby becomes restricted to – and defined by – a model that provides access to only part of the world, an engagement or contact that is perforce partial and incomplete, and that has so dominated the field that 'aesthetic' has become identified with pleasure and beauty to the exclusion of all else, such that any alternative seems inconceivable.

In a recent essay, the novelist Hari Kunzru explores our attachment to harmony (and its close relation, simplicity) and suggests that here '[e]verything that is not essential has been refined away'. But this requires a prior conception of what the 'non-essential' amounts to. He refers to the German physicist Sabine Hossenfelder, who claims that notions of beauty influence scientific theories to their detriment: nostalgia for harmony is perhaps 'responsible for the failure of fundamental physics to progress since the Seventies'. That is, physics is 'stuck' because physicists 'are looking for beautiful solutions to problems when the universe may not conform to human notions of beauty at all'.[23] The world, for Kunzru and Hossenfelder, may instead be ugly, that is irreducibly complex and messy, and a willing blindness to this possibility equally blinds the sorts of theories that physics, epistemology – and aesthetics – can produce. What could an acknowledgement of disharmony and disorder lead to, and how might it enrich aesthetic theory? These questions are also invitations to broaden the scope of what the discipline can encompass. Breaking

---

[23]Hari Kunzru, 'Complexity', *Harpers Magazine* 342 (2021): 7–9.

away from the 'fix' on harmony means letting in the ugly and the discordant, and attending to that which we might prefer to ignore.

One pioneering effort in this regard can be found in the work of Arnold Berleant, who has been the first to describe what he calls 'negative aesthetics'. As a preliminary definition, he describes 'an aesthetic occasion [which] is perceptually distressing, repellent, or painful, or has effects that are harmful or destructive'. Aesthetic experience, he counsels, 'is not always benign' but can have an element in which 'negative value is actively present' and which is, on the face of it, disharmonious. This occurs in the 'primacy of perceptual experience', but Berleant notes that 'it would be mistaken to think that modes of negativity can be arranged in neat categories and that each instance must clearly exemplify one form or another'.[24] Instead, he suggests that 'individual instances' of the negative 'involve subtle distinctions and require fluid categories that alter with the circumstances':[25] negative aesthetic experiences can be wide-ranging and admit of degrees.

Admitting the possibility of the negative opens up the boundaries of aesthetic experience to include that which opposes the search for harmony, and that expands the subject/object relation in previously unconsidered ways. That an object might be judged monstrous, or an instance of attention might be painful in its focus, suggests that in the aesthetic we can and do attend to, and judge, that which runs counter to a hope of reconciliation or even quashes such hope altogether. Sometimes, it is only through disinterested attention that we can come

---

[24]Berleant, *Sensibility and Sense*, 158, 160.
[25]Ibid., 161.

*directly* to face, and fully take in, that which we might well prefer to dismiss, or minimize through ready-made comforting categories.

However, when considered more closely, Berleant's exploration of the negative still retains an allegiance to harmony and hence positivity in his delineation of aesthetic values. In a separate work, Berleant itemizes a number of instances of the negative in our urban environments, including the 'aesthetic intrusion' of noise; 'aesthetic pain' from noxious emissions; 'aesthetic distortion' from smog and the 'strident colours' of signage; 'aesthetic deprivation' from cramped spaces and inadequate natural light; and finally 'aesthetic depravity' from the excesses of drugs, alcohol, pornography and processed foods.[26] These are no doubt all negative; however, Berleant sees them not as bona fide aesthetic experiences in themselves but rather as 'offenses to our aesthetic sensibility' against an idealized relation to the environment in which a 'profound intimacy develops, an almost mystical bond', and he refers with approval to Schiller's view of the aesthetic as that which can make us whole: the 'experience of beauty instills a social character in humans by establishing harmony in individuals and from thence into society'.[27] What Berleant seems to mean in these instances is rather a 'distortion *of* the aesthetic', an 'intrusion *against* the aesthetic', a 'deprivation *of* the aesthetic' and so on. They are 'offenses' because they impede an idealized 'aesthetic' relation with the urban world that he seeks to promote and thus are not true aesthetic experiences themselves. The aesthetic, for Berleant, is an instrumental value in the service of a greater good.

---

[26]Arnold Berleant, *Aesthetics beyond the Arts: New and Recent Essays* (Farnham: Ashgate Publishing, 2012), 198–9.
[27]Ibid., 198.

While Berleant is perhaps unique in his acknowledgement of the negative, he does this with a sense of loss, of the ways that we have been impoverished against a harmony that he strives to regain. What is instructive about his work, and the other attempts to introduce so-called 'negative' aesthetic experience we have seen, is an implicit *polarity* of values: if not positive (and harmonious), then negative, and their converse; if not beautiful, then ugly; if not pleasurable then painful, and so on. Negative aesthetics are seen as transgressive 'offenses' but what is actually transgressed here are our preconceptions themselves, of what is 'normal' or part of the order of things, of what aesthetic sensibility should be, as though that order were some kind of natural relational state that can be (re-)achieved, and that which conflicts with it can somehow be expiated. There is, in Berleant's work as with so many others, a moral impetus that underwrites and directs aesthetic theorizing, and it is this impetus that I seek to dispel.

To this end, I elect not to use the term 'negative' to describe a broadening of aesthetics, as it carries with it the notion of a polarity, or scale of values that some experiences or some objects trespass. Admittedly, the 'discordant' is perhaps not much more helpful as a term, as it is also often understood against the backdrop of what true concord should be and again highlights experiences that appear to fail to meet it. What I seek in the term is the idea that the subject/object relation can be one of disharmony or acrimony or incomprehension or disorder, one that nevertheless yields a bona fide aesthetic experience – minimal or more robust – that is shorn of these preconceptions, but that can be considered as aesthetic nonetheless.

If we take the notion of aesthetic attention at its most straightforward and literal, we can understand it as bringing closer in perception the particularities of a given phenomenon, without predetermining what these are or ought to be. Disinterest requires attention without preconception, with an openness to whatever we might find, without prematurely closing out possible judgements and possible values. And when those judgements are made, and those values assigned, it is indeed limiting to reduce them to some point on an implicit scale. What we find ugly need not be painful – but it can be. It can also be comical or absorbing or banal, and we cannot determine our responses in advance, or pre-order what their impact on us might be. And, anyway, I have all along argued that our emotive reactions are contingent, and besides the point of what makes an experience aesthetic in the first instance.

So, again, what might an acknowledgement of disharmony and disorder lead to, and how might it enrich aesthetic theory? These are not moral or existential questions about what we can learn from or gain by a richer understanding of the aesthetic in our lives. They are instead, quite simply, questions about how aesthetic theory can best go about its business, with perhaps greater scope than it has previously been given. It is to suggest that the ugly, the incoherent, the distressing and so on need not pose unique or special problems for aesthetic theorists, and that we need not labour to account for them or make them somehow fit into neatly pre-conceived aesthetic categories. There is no paradox of horror on this account – although there might be horror itself. Freeing the aesthetic from an attachment to felt emotion as a necessary ingredient in our experiences, just

as freeing it from a commitment to harmony and reconciliation, is intended to open up the discipline to the wide variety of objects and activities that can command aesthetic attention and appraisal, and to allow aesthetic theory to encompass the myriad ways in which we experience the world most fully. That historically there have been some objects, some values and some experiences that aesthetics has had difficulty accounting for or explaining has, for me, been symptomatic of a more general structural flaw in the conceptual underpinnings of the discipline itself rather than an acceptance that the aesthetic has to do with only one part of our lives, or one set of values, or with some objects rather than others. That some things haven't seemed to fit into the mainstream theories is not an indication that they shouldn't fit but that we need to revise these theories to make them fit so that aesthetic experience can come to be understood as a legitimate, if unique, form of the many kinds of human engagement that is worthy of close and detailed consideration. In all of its potential breadth, the aesthetic too is part of what makes us human.

# POSTSCRIPT

What, then, does the 'aesthetic' mean? Is it, as my neighbour suggested, 'the study of how things look'? Well yes, and not quite. If anything, it is more the study of how we look at things, of one way that we approach the world. It is thus also a study of how we act in the world: by looking, yes, but also sometimes by judging that which we perceive. And more, as Lopes was committed to exploring, how we might form intentions and goals – order our lives – based on the judgements we have made and the values we have discerned. But to consider why we might have aesthetic reasons to act in these further ways requires an answer to the question of why anything might be aesthetic at all, and what makes it so. This answer – or at least one answer to this question – has been the specific goal of this work. In each of the elements of aesthetic experience I have highlighted, I have sought to remove strictures such as pleasure, harmony and the moral good from a purely *aesthetic* theory, and in so doing, I have counselled breadth, variety, flexibility and multi-dimensionality. In claiming that anything at all can be an aesthetic object and give rise to an aesthetic experience, one lingering question is whether I have gone too far. If everything is aesthetic, to pervert a truism, then nothing is. Is that the case here? Again yes, and not quite.

This work has been wholly conceptual; my interest has been in an analysis of the fundamental components of aesthetic experience, wherever and whenever they occur. If I am correct that a minimalist

account lies in a form of disinterested attention, then anything can be an aesthetic object for us, for the duration of that attention. If, more robustly, aesthetic judgement can be distinguished by certain formal peculiarities, then anything can be judged aesthetically. And if aesthetic values are determined by those judgements, we must be prepared to accept their plurality and breadth. So *conceptually* the result is that anything can be aesthetic: sunsets, knives, chickens, food. Aesthetic judgements can equally yield the beautiful, the monstrous and the banal. But *empirically* this will not always be the case, and the difference is important. There are bound to be objects and situations in which our attention will not be disinterested, where moral or political commitments, local conditions, personal preferences and idiosyncrasies so impinge upon our notice that a possible aesthetic response is consistently overridden. Unlike Wiseman, I cannot undergo a dental procedure with anything like aesthetic attention, although I can have an aesthetic experience of a display of washing machines.

Not everything is a possible aesthetic object for each of us at all times, and not every situation will allow us to become 'aesthetic subjects'. There are no doubt good and interesting historical, cultural and psychological reasons for this. But this work has been neither a history nor a philosophical anthropology. In being guided by Sparshott's concerns and perspicacious questions, I have also chosen to analyse various attempts to define the aesthetic and uncover conceptual problems with its use; many of these uses, when applied to pleasure, perception, attention, judgement, value and so on, have belied certain pre-theoretical commitments that are not always apparent, and not

always consistent. The task of aesthetic theory, for Sparshott, was, in part, to expose those inconsistencies and render the use of 'aesthetic' as 'maximally extensive' and coherent as possible,[1] and open up the conceptual field. What I called 'discordant aesthetics' in the last chapter is the result: there is no strictly logical or philosophical reason to constrain the boundaries of aesthetic experience, or to limit the types of objects in its compass. Attempts to do so, upon examination, have proven to be without solid foundation, and at times to rely on a fall-back commitment to a certain philosophical tradition. But if it is the role of philosophy to question unreservedly, then its own tradition should surely come under examination as well.

Absent elisions, avoidances and inconsistencies, the field is wide open. This is not a weakness but a strength, and an opportunity that is timely: as the discipline continues to branch out into previously neglected areas, as it continues to widen its focus, it can best be served by widening its conceptual parameters at the same time. But the roots of the discipline remain, and the purpose of this project has been to articulate them, at times question them, and, most importantly, strengthen them. My conclusion – that the aesthetic is a unique but important part of our engagement with the world – will not be surprising or unfamiliar to the many theorists working in the field.

---

[1] Sparshott, *Theory of the Arts*, 467.

# BIBLIOGRAPHY

Adorno, Theodor. *Aesthetic Theory*. Translated by R. Hullot-Kentor. Minneapolis, MN: Minnesota University Press, 1997.

Allison, Henry. *Kant's Theory of Taste: A Reading of the Critique of Aesthetic Judgement*. Cambridge: Cambridge University Press, 2001.

Bartoshuk, Linda and Valerie Duffy. 'Chemical Senses: Taste and Smell'. In *The Taste Culture Reader: Experiencing Food and Drink*, edited by Carolyn Korsmeyer, 25–34. New York, NY: Berg Publishers, 2007.

Beardsley, Monroe. 'Aesthetic Experience'. In *The Aesthetic Point of View*, edited by Michael J. Wreen and Donald M. Callen, 285–97. Ithaca, NY: Cornell University Press, 1982.

Beardsley, Monroe. 'Aesthetic Experience Regained'. In *The Aesthetic Point of View*, edited by Michael J. Wreen and Donald M. Callen, 77–92. Ithaca, NY: Cornell University Press, 1982.

Beardsley, Monroe. 'The Aesthetic Point of View'. In *The Aesthetic Point of View*, edited by Michael J. Wreen and Donald M. Callen, 15–34. Ithaca, NY: Cornell University Press, 1982.

Beardsley, Monroe. 'The Aesthetic Problem of Justification'. In *The Aesthetic Point of View*, edited by Michael J. Wreen and Donald M. Callen, 65–76. Ithaca, NY: Cornell University Press, 1982.

Beardsley, Monroe. 'The Discrimination of Aesthetic Enjoyment'. In *The Aesthetic Point of View*, edited by Michael J. Wreen and Donald M. Callen, 35–45. Ithaca, NY: Cornell University Press, 1982.

Beardsley, Monroe. 'What Is an Aesthetic Quality?' In *The Aesthetic Point of View*, edited by Michael J. Wreen and Donald M. Callen, 93–110. Ithaca, NY: Cornell University Press, 1982.

Bell, Clive. *Art*. New York, NY: Capricorn Books, 1958.

Bender, John W. 'Aesthetic Realism II'. In *The Oxford Handbook of Aesthetics*, edited by Jerrold Levinson, 80–98. New York, NY: Oxford University Press, 2005.

Berleant, Arnold. *Sensibility and Sense: The Aesthetic Transformation of the Human World*. Exeter: Imprint Academic, 2010.

Berleant, Arnold. *Aesthetics beyond the Arts: New and Recent Essays*. Farnham: Ashgate Publishing, 2012.

Bosanquet, Bernard. 'The Aesthetic Theory of Ugliness'. *Proceedings of the Aristotelian Society* 1, no. 3 (1889–90): 32–48.
Brozzo, Chiara. 'Are Some Perfumes Works of Art?' *Journal of Aesthetics and Art Criticism* 78, no. 1 (2020): 21–32.
Budd, Malcolm. 'The Acquaintance Principle'. *British Journal of Aesthetics* 43, no. 4 (2003): 386–92.
Budd, Malcolm. 'Aesthetic Essence'. In *Aesthetic Essays*, 31–47. New York, NY: Oxford University Press, 2008.
Bullough, Edward. '"Psychical Distance" as a Factor in Art and an Aesthetic Principle'. In *Aesthetics: A Critical Anthology*, edited by George Dickie and Richard J. Sclafani, 758–83. London: St. Martin's Press, 1997.
Cannon, Joseph. 'The Intentionality of Judgements of Taste in Kant's *Critique of Judgement*'. *Journal of Aesthetics and Art Criticism* 66, no. 1 (2008): 53–65.
Carlson, Allen. 'The Dilemma of Everyday Aesthetics'. In *Aesthetics of Everyday Life: East and West*, edited by Liu Yuedi and Curtis L. Carter, 48–64. Newcastle upon Tyne: Cambridge Scholars Publishing, 2014.
Carroll, Nöel. 'Aesthetic Experience Revisited'. *British Journal of Aesthetics* 42, no. 2 (2002): 145–68.
Carroll, Nöel. 'On Being Moved by Nature: Between Religion and Natural History'. In *Arguing about Art: Contemporary Philosophical Debates*, edited by Alex Neill and Aaron Ridley, 167–86. New York, NY: Routledge, 2002.
Carroll, Nöel. 'Aesthetic Experience: A Question of Content'. In *Contemporary Debates in Aesthetics and the Philosophy of Art*, edited by Matthew Kieran, 69–97. Malden, MA: Wiley-Blackwell, 2006.
Carroll, Nöel. 'Recent Approaches to Aesthetic Experience'. *Journal of Aesthetics and Art Criticism* 70, no. 2 (2012): 165–77.
Cohen, Alix. 'Kant on the Possibility of Ugliness'. *British Journal of Aesthetics* 53, no. 2 (2013): 199–209.
Costelloe, Timothy. 'Review of *A History of Modern Aesthetics, Volume I*'. *Journal of Aesthetics and Art Criticism* 75, no. 1 (2017): 81–4.
Danto, Arthur. 'The Philosophical Disenfranchisement of Art'. In *The Philosophical Disenfranchisement of Art*, 1–21. New York, NY: Columbia University Press, 1986.
De Clerq, Rafael. 'Aesthetic Pleasure Explained'. *Journal of Aesthetics and Art Criticism* 77, no. 2 (2019): 121–32.
Dewey, John. *Art as Experience*. New York, NY: Capricorn Books, 1958.
Diaconu, Mădălina. 'Reflections on an Aesthetic of Touch, Smell and Taste'. *Contemporary Aesthetics* 4 (2006): article 8.
Dickie, George. 'The Myth of the Aesthetic Attitude'. *American Philosophical Quarterly* 1, no. 1 (1964): 56–65.

Dodd, Julian. 'Artistic Value and Sentimental Value: A Reply to Robert Stecker'. *Journal of Aesthetics and Art Criticism* 71, no. 3 (2013): 282–8.

Dodd, Julian. 'On a Proposed Test for Artistic Value'. *British Journal of Aesethetics* 54, no. 4 (2014): 395–407.

Dowling, Christopher. 'The Aesthetics of Daily Life'. *British Journal of Aesthetics* 50, no. 3 (2010): 225–42.

Driver, Julia. 'Expertise and Evaluation'. *Philosophy and Phenomenological Research* 102, no. 1 (2021): 220–6.

Durà-Vilà, Víctor. 'Attending to Works of Art for Their Own Sake in Art Evaluation and Analysis: Carroll and Stecker on Aesthetic Experience'. *British Journal of Aesthetics* 56, no. 1 (2016): 83–99.

Dziemidok, Bohdan. 'Aesthetic Experience and Evaluation'. In *Essays on Aesthetics: Perspectives on the Work of Monroe Beardsley*, edited by John Fisher, 53–68. Philadelphia, PA: Temple University Press, 1983.

Eaton, Marcia Muelder. 'Kantian and Contextual Beauty'. *Journal of Aesthetics and Art Criticism* 57, no. 1 (1999): 11–15.

Engstrom, Stephen. 'Kant on the Agreeable and the Good'. In *Moral Psychology*, edited by Sergio Tenenbaum, 111–60. Amsterdam: Rodopi, 2007.

Feagin, Susan. 'Incompatible Interpretations of Art'. In *Contemporary Readings in the Philosophy of Literature*, edited by David Davies and Carl Matheson, 197–210. Peterborough: Broadview Press, 2008.

Feezell, Randolph M. 'Thinking about the Aesthetic Attitude'. *Philosophical Topics* XIII, no. 3 (1985): 19–32.

Feloj, Serena. 'Is There a Negative Judgement of Taste? Disgust as the Real Ugliness in Kant's Aesthetics'. *Lebenswelt* 3 (2013): 175–85.

Fenner, David. *The Aesthetic Attitude*. New York, NY: Humanities Press, 1996.

Fisher, John. 'Evaluation without Enjoyment'. *Journal of Aesthetics and Art Criticism* 27, no. 2 (1968): 135–9.

Fisher, John. 'Universalizability and Judgements of Taste'. *American Philosophical Quarterly* 11, no. 3 (1974): 219–25.

Forsey, Jane. 'The Disenfranchisement of Philosophical Aesthetics'. *Journal of the History of Ideas* 4, no. 64 (2003): 581–97.

Forsey, Jane. *The Aesthetics of Design*. New York, NY: Oxford University Press, 2013.

Forsey, Jane. 'Aesthetic Experience, Aesthetic Value'. *Estetika: The Central European Journal of Aesthetics* LIV/X, no. 2 (2017): 175–88.

Gee, James Paul. 'Video Games, Design and Aesthetic Experience'. *Rivista di Estetica* 56:3, no. 63 (2016): 149–60.

Ginsberg, Robert. *The Aesthetics of Ruins*. New York, NY: Rodopi, 2004.

Ginsborg, Hannah. 'Lawfulness without a Law: Kant on the Free Play of Imagination and Understanding'. *Philosophical Topics* 25, no. 1 (1997): 37–81.

Ginsborg, Hannah. 'Aesthetic Judging and the Intentionality of Pleasure'. *Inquiry: An Interdisciplinary Journal of Philosophy* 46, no. 2 (2003): 164–81.

Goffin, Kris. 'The Affective Experience of Aesthetic Properties'. *Pacific Philosophical Quarterly* 100, no. 1 (2019): 283–300.

Goldman, Alan. 'The Experiential Account of Aesthetic Value'. *Journal of Aesthetics and Art Criticism* 64, no. 3 (2006): 333–42.

Gorodeisky, Keren. 'The Authority of Pleasure'. *Noûs* 55, no. 1 (2021): 199–220.

Gorodeisky, Keren. 'On Liking Aesthetic Value'. *Philosophy and Phenomenological Research* 102, no. 2 (2021): 261–80.

Gorodeisky, Keren and Eric Marcus. 'Aesthetic Rationality'. *Journal of Philosophy* 115, no. 3 (2018): 113–40.

Gorodeisky, Keren and Eric Marcus. 'Aesthetic Knowledge'. *Philosophical Studies* 179, no. 8 (2022): 2507–35.

Gracyk, Theodore. 'Sublimity, Ugliness and Formlessness in Kant's Aesthetic Theory'. *Journal of Aesthetics and Art Criticism* 45, no. 1 (1986): 49–56.

Gracyk, Theodore. 'Having Bad Taste'. *British Journal of Aesthetics* 30, no. 2 (1990): 117–31.

Gregor, Mary. 'Baumgarten's *Aesthetica*'. *Review of Metaphysics* 37, no. 2 (1983): 357–85.

Guyer, Paul. 'Thomson's Problems with Kant: A Comment on "Kant's Problem with Ugliness"'. *Journal of Aesthetics and Art Criticism* 50, no. 4 (1992): 317–19.

Guyer, Paul. 'Kant on the Purity of the Ugly'. In *Values of Beauty: Historical Essays in Aesthetics*, 141–62. Cambridge: Cambridge University Press, 2005.

Guyer, Paul. 'The Harmony of the Faculties Revisited'. In *Aesthetics and Cognition in Kant's Critical Philosophy*, edited by Rebecca Kukla, 162–93. Cambridge: Cambridge University Press, 2006.

Guyer, Paul. *A History of Modern Aesthetics, Volume I: The Eighteenth Century*. Cambridge: Cambridge University Press, 2014.

Haapala, Arto. 'On the Aesthetics of the Everyday: Familiarity, Strangeness, and the Meaning of Place'. In *The Aesthetics of Everyday Life*, edited by Andrew Light and Jonathan M. Smith, 39–55. New York, NY: Columbia University Press, 2005.

Hansen, Nat and Zed Adams. 'The Hope of Agreement: Against Vibing Accounts of Aesthetic Judgement'. *Mind* 133, no. 531 (2024): 742–60.

Higgins, Kathleen Marie. 'Aesthetics and the Containment of Grief'. *Journal of Aesthetics and Art Criticism* 78, no. 1 (2020): 9–20.

Hogarth, William. 'Analysis of Beauty, Written with a View of Fixing the Fluctuating Ideas of Taste'. In *Eighteenth Century British Aesthetics*, edited by Dabney Townsend, 209–26. Amityville, NY: Baywood Publishing, 1999.

Holberg, Erica. 'Can We Modify Our Pleasures? A New Look at Kant on Pleasure in the Agreeable'. *Kantian Review* 25, no. 3 (2020): 365–88.

Hopkins, Robert. 'How to Be a Pessimist about Aesthetic Testimony'. *The Journal of Philosophy* 108, no. 3 (2011): 138–57.
Hopkins, Robert. 'Review of *Aesthetics as Philosophy of Perception*'. *British Journal of Aesthetics* 57, no. 3 (2017): 340–4.
Hospers, John. 'Art as Expression'. In *Aesthetics*, edited by Susan Feagin and Patrick Maynard, 172–5. New York, NY: Oxford University Press, 1997.
Huddleston, Andrew. 'In Defense of Artistic Value'. *Philosophical Quarterly* 62, no. 249 (2012): 705–14.
Hudson, Hud. 'The Significance of an Analytic of the Ugly in Kant's Deduction of Pure Judgements of Taste'. In *Kant's Aesthetics*, edited by Ralfe Meerbote, 87–103. Atascadero, CA: Ridgeview Publishing, 1991.
Irvin, Sherri. 'The Pervasiveness of the Aesthetic in Ordinary Experience'. *British Journal of Aesthetics* 48, no. 1 (2008): 29–44.
Irvin, Sherri. 'Scratching an Itch'. *Journal of Aesthetics and Art Criticism* 66, no. 1 (2008): 25–35.
Jacquette, Dale. 'Bosanquet's Concept of Difficult Beauty'. *Journal of Aesthetics and Art Criticism* 43, no. 1 (1984): 79–87.
Johnson, Jonathan. 'Understandings of Ugliness in Kant's Aesthetics'. In *On the Ugly: Aesthetic Exchanges*, edited by Jane Forsey and Lars Aagaard-Mogensen, 47–66. Newcastle upon Tyne: Cambridge Scholars Publishing, 2019.
Kant, Immanuel. *Critique of Pure Reason*. Translated by Norman Kemp Smith. New York, NY: St Martin's Press, 1965.
Kant, Immanuel. *Critique of the Power of Judgement*. Translated by Paul Guyer and Eric Matthews. Cambridge: Cambridge University Press, 2000.
Katkov, G. 'The Pleasant and the Beautiful'. *Proceedings of the Aristotelian Society* 40 (1939–40): 177–206.
Kemp, Gary. 'The Aesthetic Attitude'. *British Journal of Aesthetics* 39, no. 4 (1999): 392–9.
Kieran, Matthew. 'Aesthetic Value: Beauty, Ugliness and Incoherence'. *Philosophy* 2, no. 281 (1997): 383–99.
Kölbel, Max. 'Aesthetic Judge-Dependence and Expertise'. *Inquiry* 59, no. 6 (2016): 589–617.
Konigsberg, Amir. 'The Acquaintance Principle, Aesthetic Autonomy and Aesthetic Appreciation'. *British Journal of Aesthetics* 52, no. 2 (2012): 153–68.
Korsmeyer, Carolyn. *Making Sense of Taste: Food and Philosophy*. Ithaca, NY: Cornell University Press, 1999.
Korsmeyer, Carolyn. 'Terrible Beauties'. In *Contemporary Debates in Aesthetics and the Philosophy of Art*, edited by Matthew Kieran, 51–63. London: Blackwell, 2006.
Kulka, Tomas. 'Why Aesthetic Value Judgements Cannot Be Justified'. *Estetika: The Central European Journal of Aesthetics* 46, no. 1 (2009): 3–28.

Kunzru, Hari. 'Complexity'. *Harpers Magazine* 342 (2021): 7–9.
Küplen, Mojca. 'Disgust and Ugliness: A Kantian Perspective'. *Contemporary Aesthetics* 9 (2011): 1–21.
Küplen, Mojca. 'The Aesthetics of Ugliness – A Kantian Perspective'. *Proceedings of the European Society for Aesthetics* 5 (2013): 260–79.
Küplen, Mojca. 'Guyer's Interpretation of Free Harmony in Kant'. *Postgraduate Journal of Aesthetics* 10, no. 2 (2013): 17–32.
Küplen, Mojca. 'Kant and the Problem of Pure Judgements of Ugliness'. *Kant Studies Online* (2013): 102–43.
Leddy, Thomas. 'Everyday Surface Qualities: "Neat," "Messy," "Clean," "Dirty"'. *Journal of Aesthetics and Art Criticism* 53, no. 3 (1995): 259–68.
Leddy, Thomas. *The Extraordinary in the Ordinary: The Aesthetics of Everyday Life*. Peterborough: Broadview Press, 2012.
Levinson, Jerrold. 'What Is Aesthetic Pleasure?' In *The Pleasures of Aesthetics: Philosophical Essays*, 3–10. Ithaca, NY: Cornell University Press, 1996.
Levinson, Jerrold. 'Introduction'. In *Suffering Art Gladly: The Paradox of Negative Emotion*, edited by Jerrold Levinson, x–xvi. New York, NY: Palgrave Macmillan, 2014.
Levinson, Jerrold. 'Towards an Adequate Conception of Aesthetic Experience'. In *Philosophical Pursuits: Essays in Philosophy of Art*, 28–46. New York, NY: Oxford University Press, 2017.
Lopes, Dominic McIver. 'The Myth of (Non-Aesthetic) Artistic Value'. *Philosophical Quarterly* 61, no. 244 (2011): 518–36.
Lopes, Dominic McIver. *Being for Beauty*. New York, NY: Oxford University Press, 2018.
Lopes, Dominic McIver. 'Normativity, Agency, and Value: A View from Aesthetics'. *Philosophy and Phenomenological Research* 102, no. 1 (2021): 232–42.
Lorand, Ruth. 'The Purity of Aesthetic Value'. *Journal of Aesthetics and Art Criticism* 50, no. 1 (1992): 13–21.
Lorand, Ruth. 'Beauty and Its Opposites'. *Journal of Aesthetics and Art Criticism* 52, no. 4 (1994): 399–406.
Mäcklin, Harri. 'Aesthetic Self-Forgetfulness'. *British Journal of Aesthetics* 61, no. 4 (2012): 527–41.
Matherne, Samantha. 'Aesthetic Learners and Underachievers: Symposium on Dom Lopes' *Being for Beauty*'. *Philosophy and Phenomenological Research* 102, no. 1 (2021): 227–31.
Matravers, Derek. 'The Aesthetic Experience'. *British Journal of Aesthetics* 43, no. 2 (2003): 158–74.
McAdoo, Nick. 'The Aesthetic Attitude'. *British Journal of Aesthetics* 37, no. 4 (1997): 417–19.

McCormick, Peter. 'What Came about Brought to Nothing: Negative Aesthetic Value'. *Act Philosophica Fennica* 72 (2003): 33–44.
McDowell, John. 'Aesthetic Value, Objectivity and the Fabric of the World'. In *Pleasure, Preference and Value*, edited by Eva Schaper, 1–16. Cambridge: Cambridge University Press, 1983.
McDowell, John. *Mind, Value, and Reality*. Cambridge, MA: Harvard University Press, 1998.
Meskin, Aaron and Jon Robson. 'Taste and Acquaintance'. *Journal of Aesthetics and Art Criticism* 73, no. 2 (2015): 127–39.
Moreall, John. 'What's So Bad about Bad Taste?' *Contemporary Philosophy* 24, no. 5 (2002): 28–32.
Mothersill, Mary. 'Critical Reasons'. *The Philosophical Quarterly* 11, no. 42 (1961): 74–8.
Mothersill, Mary. *Beauty Restored*. New York, NY: Adams, Bannister, Cox, 1991.
Nanay, Bence. *Aesthetics as Philosophy of Perception*. New York, NY: Oxford University Press, 2016.
Neville, Michael. 'Kant's Characterization of Aesthetic Experience'. *Journal of Aesthetics and Art Criticism* 33, no. 2 (1974): 193–202.
Nguyen, C. Thi. 'The Uses of Aesthetic Testimony'. *British Journal of Aesthetics* 57, no. 1 (2017): 19–36.
Nguyen, C. Thi. 'The Arts of Action'. *Philosophers Imprint* 20, no. 14 (2020): 1–27.
Nguyen, C. Thi. 'Autonomy and Aesthetic Engagement'. *Mind* 129, no. 516 (2020): 1127–56.
Nguyen, C. Thi. 'The Engagement Account of Aesthetic Value'. *Journal of Aesthetics and Art Criticism* 81, no. 1 (2023): 91–3.
Packer, Mark. 'Dissolving the Paradox of Tragedy'. *Journal of Aesthetics and Art Criticism* 47, no. 3 (1989): 211–19.
Panos, Paris. 'The Deformity-Related Conception of Ugliness'. *The British Journal of Aesthetics* 57, no. 2 (2017): 139–60.
Parret, Herman. 'On the Beautiful and the Ugly'. In *On the Ugly: Aesthetic Exchanges*, edited by Jane Forsey and Lars Aagaard-Mogensen, 17–28. Newcastle upon Tyne: Cambridge Scholars Publishing, 2019.
Parsons, Glenn and Allen Carlson. *Functional Beauty*. New York, NY: Oxford University Press, 2008.
Peacocke, Antonia. 'Let's Be Liberal: An Alternative to Aesthetic Hedonism'. *British Journal of Aesthetics* 61, no. 2 (2021): 163–83.
Perullo, Nicola. 'Haptic Taste as a Task'. *The Monist* 101, no. 3 (2018): 261–76.
Petts, Jeffrey. 'Aesthetic Experience and the Revelation of Value'. *Journal of Aesthetics and Art Criticism* 58, no. 1 (2000): 61–71.

Phillips, James. 'Placing Ugliness in Kant's Third Critique: A Response to Paul Guyer'. *Kant-Studien* 102, no. 3 (2011): 385–95.

Plakias, Alexandra. 'The Aesthetics of Food'. *Philosophy Compass* 16, no. 11 (2021): e1–e12.

Pole, D.L. 'Varieties of Aesthetic Experience'. *Philosophy* 30 (1955): 238–48.

Prall, D. W. *Aesthetic Judgement*. New York, NY: Thomas Crowell Company, 1967.

Price, Kingsley. 'The Truth about Psychical Distance'. *Journal of Aesthetics and Art Criticism* 35, no. 4 (1977): 411–23.

Prinz, Jesse. 'Seeing With Feeling'. In *Aesthetics and the Sciences of Mind*, edited by Greg Currie, et al., 143–58. Oxford, NY: Oxford University Press, 2014.

Rachel, Stuart. 'Is Unpleasantness Intrinsic to Unpleasant Experiences?' *Philosophical Studies* 99, no. 2 (2000): 187–210.

Riggle, Nicholas. 'Street Art: The Transfiguration of the Commonplaces'. *Journal of Aesthetics and Art Criticism* 68, no. 3 (2010): 243–57.

Riggle, Nicholas. 'On the Interest in Beauty and Disinterest'. *Philosophers' Imprint* 16, no. 9 (2016): 1–14.

Riggle, Nicholas. 'Convergence, Community, and Force in Aesthetic Discourse'. *Ergo* 8, no. 47 (2021): 615–57.

Robson, Jon. 'Appreciating the Acquaintance Principle: A Reply to Konigsberg'. *British Journal of Aesthetics* 53, no. 2 (2013): 237–45.

Rogerson, Kenneth F. 'Dickie's Disinterest'. *Philosophia: Philosophical Quarterly of Israel* 17, no. 149 (1987): 149–60.

Rosenkranz, Karl. *Aesthetics of Ugliness: A Critical Edition*. Translated by Andrei Pop and Mechtild Widrich. London: Bloomsbury Academic, 2015.

Ross, Alex. 'The Pit and the Podium'. *The New Yorker* XCIX, no. 15 (05 June, 2023): 82–3.

Saito, Yuriko. *Everyday Aesthetics*. New York, NY: Oxford University Press, 2007.

Saito, Yuriko. *Aesthetics of the Familiar*. New York, NY: Oxford University Press, 2017.

Sartwell, Crispin. 'Aesthetics of the Everyday'. In *The Oxford Handbook of Aesthetics*, edited by Jerrold Levinson, 761–70. New York, NY: Oxford University Press, 2003.

Schaper, Eva. 'The Pleasures of Taste'. In *Pleasure, Preference and Value*, edited by Eva Schaper, 39–56. Cambridge: Cambridge University Press, 1983.

Schellekens, Elisabeth. 'Taste and Objectivity: The Emergence of the Concept of the Aesthetic'. *Philosophy Compass* 4, no. 5 (2009): 734–43.

Seel, Martin. 'Beauty. A Brief Conceptual Journey'. *Aesthetic Investigations* 1, no. 1 (2015): 165–73.

Shelley, James. 'Against Value Empiricism in Aesthetics'. *The Australasian Journal of Philosophy* 88, no. 4 (2010): 707–20.

Shelley, James. 'The Default Theory of Aesthetic Value'. *British Journal of Aesthetics* 59, no. 1 (2019): 1–12.

Shelley, James. 'Punting on the Aesthetic Question'. *Philosophy and Phenomenological Research* 102, no. 1 (2021): 214–19.

Shelley, James. 'Beyond Hedonism about Aesthetic Value'. In *Disinterested Pleasure and Beauty: Perspectives from Kantian and Contemporary Aesthetics*, edited by Larissa Berger, 257–74. Berlin: De Gruyter, 2023.

Shier, David. 'Why Kant Finds Nothing Ugly'. *British Journal of Aesthetics* 38, no. 4 (1998): 412–18.

Shiner, Larry. 'Art Scents: Perfume, Design and Olfactory Art'. *British Journal of Aesthetics* 55, no. 3 (2015): 375–92.

Shiner, Larry. 'Opening the Way for an Olfactory Aesthetics: Smell's Cognitive Powers'. *Rivista di Estetica* 61:3, no. 78 (2021): 8–26.

Shusterman, Richard. 'The End of Aesthetic Experience'. *Journal of Aesthetics and Art Criticism* 55, no. 1 (1997): 29–41.

Silverbloom, Rachel. 'Schiller and Adorno: The Critical Power of Art in Beauty and Ugliness'. *Wassard Elea Rivista* IV, no. 3 (2017): 133–44.

Smuts, Aaron. 'The Paradox of Painful Art'. *Journal of Aesthetic Education* 41, no. 3 (2007): 59–76.

Sparshott, Francis. *The Theory of the Arts*. Princeton, NJ: Princeton University Press, 1982.

Stecker, Robert. 'Two Conceptions of Artistic Value'. *Iyyun: The Jerusalem Philosophical Quarterly* 46 (1997): 51–62.

Stecker, Robert. 'Only Jerome: A Reply to Nöel Carroll'. *British Journal of Aesthetics* 41, no. 1 (2001): 76–80.

Stecker, Robert. 'Aesthetic Experience and Aesthetic Value'. *Philosophy Compass* 1, no. 1 (2006): 1–10.

Stecker, Robert. 'Carroll's Bones'. *British Journal of Aesthetics* 46, no. 3 (2006): 282–6.

Stecker, Robert. 'Art Interpretation'. In *Contemporary Readings in the Philosophy of Literature*, edited by David Davies and Carl Matheson, 217–36. Peterborough: Broadview Press, 2008.

Stecker, Robert. 'Artistic Value Defended'. *Journal of Aesthetics and Art Criticism* 70, no. 4 (2012): 355–62.

Stecker, Robert. 'Aesthetic Autonomy and Aesthetic Heteronomy'. In *Aesthetic and Artistic Autonomy*, edited by Owen Hulatt, 31–50. London: Bloomsbury Press, 2013.

Stecker, Robert. 'Entangled Values: A Reply to Dodd'. *British Journal of Aesthetics* 55, no. 3 (2015): 393–8.

Steenberg, Elisa. 'The Scholar's Object: Experience Aesthetic and Artistic'. *Journal of Aesthetics and Art Criticism* 30, no. 1 (1971): 49–54.

Stolnitz, Jerome. 'Of the Origins of "Aesthetic Disinterestedness"'. *Journal of Aesthetics and Art Criticism* 20, no. 2 (1961): 131–43.
Tafalla, Marta. 'Smell and Anosmia in the Aesthetic: Appreciation of Gardens'. *Contemporary Aesthetics* 12, (2014): article 19.
Taylor, Charles. 'McDowell on Value and Knowledge'. *The Philosophical Quarterly* 50, no. 199 (2000): 242–9.
Telfer, Elizabeth. *Food for Thought: Philosophy and Food*. New York, NY: Routledge, 1996.
Van der Berg, Servas. 'Aesthetic Hedonism and Its Critics'. *Philosophy Compass* 15, no. 1 (2020): e1–e15.
Walsh, Dorothy. 'Critical Reasons'. *The Philosophical Review* 69, no. 3 (1960): 386–93.
Walton, Kendal. 'How Marvelous! Toward a Theory of Aesthetic Value'. *Journal of Aesthetics and Art Criticism* 51, no. 3 (1993): 499–510.
Watkins, Michael and James Shelley. 'Response-Dependence about Aesthetic Value'. *Pacific Philosophical Quarterly* 93, no. 3 (2012): 338–52.
Wenzel, Christian. 'Kant Finds Nothing Ugly?' *British Journal of Aesthetics* 39, no. 4 (1999): 416–22.
Wenzel, Christian. 'Do Negative Judgements of Taste Have *A Priori* Grounds in Kant?' *Kant-Studien* 103, no. 4 (2012): 472–93.
Wicks, Robert. 'Dependent Beauty as the Appreciation of Teleological Style'. *Journal of Aesthetics and Art Criticism* 55, no. 4 (1997): 387–400.
Williams, Jessica. 'Kant on Aesthetic Attention'. *British Journal of Aesthetics* 61, no. 4 (2021): 421–35.
Wiseman, Mary. 'Damask Napkins and the Train from Sichuan: Aesthetic Experience and Ordinary Things'. In *Aesthetics of Everyday Life: East and West*, edited by Liu Yuedi and Curtis L. Carter, 134–44. Newcastle upon Tyne: Cambridge Scholars Publishing, 2014.
Wolheim, Richard. *Art and Its Objects*. Cambridge: Cambridge University Press, 1980.
Zangwill, Nick. 'Unkantian Notions of Disinterest'. *British Journal of Aesthetics* 32, no. 2 (1992): 149–52.
Zangwill, Nick. 'Kant on Pleasure in the Agreeable'. *Journal of Aesthetics and Art Criticism* 53, no. 2 (1995): 167–76.
Zangwill, Nick. 'The Beautiful, the Dainty and the Dumpy'. *British Journal of Aesthetics* 38, no. 1 (1998): 317–29.
Zangwill, Nick. 'The Concept of the Aesthetic'. *European Journal of Philosophy* 6, no. 1 (1998): 78–93.
Zangwill, Nick. 'Aesthetic Realism I'. In *The Oxford Handbook of Aesthetics*, edited by Jerrold Levinson, 63–79. New York, NY: Oxford University Press, 2005.

Zangwill, Nick. 'Beauty'. In *The Oxford Handbook of Aesthetics*, edited by Jerrold Levinson, 325–43. New York, NY: Oxford University Press, 2005.

Zangwill, Nick. 'Disinterestedness: Analysis and Partial Defense'. In *Disinterested Pleasure and Beauty: Perspectives From Kantian and Contemporary Aesthetics*, edited by Larissa Berger, 59–78. Berlin: De Gruyter, 2023.

Ziff, Paul. 'Anything Viewed'. In *Aesthetics*, edited by Susan Feagin and Patrick Maynard, 23–9. New York, NY: Oxford University Press, 1997.

Zuckert, Rachel. 'A New Look at Kant's Theory of Pleasure'. *Journal of Aesthetics and Art Criticism* 60, no. 3 (2002): 239–52.

# INDEX

aesthetic appreciation 13, 47–8, 103–7
aesthetic attitude
   and *ad tendere* 165, 168, 185
   and in-itself 40, 47, 50–1, 54
   and motivation 12, 38–40, 45–6, 81–2
   as preparatory state 37–8, 40, 42, 61, 70
aesthetic experience
   cognitivist model of 170–4
   experiential model of 174–7
   and harmony 182–7
   value of 143–5, 149–50, 152
aesthetic judgement (*and see* Kant, *Critique of Judgement*)
   *vs.* cognitive judgements 93–5, 163–4, 170
   *vs.* culinary judgements 89–90
   logical form 86, 88, 90–5, 134
   *vs.* moral judgements 89–92
aesthetic object 18–19, 49–51, 55, 60, 164, 167, 175
aesthetic pleasure (*and see* Beardsley, Bell, de Clerq, Levinson, Stecker)
   and Everyday Aesthetics 27–30, 55, 175
   and disinterest 68–70, 168
   and hedonism (*see also* value empiricism) 33, 36, 141–4, 158
aesthetic realism 18, 95–6, 127, 132, 158
aesthetic value
   as instrumental 141–2, 148, 152–3, 158, 188

   as metaphorical 138–9, 155
   and pleasure (*see also* value empiricism) 140, 144–5
   substantive *vs.* verdictive 128–32

Beardsley, Monroe 32–3, 41, 65–7
Bell, Clive 30–1
Berleant, Arnold 156–7, 187–9

Carroll, Nöel 29, 44, 150–1, 171, 183

De Clerq, Rafael 31–2
discordant aesthetics 189–91
Durà-Vilà, Víctor 143–4, 147, 150

Goffin, Kris 54 fn.63, 71–4
Gorodeisky, Keren and Eric Marcus 86, 88, 90, 92, 98, 103–5
Guyer, Paul 6, 40, 64–5, 122–3

Irvin, Sherri (*see* aesthetic pleasure: Everyday Aesthetics)

Kant, Immanuel
   *Critique of Pure Reason* 111, 162
   *Critique of Judgement*
      the agreeable 110, 112, 114–20
      the beautiful 112–14
      the good 110, 112, 114–15, 118–19
      K-disinterest 112–14
      S-disinterest 112, 115–17

Levinson, Jerrold 33–4, 37, 40–1, 46–7, 66–8, 141, 143, 146–7
Lopes, Dominic McIver 4, 9–14, 86, 106, 142, 168

Matherne, Samantha 14, 19
McDowell, John 70-1, 75
Mothersill, Mary 9-10

Nanay, Bence 41, 48, 55
Nguyen, C. Thi 75-8, 101-3

paradox of negative emotion 2-4, 82 fn. 104, 148
Parsons, Glenn and Allen Carlson 28-9
Peacocke, Antonia 33, 76, 146-7, 158

Riggle, Nick 47, 49-50

Saito, Yuriko (*see* aesthetic pleasure: Everyday Aesthetics)

Schaper, Eva 42, 88, 92, 94, 98, 109-10
Shelley, James 4, 12-13, 56, 91, 134, 141-2, 154
Sparshott, Francis (*see also* the Sparshott Test) 23-6, 37, 43, 45, 79, 126
the Sparshott Test 25, 59, 79, 85, 157
Stecker, Robert 41, 43-4, 142, 146, 149-52

value empiricism 141-6

Wiseman, Mary 41, 78, 175

Zangwill, Nick 67, 87-8, 109, 128-32
Ziff, Paul 56-7, 60

www.ingramcontent.com/pod-product-compliance
Lightning Source LLC
Chambersburg PA
CBHW060838170526
45158CB00001B/181